709.2
Delpr. S

The Master of
ILLUSIONS
Pictures to Ponder from a Visual Virtuoso

Sandro Del-Prete

Edited by Annemarie Koch

STERLING

New York / London
www.sterlingpublishing.com

STERLING and the distinctive Sterling logo are registered trademarks of Sterling Publishing Co., Inc.

Library of Congress Cataloging-in-Publication Data

Del-Prete, Sandro, 1937-
 The master of illusions : pictures to ponder from a visual virtuoso / Sandro Del-Prete.
 p. cm.
 Includes index.
 ISBN-13: 978-1-4027-5400-5
 ISBN-10: 1-4027-5400-0
 1. Del-Prete, Sandro, 1937—-Catalogs. 2. Optical illusions—Catalogs. I. Title.

N7153.D435A4 2008
760.092—dc22

 2007038942

10 9 8 7 6 5 4 3 2 1

Published by Sterling Publishing Co., Inc.
387 Park Avenue South, New York, NY 10016
© 2008 by Sandro Del-Prete
Distributed in Canada by Sterling Publishing
$^{c}/o$ Canadian Manda Group, 165 Dufferin Street
Toronto, Ontario, Canada M6K 3H6
Distributed in the United Kingdom by GMC Distribution Services
Castle Place, 166 High Street, Lewes, East Sussex, England BN7 1XU
Distributed in Australia by Capricorn Link (Australia) Pty. Ltd.
P.O. Box 704, Windsor, NSW 2756, Australia

Book design and layout: Rachel Maloney
Art: Sandro Del-Prete (http://www.sandro-del-prete.info)
Photos: Malu Barben, (http://www.malubarben.com)
Text: Sandro Del-Prete, Annemarie Koch, Michel A. Di Iorio, Brigitte Del-Prete
Text edited for the author by Annemarie Koch (http://www.annemarie-koch.ch)
Text translated for the author by Michel A. Di Iorio, Les Mots Justes (http://www.les-mots-justes.net)

Printed in China
All rights reserved

Sterling ISBN-13: 978-1-4027-5400-5
 ISBN-10: 1-4027-5400-0

For information about custom editions, special sales, premium and
corporate purchases, please contact Sterling Special Sales
Department at 800-805-5489 or specialsales@sterlingpublishing.com.

Dedication

Though many good people deserve recognition and my profound thanks, I would like to dedicate this particular book to someone very special and dear to my heart: my wife, Yolanda Del-Prete, who was always there for me, no matter what!

In the early years, she endured the ravings of a hungry young artist, out to change the world with an image and a dream. She believed in the man as well as the artist, and this gave me the courage to persevere. When the dream became a reality, and *Illusoria-Land* was opened to the public, she was there to cheer me on and encourage me, reminding me that there was still much to accomplish; that the dream had only just begun.

Now that the autumn years are but a memory, and the winter of my youth has deftly crept into my life, she is still there, stoking the fire to keep my feet warm as I embark on this newest of journeys!

Without her, I fear that I might have lost my way Thank you, my precious Yolanda, for your patience, for your guidance, and for believing in the dreamer, as well as the man!

—Sandro Del-Prete

CONTENTS

FOREWORD

Sandro Del-Prete is a visionary artist who has seemingly transcended the conventional laws of physics to create his very own land of illusions. He is, in fact, living his dreams: designing and creating them by lending them form.

In the ordinary world where one tends to dwell on the deceptions and fallacies of life, entering Sando Del-Prete's land of illusions is amazingly encouraging and refreshing! How delightful it is to hear and feel words like *illusions* or *illusorisms,* or expressions like land of illusions! They have the power to convey notions of dreams and hopes, and to transmute reality into something more mysterious.

Long before I came to know Sandro, I had the pleasure of reading and admiring his first two books. They opened doors: gates, deeply embedded in my adulthood, that led me back to my own childhood, to my dreams and illusions. They reassured me that I was not the only dreamer in this world.

His style is uniquely poetic and highly personal. Through humorous suggestion, he invites humankind to reflect on itself. His works touch the emotions and invite one to look within, as opposed to looking only at the surface of things.

In the beginning . . .

Fifty years ago, Sandro drew inspiration from a chameleon. As he pondered the strange-looking creature, he realized that one eye looked forward while the other scrutinized the rear. Del-Prete reflected on how this little animal, with its panoptical sight, might perceive the world around it.

He began looking at things from different perspectives and tried to realize these on paper. In so doing, he discovered a new dimension—a space without directions such as ahead, behind, above, and below, or right and left. From these early reflections, he created his first illusion: *The Window Gazers* (illustrated in his first book, *Illusorisms*).

The chameleon that changed Sandro's perception has since inspired me as well. It has provided me with a new way of looking at and approaching nature. I've realized since then how refreshing it can be to look at the world from different angles and to channel their diversity into their common denominator.

In 2006, Sandro's *Illusoria-Land* (*Land of Illusions*) celebrated its twenty-fifth anniversary, bearing witness that illusions can survive, that they carry life within them. They do so under one condition, however: they must be animated by the love in one's heart. This makes it possible for them to develop and expand from the three-dimensional world into infinity.

Indeed, the flow of visitors to *Illusoria-Land,* his two books, a world first in art, and the present volume confirm that illusions can survive. The festivities surrounding the twenty-fifth anniversary remain unforgettable to me. It was typical of Sandro to give something to his brethren to take along with them—to motivate them to discover themselves by stimulating their interest in this world and its creations.

Have I sparked your interest, too? Well that pleases me, because I'd like to tell you a bit more about this astonishing celebration. When I first visited Sandro's *Illusoria-Land*, I noted the following impressions in my biweekly column:

He began with a special exhibit, the aim of which was to allow us to reach new dimensions through the use of illusions.

To this end, he handed me a box with a mirror on top of it. The ceiling of the room in which we were standing was also covered with mirrors. I gazed with curiosity into the mirror-top of my box and was amazed by what I saw. I had never seen myself from this perspective. Three meters below me, I could see my hairstyle from above while walking around with my head in the box. I wondered what men felt when they realized all of a sudden that they had the beginnings of a bald patch.

Sandro's presentation of images and sculptures provoked self-awareness in me and encouraged me to acknowledge new perceptions. *The Little Rascal* lashed his tongue at me and followed me with his eyes, his face in a smirk.

The Bridge of Life shows that life never truly stands still. Collectively, *Adam and Eve*, along with *Aphrodite*, the *Love Poem of the Dolphins*, and a *Copa Mysteriosa* invite one to recognize new perspectives. *A Bar Table with a Blue Crystal Fire* invites one to pause and to meditate on what has been presented.

The climax of the exhibition is a huge panoramic oil painting that uses a relief technique showing Thun Lake with the Eiger, Mönch, and Jungfrau—the world-famous mountain range in the Swiss Alps. In the forefront, one perceives columns and a floating vase (a vase floating in midair). This image is a novelty, as Sandro Del-Prete is the first artist to use techniques of inversion and eversion in the same image. I was invited to walk before the image, but when I did, the whole exhibit began to move. The vase and columns were really moving, though I had not had a single drop of alcohol. . . .

In honor of this anniversary, his son Silvano composed the background music to this event. What a beautiful complement: colorful, warm, light, recalcitrant and harmonious tones from both father and son which blend into a wonderful feast for the eyes and ears. There are indeed many things to admire in *Illusoria-Land*: from holograms and a suspended bridge over a revolving precipice, to *Castel Nero* (*The Castle of Darkness*), where blind people have found jobs that have helped strengthen their self-esteem.

Sandro Del-Prete's enthusiasm was absolutely infectious. His objective was to bring the joy of life and encouragement to everyday living. He succeeded in opening one's eyes where normally, one would have simply passed by. His exhibition helped heighten our consciousness, while his words helped us to gain a deeper insight into life.

His optical illusions were—and remain—truly "world class." In addition to his permanent exhibition, they can be found in the book *Masters of Deception* (Al Seckel, New York: Sterling, 2004; ISBN: 1-4027-0577-8). In this same book, one stumbles upon such prominent names as Salvador Dali and M. C. Escher.

A guest artist invited to the vernissage,* Hans Ledermann, described the event by saying, "I see things as they are, knowing that they are not, in fact, as I see them. What a pity this exhibition isn't enjoyed by millions!"

A jewel for teenagers, a beautiful cultural contribution to the city of Bern, and a genuine tourism treasure—such exhibitions are also superb teaching aids, helping students and adults alike to improve their observation and perception skills.

Illusions sometimes do materialize . . . and survive!

Dear Sandro! I thank you for having had the courage to make your Land of Illusions materialize. I thank you for your books, especially this third one, for which I have had both the honor and pleasure of writing the foreword. I thank you for all that you have given us to ponder, for breaking out of the box, and being courageously different. For this book, and for all of your future endeavors, I wish you the best of success. May all your readers be as inspired by you as I am.

Sandro Del-Prete is the true master of optical illusions and deceptions.

—Annemarie Koch, contributing editor

* A French word referring to the day before an exhibition opens, reserved for artists to put finishing touches to their paintings—literally, to varnish.

PREFACE

Sandro Del-Prete: a True Master of the Art of Optical Illusions

An art movement without name? The names of Del-Prete's precursors are well known, however: Giuseppe Arcimboldo (1527–1593), Salvador Dalí (1904–1989), M. C. Escher (1898–1972), and Oscar Reutersvärd (1915–2001). This new trend in late–twentieth-century art contrasts with earlier movements like The Blue Rider or Bauhaus, on a regional level. According to the *Zeitgeist* (meaning the spirit of the time), it developed globally because more and more young people were fascinated by this new form of art.

Whereas Salvador Dalí and René Magritte (1898–1967) were members in good standing of the circle of Parisian surrealists, it was not so easy to classify M. C. Escher. He was a lone wolf; the easiest, or most convenient way of referring to him was as "A Man on the Cutting Edge of Cultural History" (the title of Sabine Lepsky's doctoral dissertation, 1992). Meanwhile, M. C. Escher attained worldwide recognition as an artist, in defiance of the art establishment.

In 1998, during the "La Sapienza" University convention, hundreds of Escher fans from all over the world traveled to Rome to celebrate his 100th birthday. They shared a deep bond with Escher and were greatly influenced by his work. A book authored by Dr. Schattschneider and M. Emmer, *M. C. Escher's Legacy—A Centennial Celebration,* is a clear testimonial to this. Other books have also contributed to his notoriety; among them are works by Bruno Ernst, as well as the bestseller *Gödel, Escher, Bach* by Douglas R. Hofstadter.

As a matter of fact, this art trend has not been given a real name to this day. It finds its raison d'être in the artistic design of illusions, impossible objects, optical deceptions, double-perspective, transformations, anamorphosis, and a good deal more. Unfortunately for the artist, an unnamed art movement is not truly recognized by the established art scene: instead, it is often negated.

In 2004, a new book by Al Seckel, *Masters of Deception,* was released in the United States. This book rapidly climbed the bestseller list. The collection of works that he presents are those of world-renowned artists; among them are the five mentioned above. Del-Prete is mentioned in the foreword by Douglas R. Hofstadter. Though the artists all reside in different countries, thanks to the Escher convention in Rome, they came to know each other personally. An important question remained to be answered: how could this movement or mental solidarity be named, considering that each artist possessed his own individual style and perspective?

In his first volume, Del-Prete coined the word *illusorism,* derived from the word *illusory,* which means based on, or having the nature of, an illusion. Illusorism could easily have applied to most of the aforementioned artists but might not cover each variation, for example, the area-filling figures by Escher, which both distinguish and complement one other.

In the present volume, Del-Prete explores the amplitude of images and ideas once again, but this time with an added touch of color. He presents a complete range of his works: from the shape of a design, to reproductions, through lithography, and from oil paintings to sculptures. He even presents examples of relief images that seem to move and change when one passes in front of them. He calls these *inversion sculptures and statues*.

In some of the relief images, he has combined both inversion and eversion techniques. The surprising result boggles the mind with apparent illogical "movement" in opposing directions. Unfortunately, it is not possible to show these effects in the two dimensions available in the imagery of a book, even if images from different angles were combined. One needs to walk before them to really experience their amazing illusory effects.

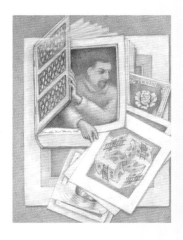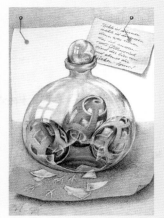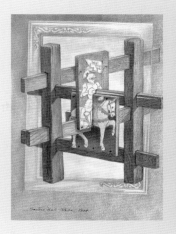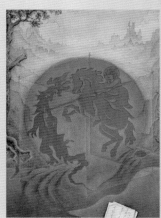

FAMOUS AND NEW ILLUSORISMS

Certain images in this chapter were selected from my first published volume, *Illusorisms* (published as *Illusorismen, Illusorismes,* Benteli Verlag, Bern, 1981), and others were selected from my second book, *Illusoria* (Benteli Verlag, Bern, 1987). These images represent my early development and were presented in black and white; color was something that I added later to these works. I have since created numerous new images, some of which have been reproduced in books by Al Seckel (published by Sterling Publishing Co., Inc., New York, 2004). Subsequently, I produced many other illustrations in color that have not yet been reproduced or published.

The Artist Presents His Work

"I would like to present my images to you through my book. I have emerged from it as if to show these illustrations to a neighbor. And now, please enjoy your journey through my illusorisms!"

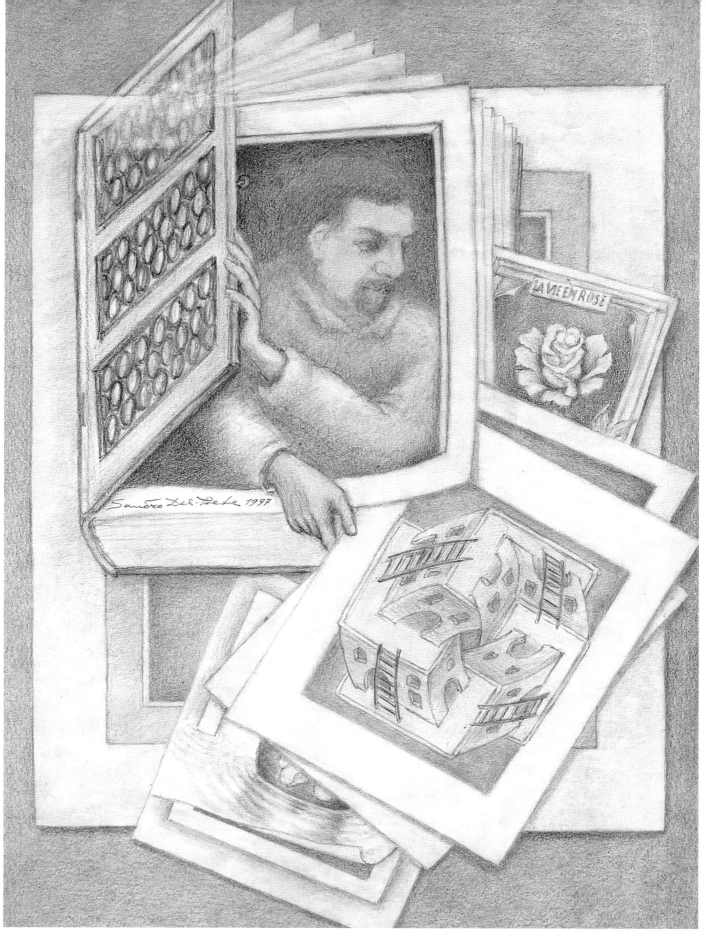

THE BILATERAL AGREEMENT

Agreements are often the product of troublesome negotiations. Here, through the use of symbolism, two opinions merge into one agreement; the arduous negotiations that went into it are represented by tears in the paper.

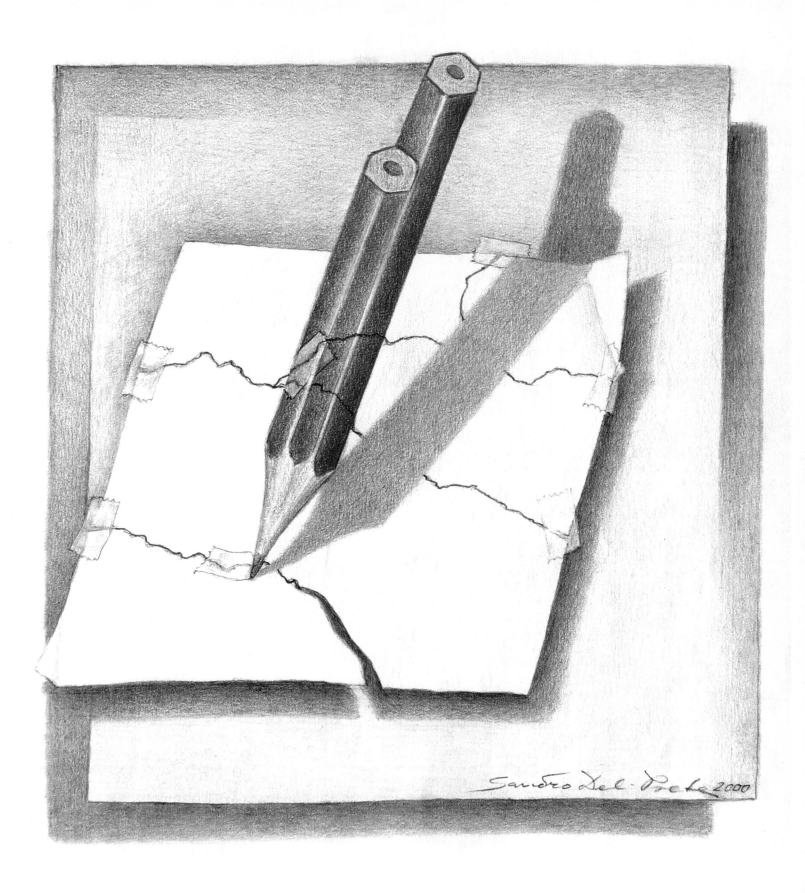

Hibernation

Old Man Winter's image is reflected in the crystalline mirror of an ice grotto. As a sign of his reign, he extends three fingers of his hand towards the reflection— and in between, one can distinguish his lovely counterpart. . . .

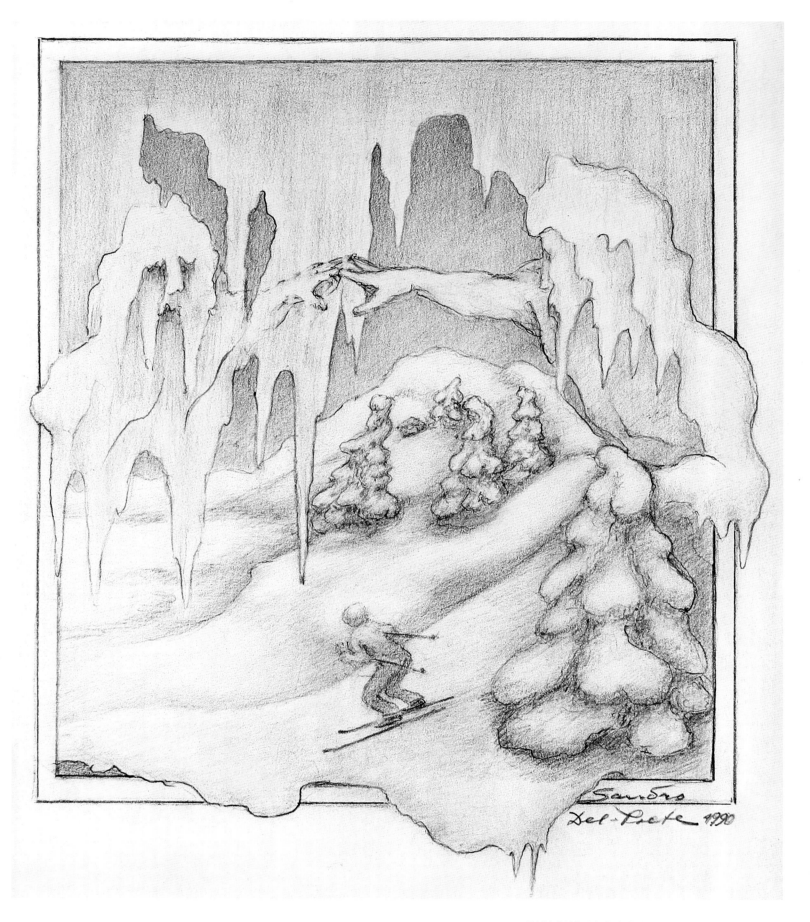

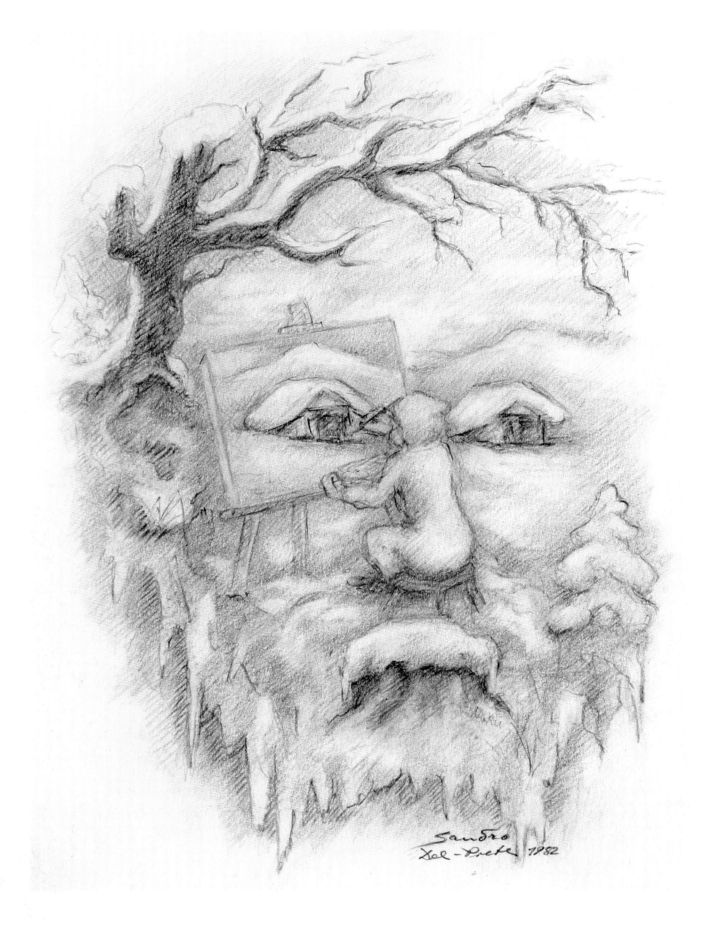

Mountain Spirit in Winter

Throughout the ages, simple, nature-loving people often attributed a soul-like phenomenon to spiritual manifestations, events, and objects. Imaginative and especially superstitious people often reported having seen ghosts or demons (*spirits*)—many tales and legends testify to this. This image illustrates a mountain spirit, as might have been seen or imagined by a mountain dweller.

What Is the Perfume of an Orchid?

Translation of text in the image: "What is the perfume of an orchid? An orchid with a seductive aroma. . . ."

A girl emerges from the outline of two orchids and a tropical bird sitting on a branch covered in moss.

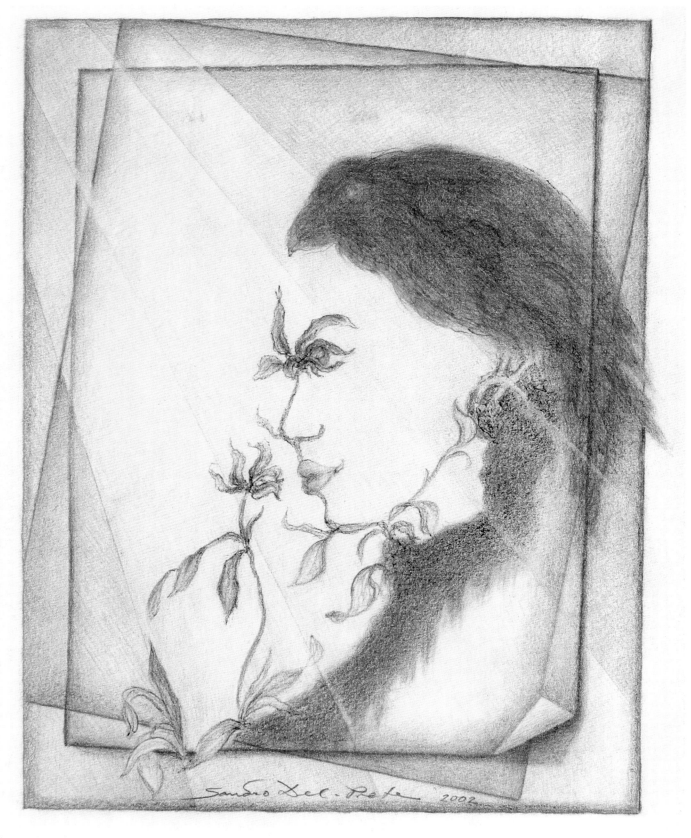

"Wie duftet eine Orchidee?"
"Orchidé à l'odeure séduisante"

Orchid of Love

From one orchid plant, two "new" ones have grown—demonstrating tender, loving affection.

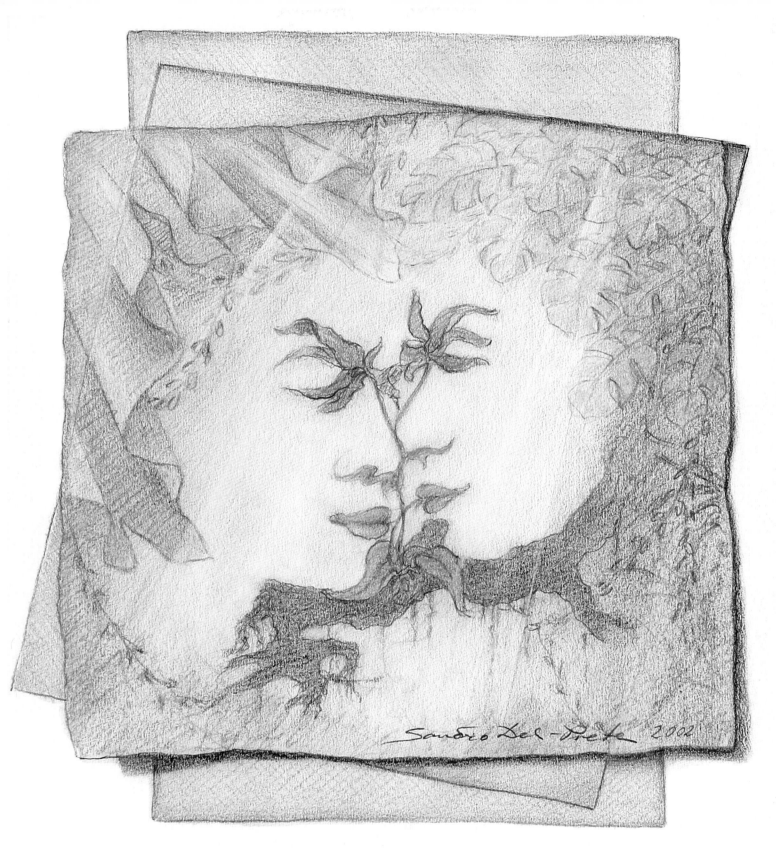

"Orchidé de la tendre affection"

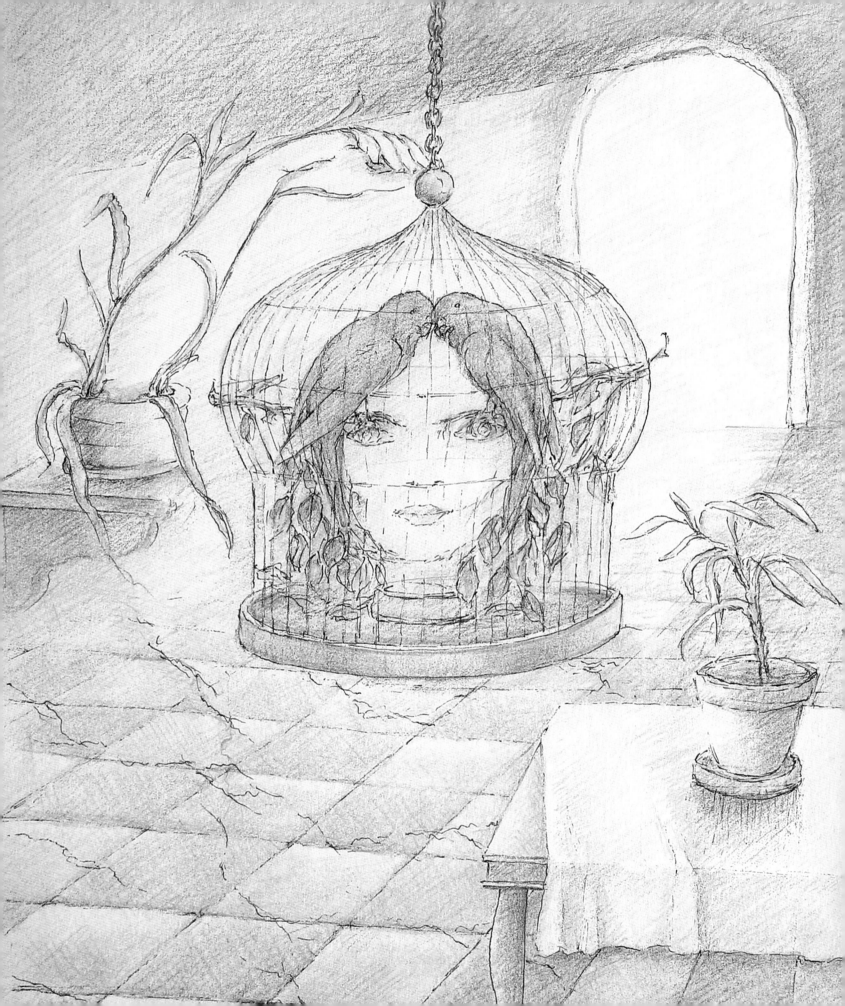

THE BUDGIE CAGE

A cage with two lovebirds sets the stage for an extraordinary phenomenon. If you look closely, all the elements in the birdcage merge into the shape of a girl's face.

Easter Eggs

Nothing is inside,
 nothing without;
 because what is inside
 is riddled with doubt!
 The eggs are illusory, as are the chick's footprints!

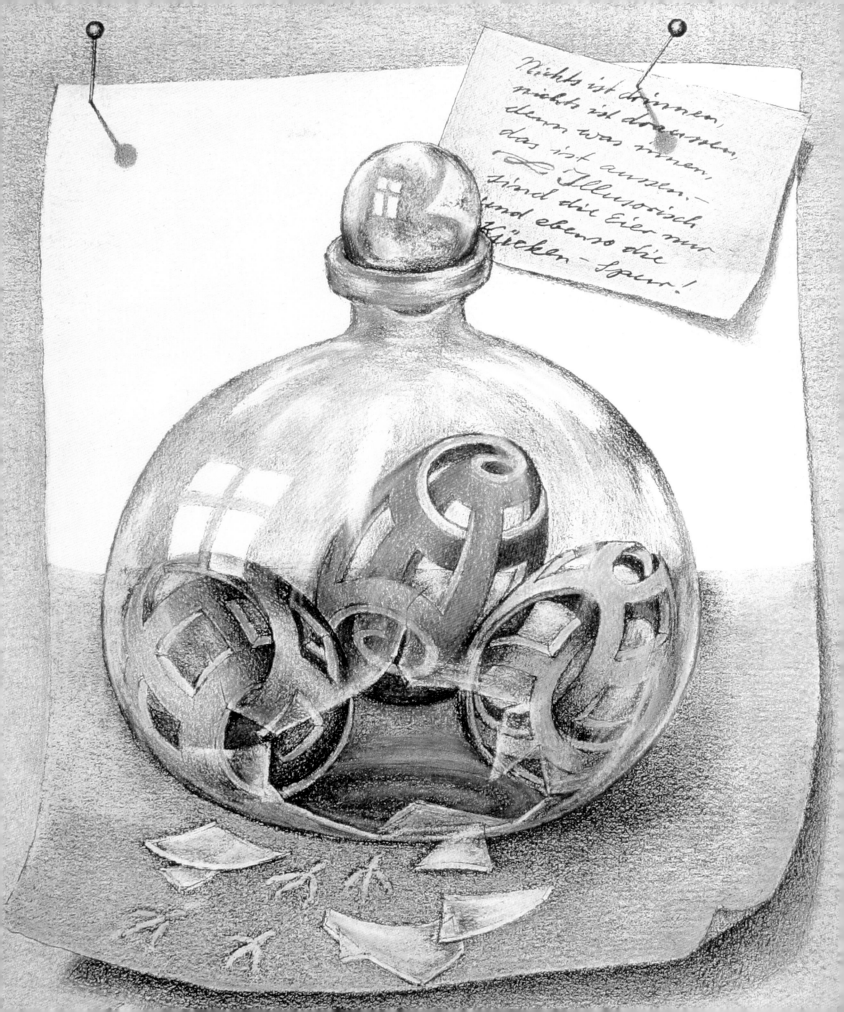

Rotating Cogwheels

These interlacing cogwheels were designed for the Rotary Club, of which I am a member in good standing. It uses symbolism to demonstrate how members of the club are interlinked.

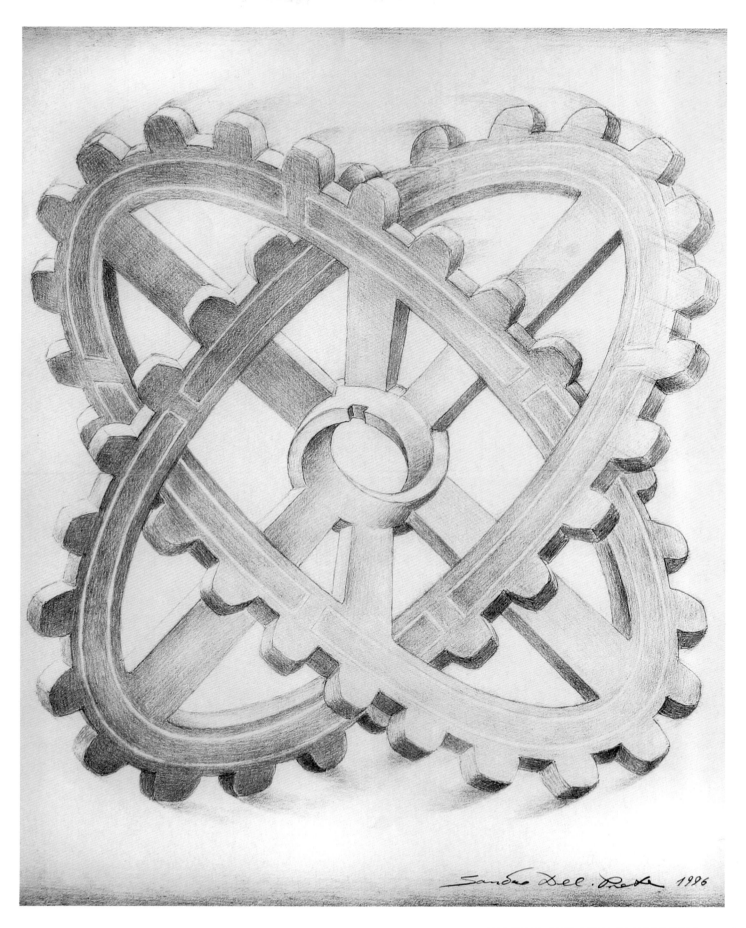

Sandro Del-Prete 1986

Spectacled Subject

These spectacles, deposited on the page, look like someone's face—is it the reader's?

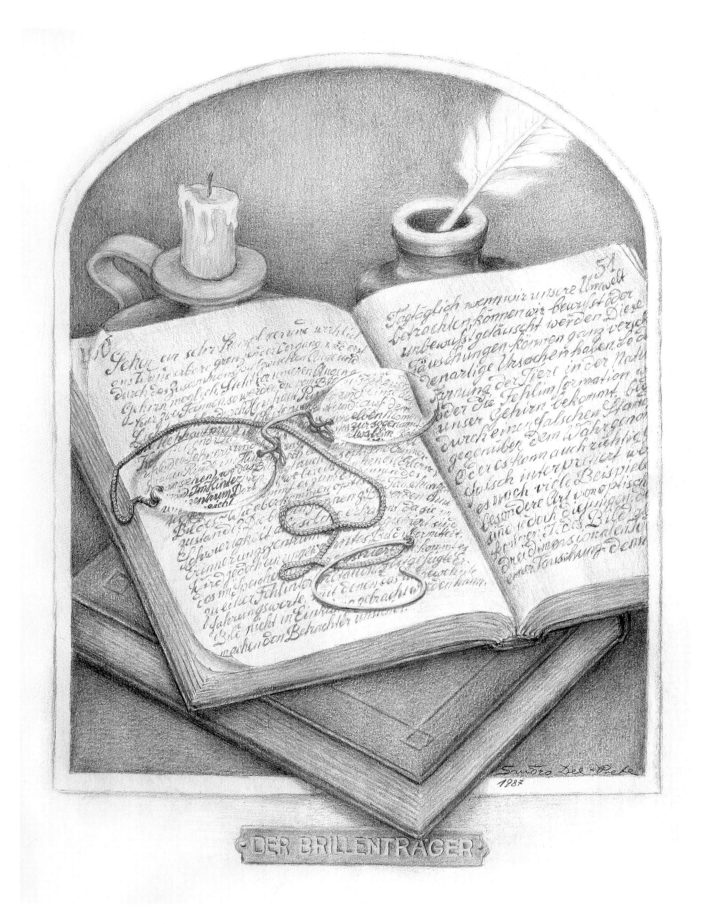

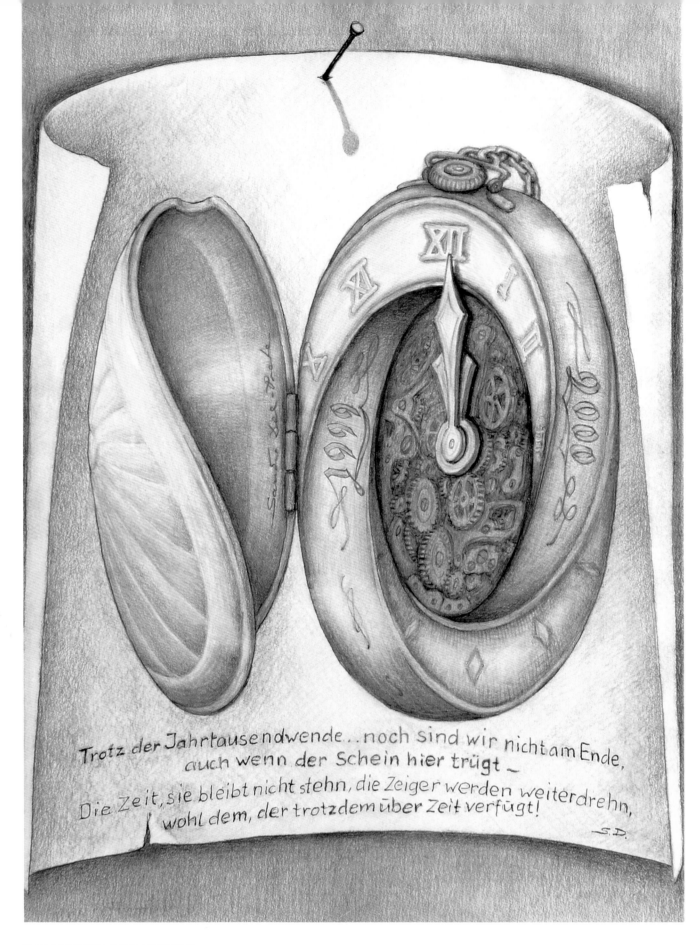

Trotz der Jahrtausendwende...noch sind wir nicht am Ende,
auch wenn der Schein hier trügt —
Die Zeit, sie bleibt nicht stehn, die Zeiger werden weiterdrehn,
wohl dem, der trotzdem über Zeit verfügt!

S.D.

Millennium Watch

"Though the millennium has changed . . . we haven't yet reached the end of our trip, in spite of appearances, which can be deceiving."

"Time does not stand still—the hands of the watch continue to progress, to the delight of those who still have time!"

The Endless Towers

This image is an homage to M. C. Escher.

 Inspired by Escher's image of monks ascending (or descending?) the stairs of a building, here the building was conceived a little differently: it was erected from a central perspective. On looking downward, one can see the four towers twist, one into the other, creating an endless staircase. The four towers symbolize the four seasons. If one succeeds in climbing any of the four towers, he would find himself back where he started: at the beginning of the year.

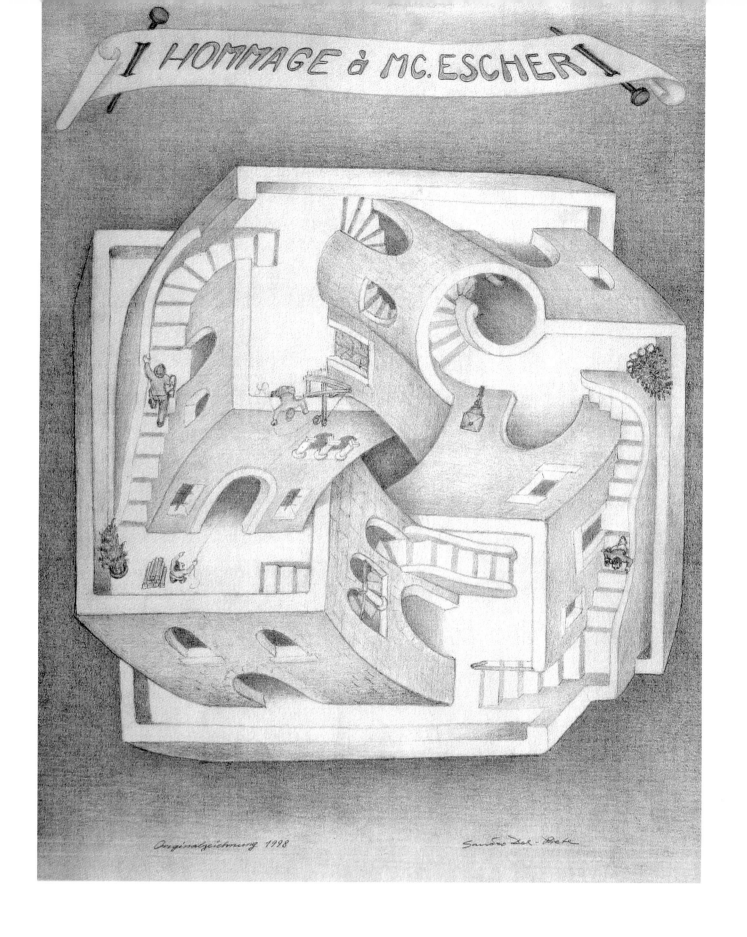

The Silent Wail of a Crinkled Piece of Paper

It was just a sheet of crumpled paper in the trash, until someone decided to recycle it, one last time. The person took it out of the trash, flattened it out, and gazed intently at the pattern of the creases. After a moment's contemplation, he perceived the silent wail of the piece of paper that had carelessly been discarded, without respect.

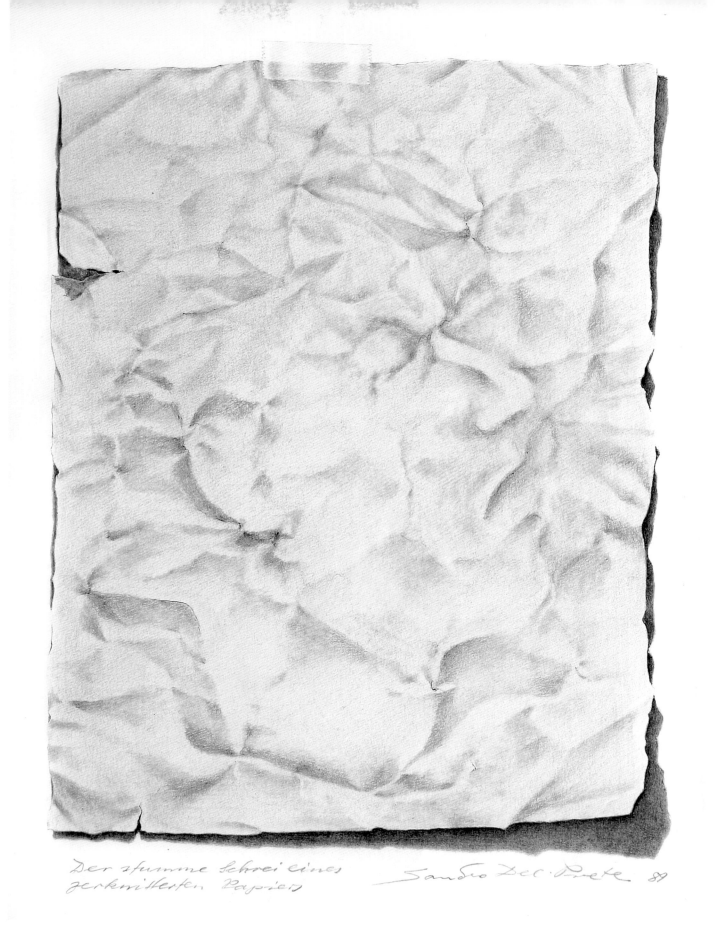

Der stumme Schrei eines
zerknitterten Papiers

Sandro Del-Prete 89

The Discovery of Illusorism (Self-Portrait)

In this illustration, I am looking at a cube-shaped structure that could never be built in reality. Accordingly, the position of my hands is illusory and possible only on paper. The structure is a symbol of illusorism. Just as surrealism evolved from realism, I have developed illusorism from illusionism. Since illusorism contorts reality to a certain extent, it is also connected to realism; I have illustrated this fact by means of the contorted side walls of the structure.

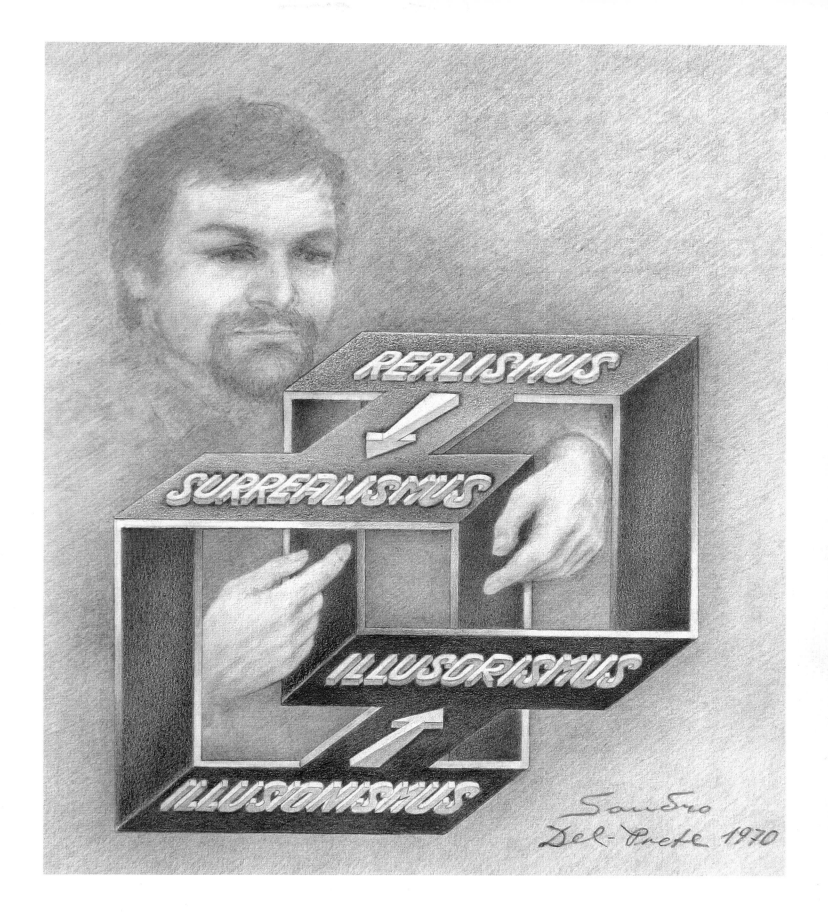

The Columns

Although the viewer can see three columns at the bottom, only two remain on top. It is interesting to see how the middle one dissolves into thin air without losing its contours. A round column consists of two lines, while a cornered column displays two surfaces and three edges. Two times three edges makes six lines, and it takes six lines to draw the contours of three round columns.

Evolution of Power

In former times, a man had to carry out his work using his brawn, not his brain. Here we can see a man carrying a heavy load of cotton on his head. Exhausted by the effort, he needs to sit down. The human spirit, on the other hand, does not tire, but tries to think of ways to complete his work without having to endure such difficult labor. In this close-up, we can see a man using the power of his brain to invent machines that replace muscle power.

Einstein

It may well be taken as a joke that the portrait of this famous man is made up of three young bathing beauties. Whether this is a good or a bad joke, I can't say—all things are relative! This no doubt would be the opinion of the man who conceived the theory of relativity.

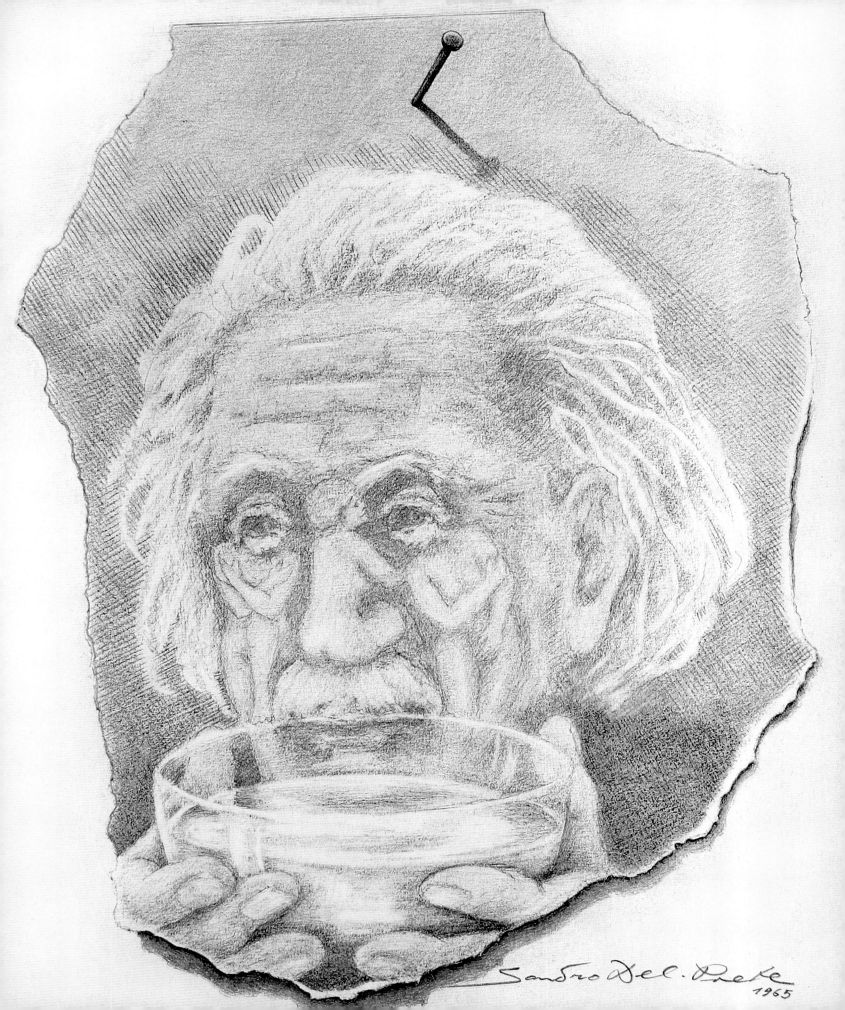

Sandro Del-Prete
1965

Ascent and Descent

What happens in the life of a human being is depicted here in slow motion. People strive for the zenith throughout their lives, but while believing that they are ascending toward that zenith, they may very well be on a downward slope without being any the wiser. No matter which way they are heading, their descent is bound to come sooner or later. On this flight of stairs, it is impossible to tell on which step the change of direction occurs.

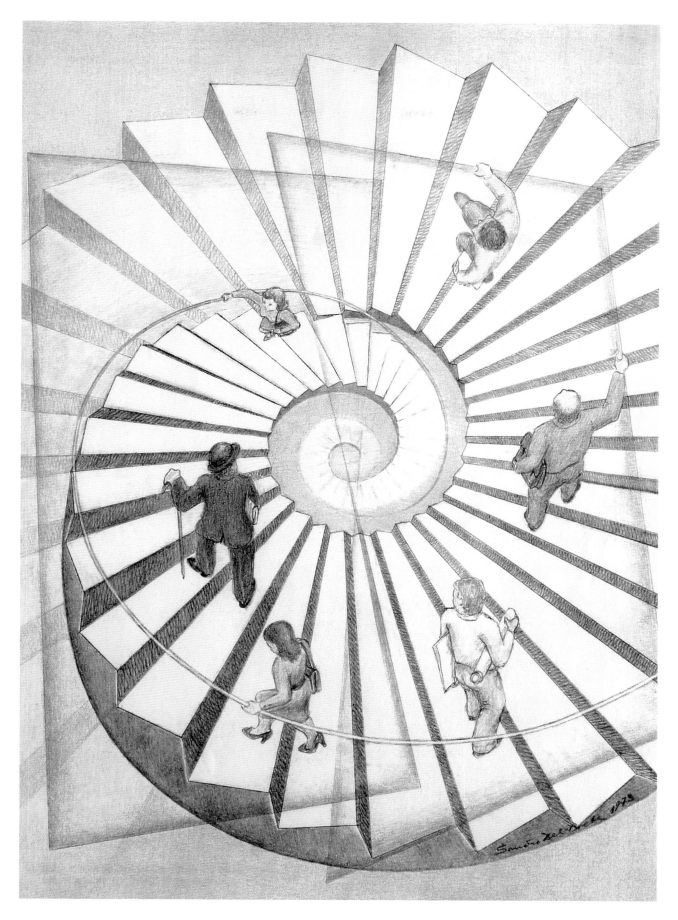

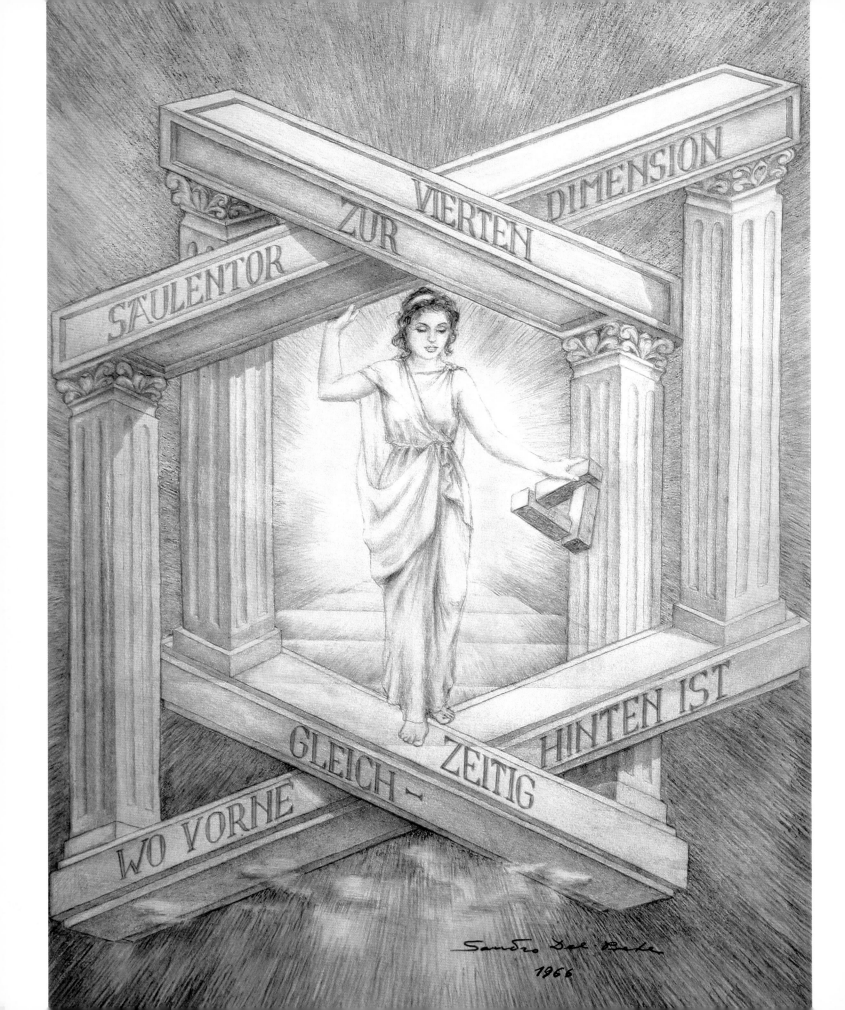

GATEWAY TO THE FOURTH DIMENSION

The fourth dimension has yet to be defined. This illustration represents the illusion of a fourth dimension by neutralizing the directional notions of "front" and "back." Thus, the viewer has the impression that all the corners are at the back, though logically, this cannot be. In this gateway to the fourth dimension, the suggestive effect is so powerful that one almost feels the two shorter crossbars curving back in an arch.

Cosmic Wheels

Here the planetary system is symbolized with the help of two intertwined coach wheels. The common hub and spokes represent the sun, its beams, and gravitational force. The sun holds the planets "prisoner" in their respective orbits. Since the lines are deliberately drawn in erroneous perspective, the wheels appear to tilt over. One and the same side of a wheel can be seen—from above in the lower part of the illustration and from beneath in the upper part; with the other wheel, it is the exact opposite.

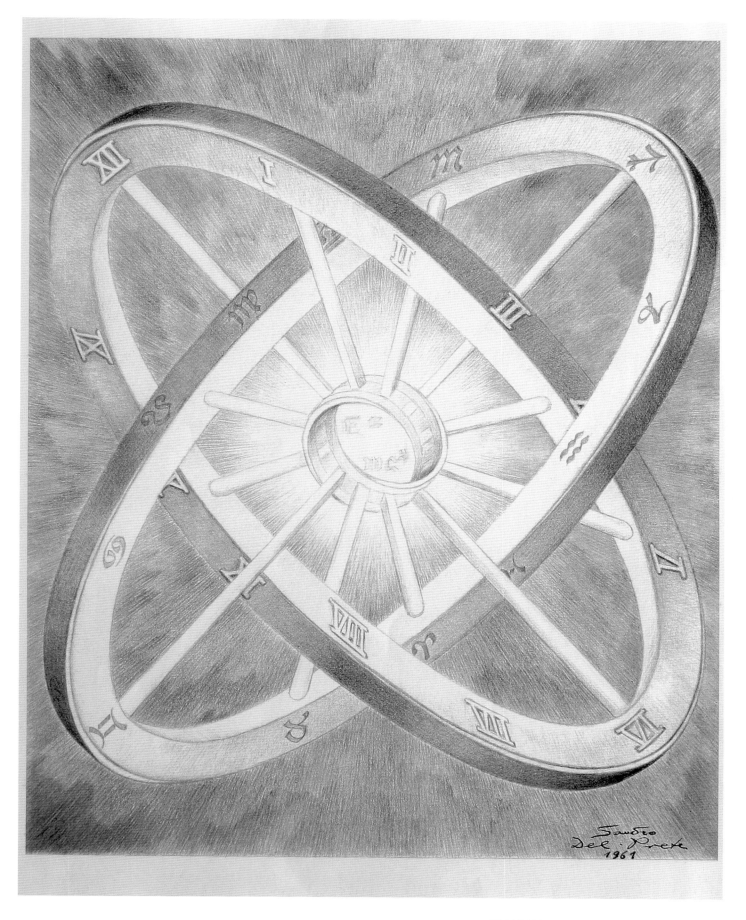

The Crusader of the Lattice Fence

The light-colored boards on the right lead to the back, while the dark ones come to the front while still crossing in the same pile. The boards cross over each other three times without bending!

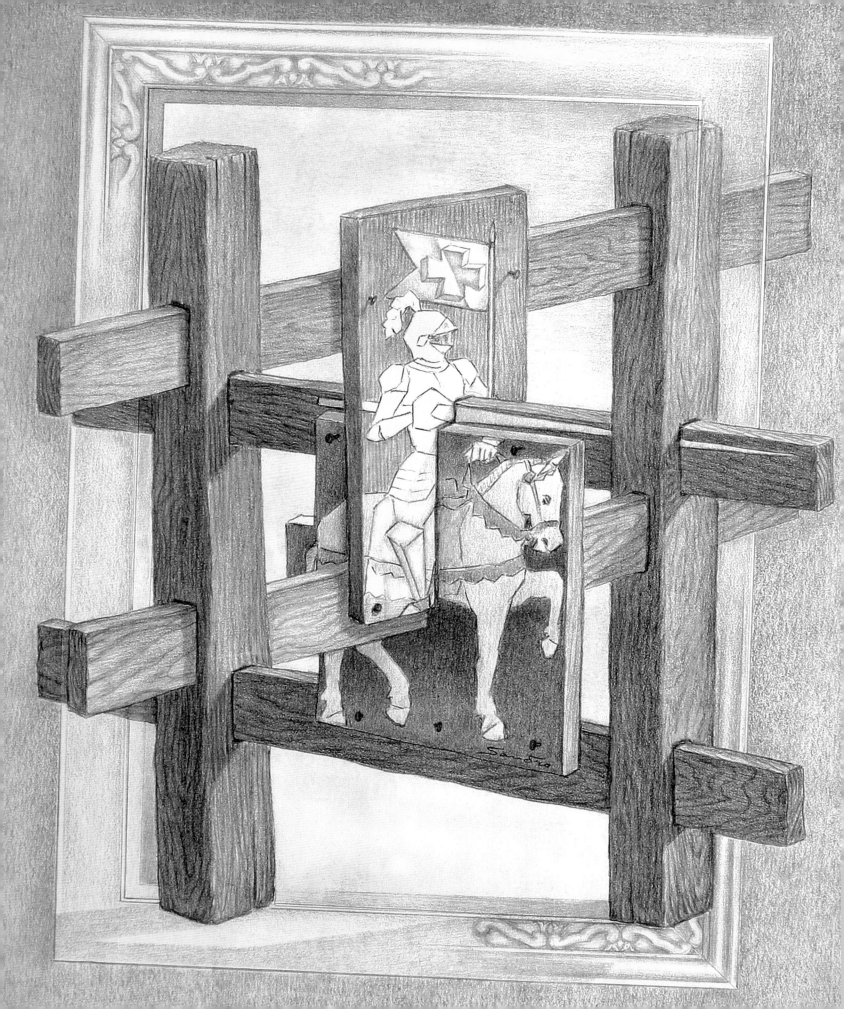

Quadrature of the Wheel

The invention of the wheel was one of mankind's greatest achievements. Since then, countless types of wheels have been developed. So I decided to join the ranks of brilliant wheel inventors. It took me a great deal of thinking and drawing, but then I'd got it: I had designed my own wheel—a wheel the world had not set eyes on before. This six-edged square wheel, seen from the side when not in motion, does in fact look like a square. On turning the crank, however, it changes into a circular disk, which again changes into a hexagon.

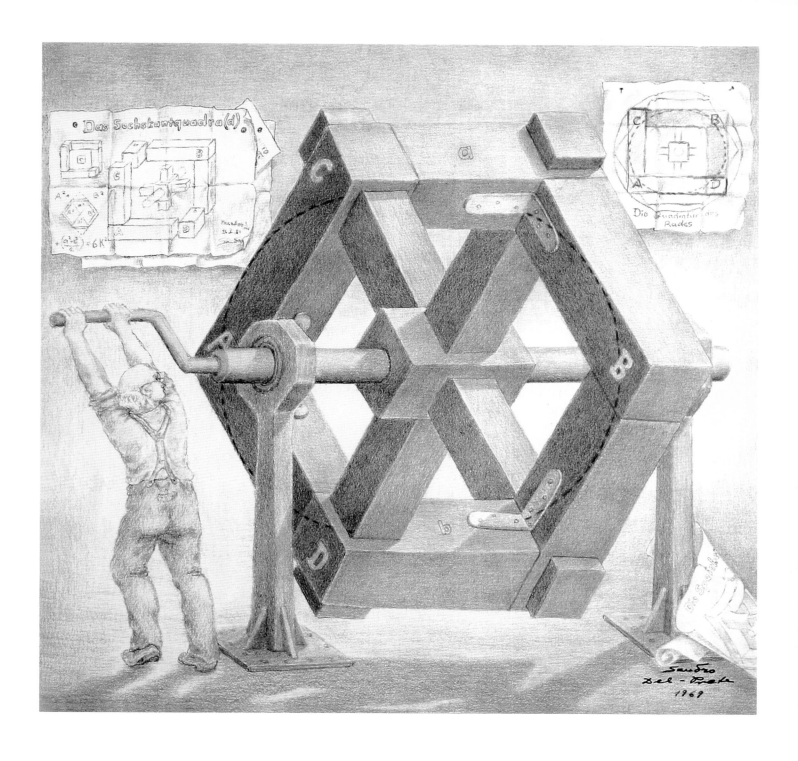

A Rocking Horse Swing Named Pegasus

This flying horse has planks protruding from its body in a horizontal plane but that appear to be pierced vertically by the rods. The legs and rockers are equally distorted. It is little wonder that total concentration is required to ride such a horse!

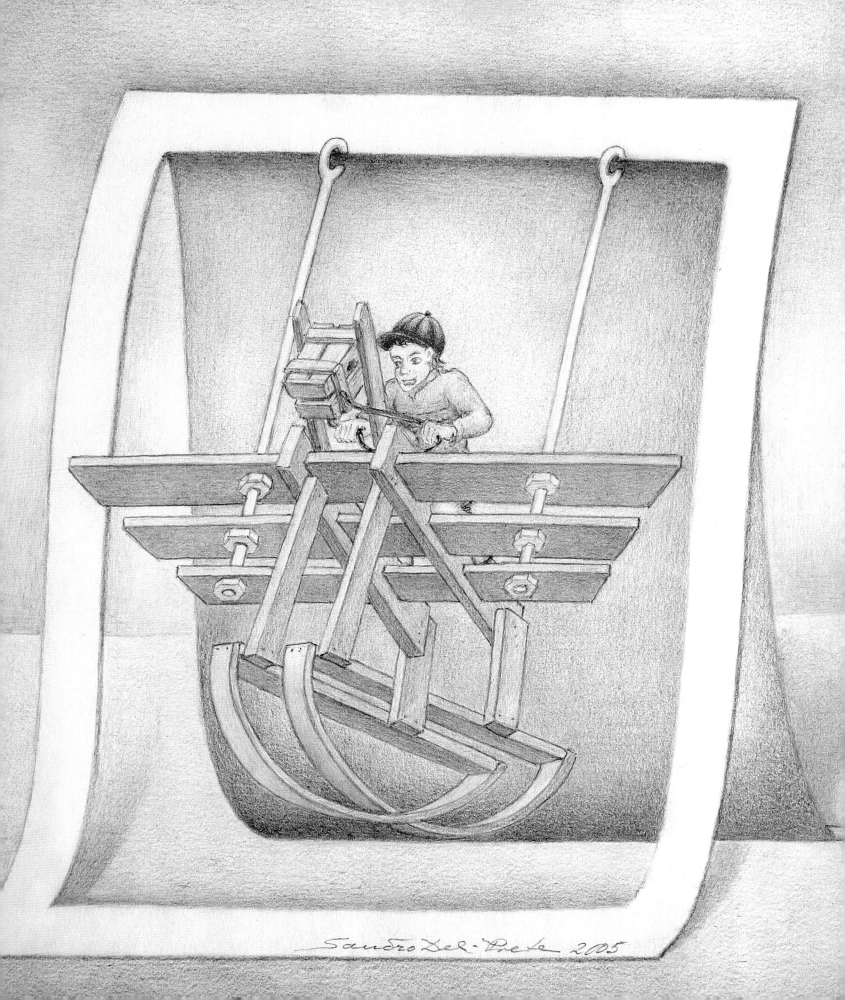

Sandro Del-Prete 2005

The Garden Fence

Horses usually take hurdles in a jump. In this illustration, two boys have jumped over the fence on a wooden horse. Despite its inability to move, the horse succeeds in taking its riders into the neighbor's garden, imitating its notorious ancestor from mythical Troy.

The four horizontal boards are superimposed on the pickets in a vertical pattern, though the horse's "belly" crosses them on a horizontal plane. To be feasible, the lowermost boards need to occupy the same height as the uppermost ones while simultaneously running parallel to each other in a straight line. Cover either end of the fence to see the visual paradox. The boards are aligned both horizontally and vertically. This illustration is based on the impossible triangle.

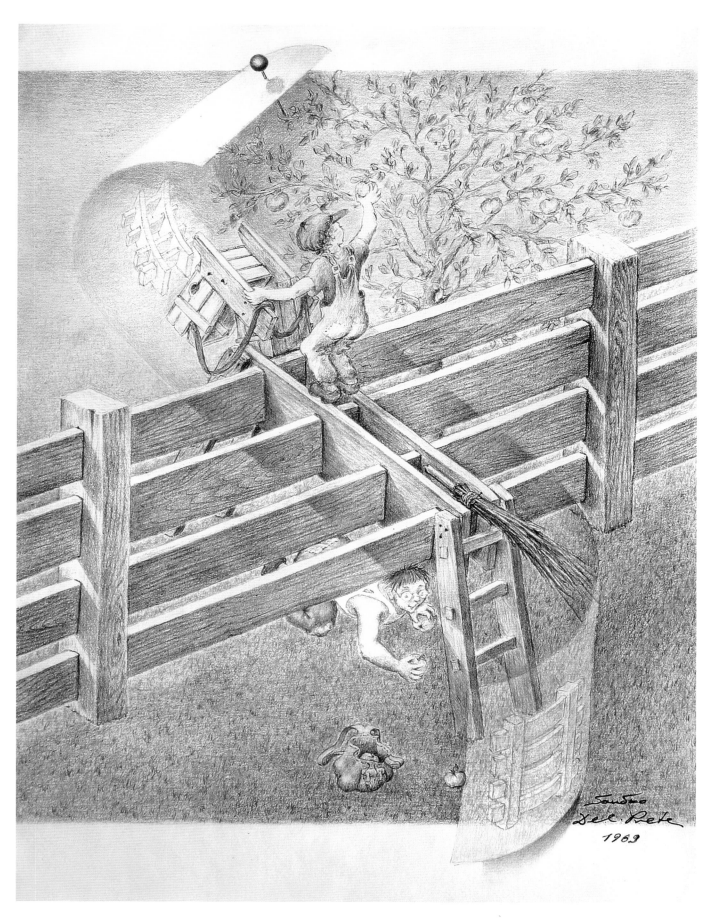

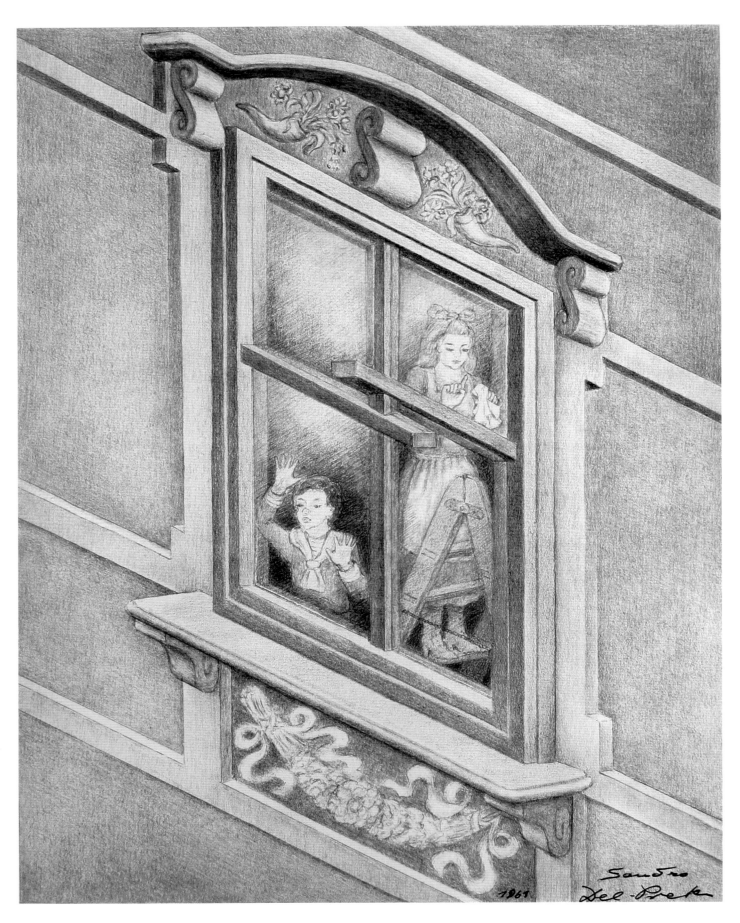

The Window Gazers

In this illustration, we see a window facing south in its upper part and west in its lower part. While the eyes of the viewer travel from top to bottom, the window apparently turns an angle of 90 degrees. The difference in angles is made obvious by the erroneous construction of the crossbars. But why is this window distorted? All of its lines run straight and parallel. The answer lies in the fact that the viewer is looking up at the window from the street while simultaneously looking down on it from above.

The Impossible Scaffolding

This scaffolding is supported by two vertical, square poles connected by layers of crossbeams. Transverse boards form a horizontal platform—supporting the bucket of water. On this platform, the workers can go about their business. The absurdity of this scaffolding becomes apparent when one realizes that the lowest of the crossbeams, against which a shovel is leaning, ought to be on the same level as the top beam, to which the pulley block is fixed.

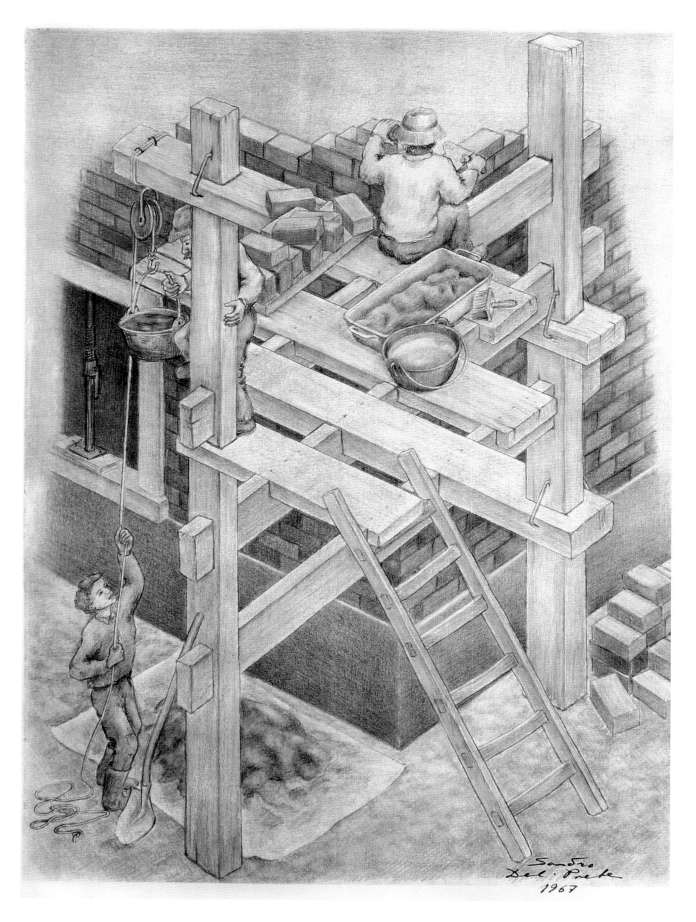

The Wine Cellar

The builder of this wine shelf must have tasted the contents of the cask beforehand—how else could he have had the inspiration for such a masterpiece? Though he hides behind the shelf, the youth can still taste the sweet wine flowing from the bung of the wine cask.

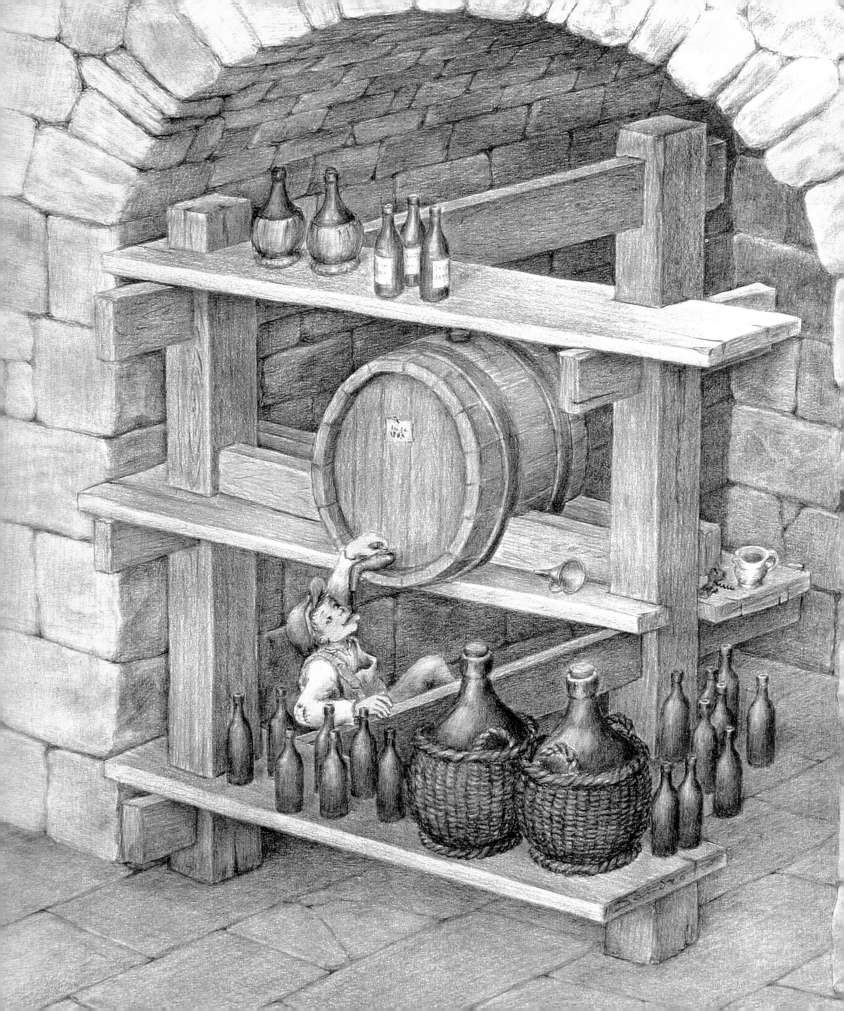

Spring in the Illustration Gallery

A river landscape makes up the background of this curious group of illustrations. As if emerging from the water, the "Primavera" figure appears in silhouette and plants a yellow daffodil by the old willow trunk.

As spring injects new life into everything, the old willow trunk begins to shoot forth—and even the stag in the lefthand illustration turns his head toward the tray of fragrant fruit.

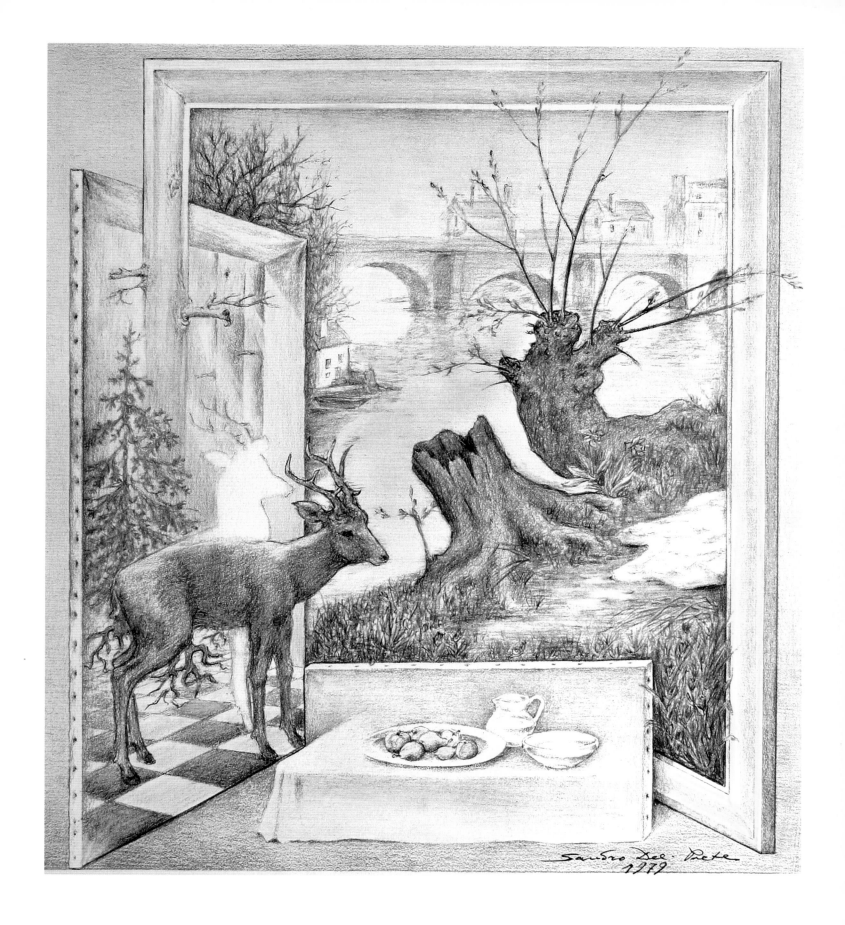

The Festival of Bacchus

This illustration contains a remarkable transformation that moves from the bottom of the image to the top. At the bottom you can see two small figures: on the left there is a man holding a wineglass, while on the right, a woman is carrying a tray of wineglasses. There is a festive atmosphere as Bacchus, the god of wine, makes his appearance. In his hands he is holding the two elated figures. He slowly brings them together to toast each other's health until the transformation of the festival is complete. If you examine the inebriated face of Bacchus, you will see that it contains the two celebrants.

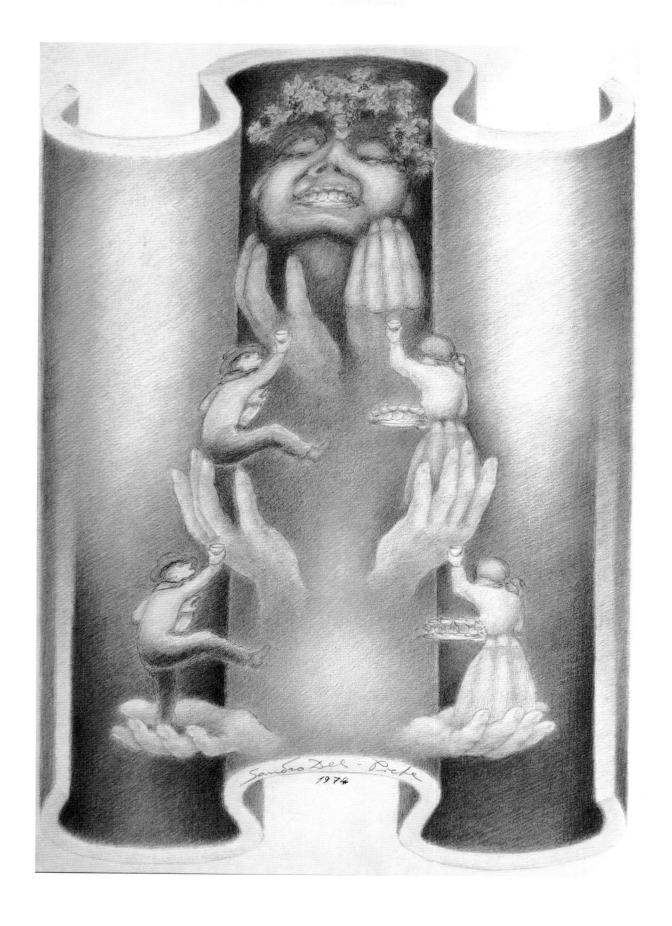

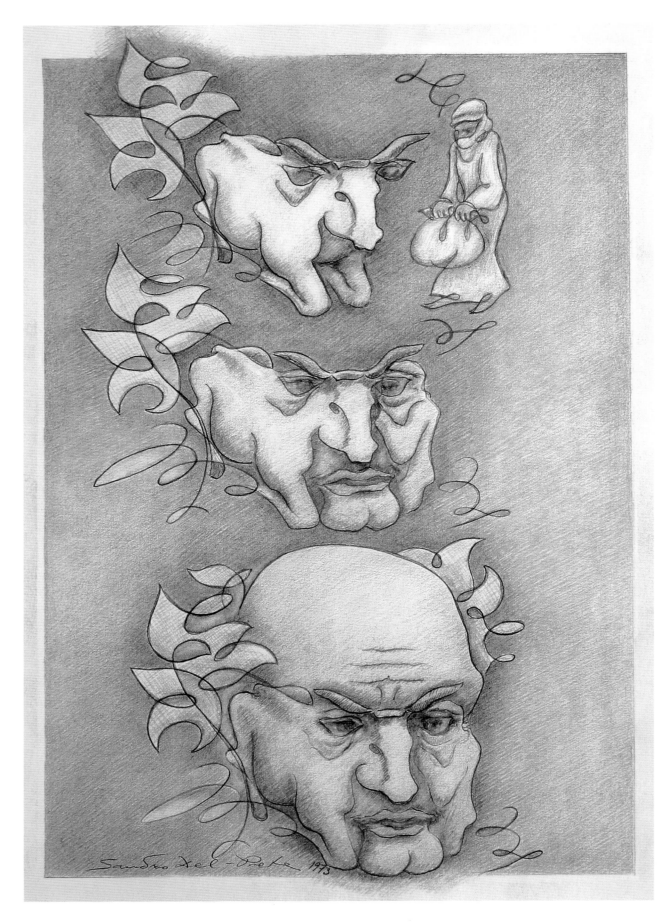

Bullock and Nomad

Although in this illustration the same drawing fragment is visible no less than three times, it undergoes a complete metamorphosis owing to several major additions. At the top, a bullock is resting under a shrub. In the center, a nomad offers a water bag to the bullock, while at the bottom, one can see the expressive face of a scholar. The difference is made by adding the lines to complete the top of his head and forehead.

Don Quixote

The knight of the woeful countenance—as described in the world-famous novel *Don Quixote* by Cervantes—was a brave, though somewhat foolish, adventurer who charged at windmills, believing them to be his enemies. Of course, he was not the only person to suffer from delusions. Even today, a good many people charge at windmills. Depending on how we look at the illustration, we can see either Don Quixote's portrait, or the famous knight in all his glory, mounted on his trusty steed, with his faithful squire Sancho Panza looking over his shoulder.

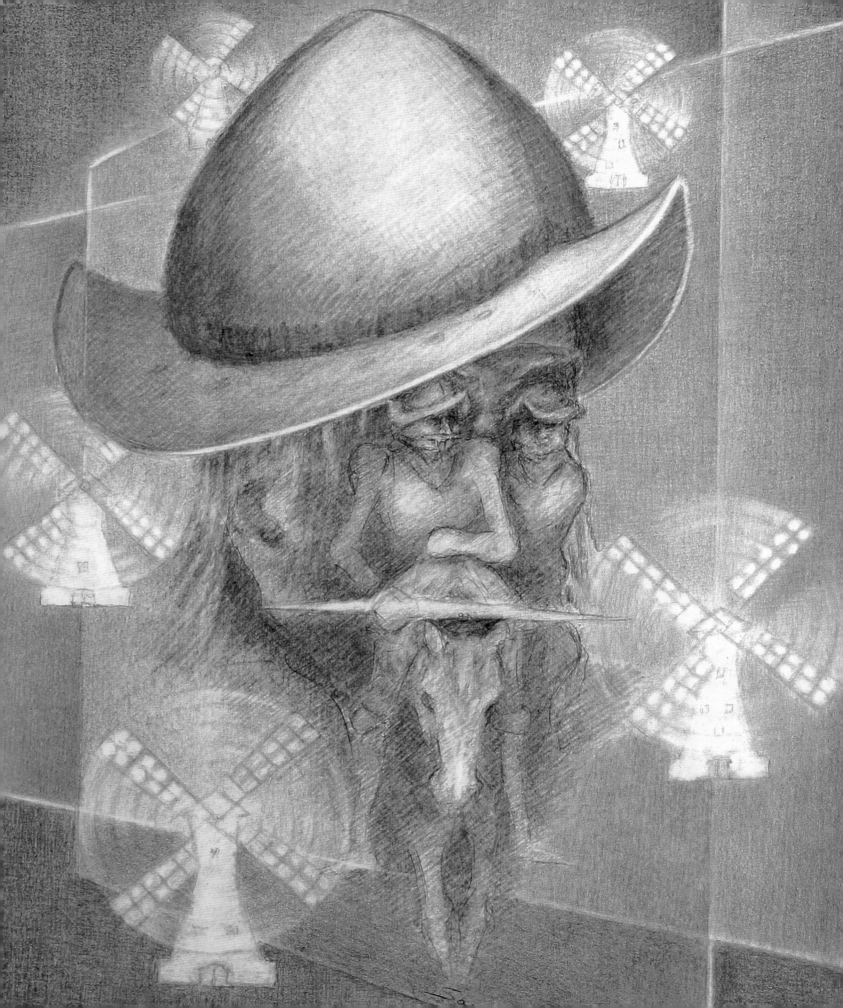

In a Hat Shop

Sitting in front of a mirror, a lady is trying on hats. In the background, above the shelves, hangs a large advertisement that reads, "He who wears our hats is well-protected." Meanwhile, the viewer is bound to have discovered the shop owner. With a polite smile on his lips and a cunning expression on his face, he is looking forward to making a good deal.

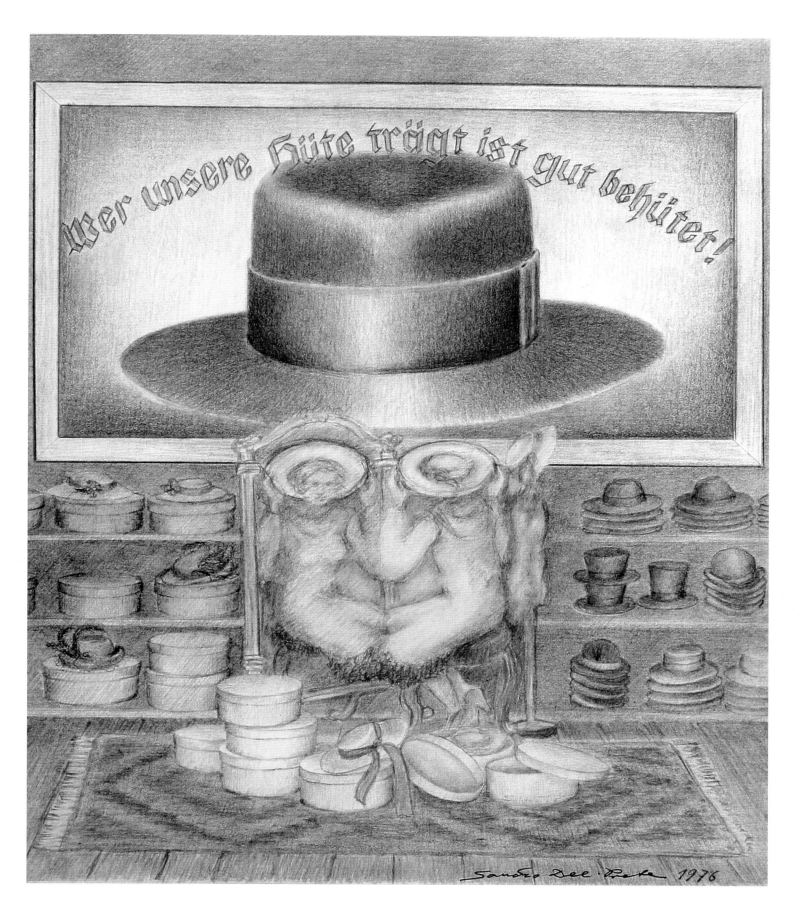

In a Ticino Village

We are exposed to a typical scene set in a Ticino village, as often seen in former times. Under the archway, a street sweeper is doing his job. The woman walking in the alley is carrying a basket loaded with hay. The illustration also reveals the profile of an elderly gentleman who could easily be the schoolmaster or mayor of the community.

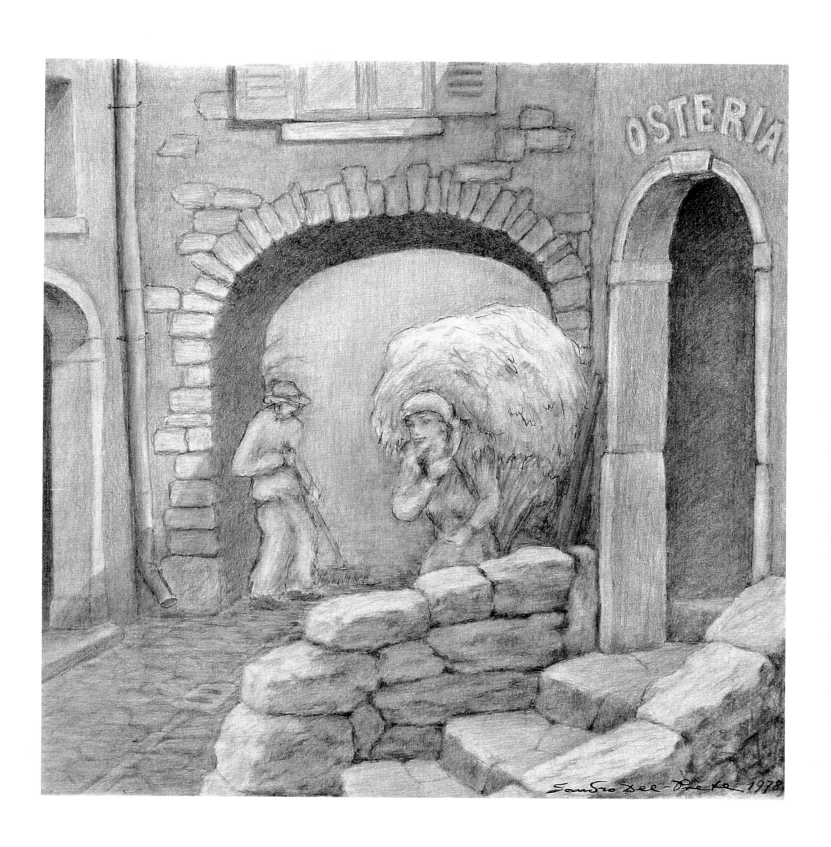

The Little Voyeur's Great Mishap

This illustration, hanging in a gallery and entitled "The Little Voyeur's Great Mishap," breaks out of its frame and extends into the museum's space. The wine is the substance flowing from one illustration into the other. Illustrations, because governed by their own laws, can represent situations that do not exist in reality. This illustration straddles the imaginary world of illustrations and the real world of fact, creating a playful interaction between them.

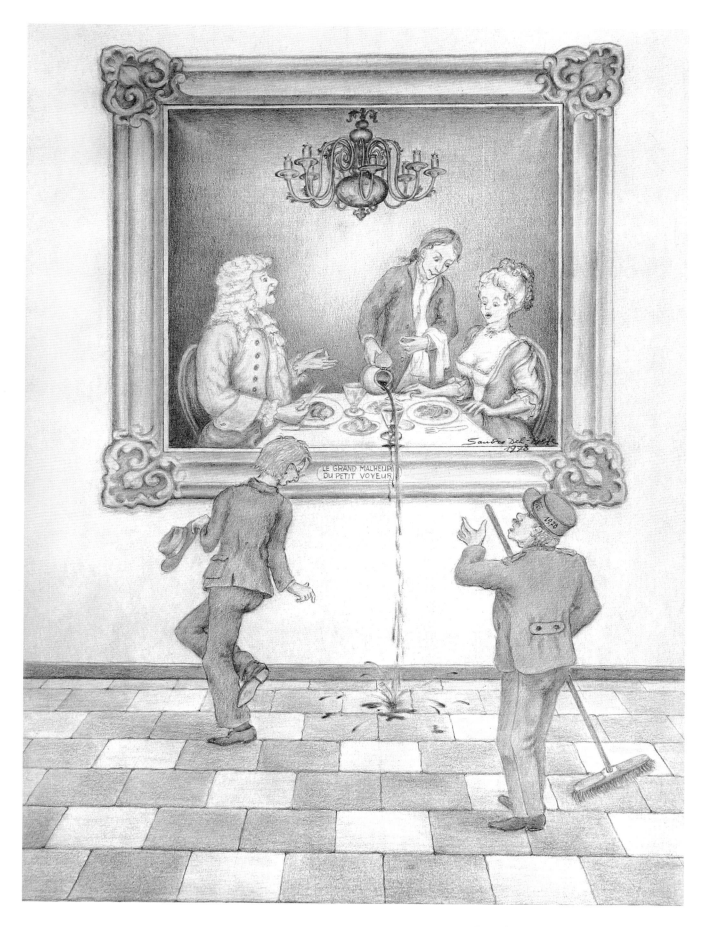

Fata Morgana

In this illustration, we see a desolate, waterless desert. However, above it, the heavens open wide, symbolic of man's quest for intervention in such sterile conditions. In the second illustration which is revealed to the observer, we see water. Defying all laws of physical reality, water flows from one illustration into the other to quench the parched earth.

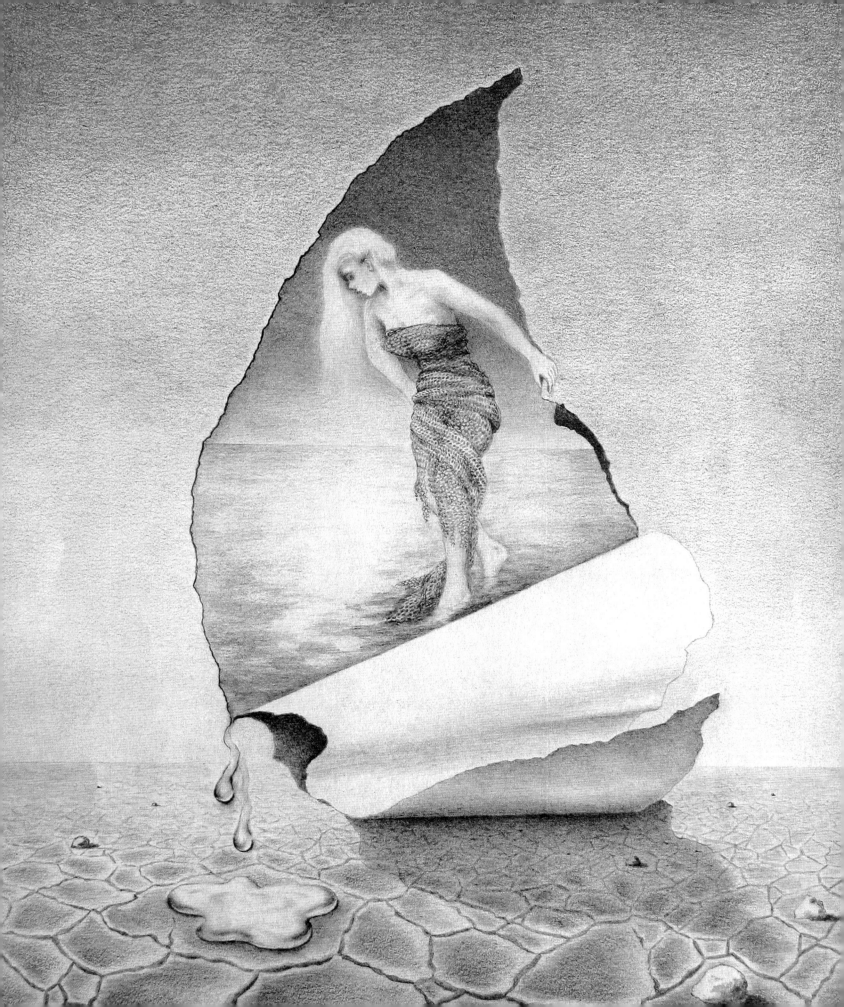

House Without a Courtyard

This building complex comprises two spirals of rectangles: one dark and one light. Apart from the impossible outline of the house, whose right and left facades can be seen simultaneously, this building has no courtyard, only a painted front, whose plaster is peeling off two of the corners. How else could the painter working on the facade raise his ladder without tumbling into the courtyard?

The woman and the boy in the courtyard are nothing but illustrations on the facade and therefore cannot really see the painter.

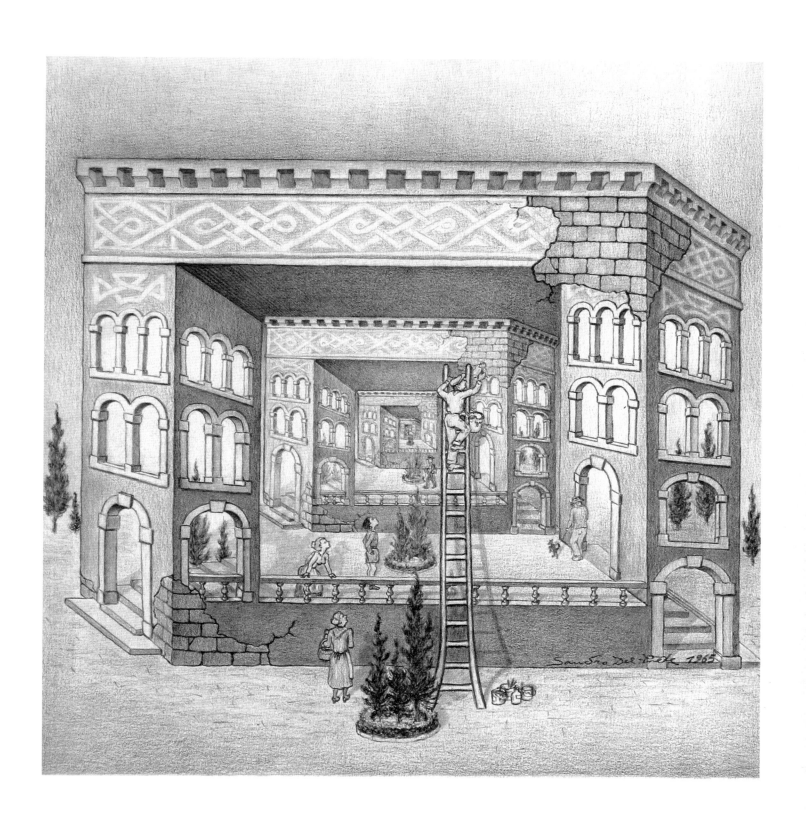

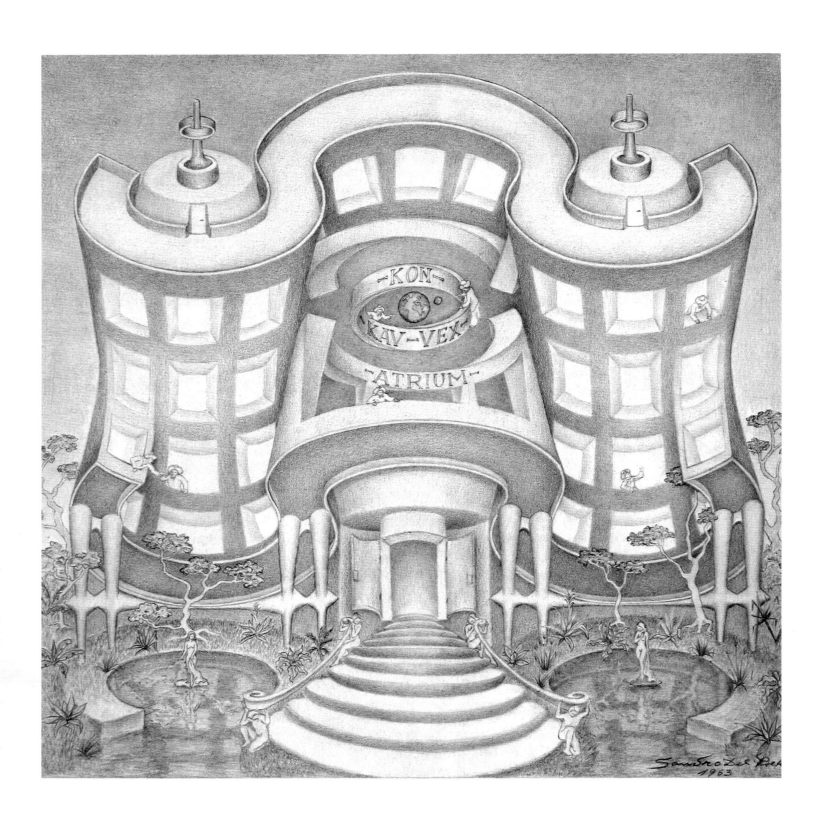

Con-Cave-Vex Atrium

Even the boldest and cleverest architect would fail in any attempt to design the plans for this project. At first glance, the viewer hardly notices that he or she is looking at it from different levels at the same time. From its base, one can see the building up to its central ring-shaped balcony; the upper part, however, is seen from a bird's-eye view. The notions of concave and convex are paradoxically illustrated by the balcony in the center. The word *atrium* refers to a courtyard, as it did in the time of the Romans.

Amor a Roma

From a distance, the observer recognizes the Coliseum in Rome. Up close, however, the building dissolves into two repeating figures, each of which delineates the other. They seem to be enmeshed in a very intimate conversation, for two of them slowly emerge from their background in the same pose, finally meeting in a tender embrace. The image illustrates the Latin palindrome on the top rim of the Coliseum—*Love will come upon you suddenly from Rome*—which can also be read backwards.

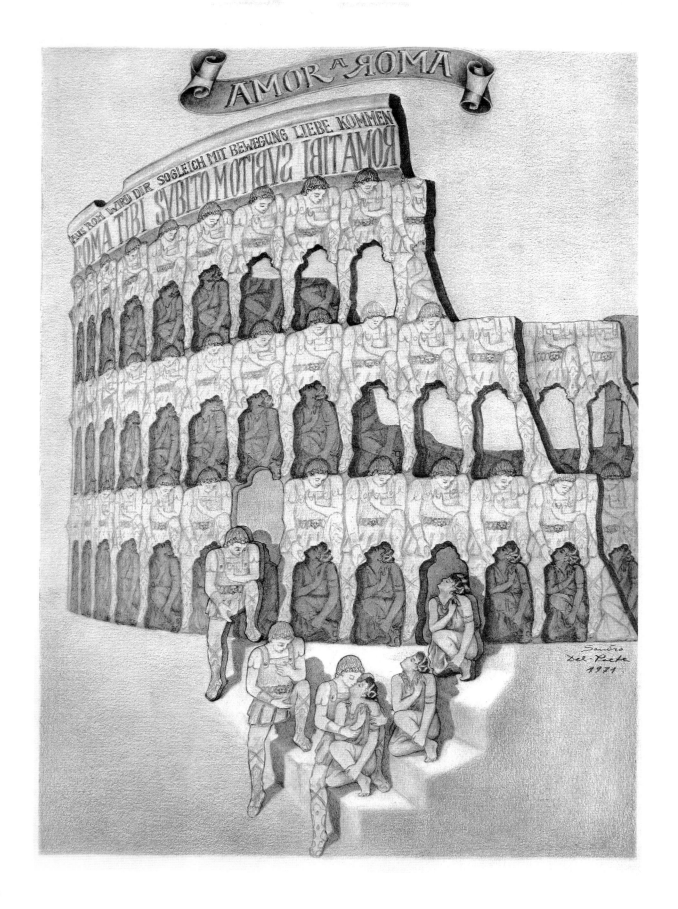

Guitar Music at the Well

This is an illustration filled with memories; it resembles the kind of portraiture often seen hanging in the living rooms of elderly people. This one is special because it reveals how the two subjects first met when younger. The wife, then a young girl, is kneeling by the well, carrying on her shoulder the pitcher she wants to fill. She is looking in the direction of her fiancé. Wearing a broad Mexican hat, he is sitting on the other side of the well and serenades his darling with melodious tunes on the guitar.

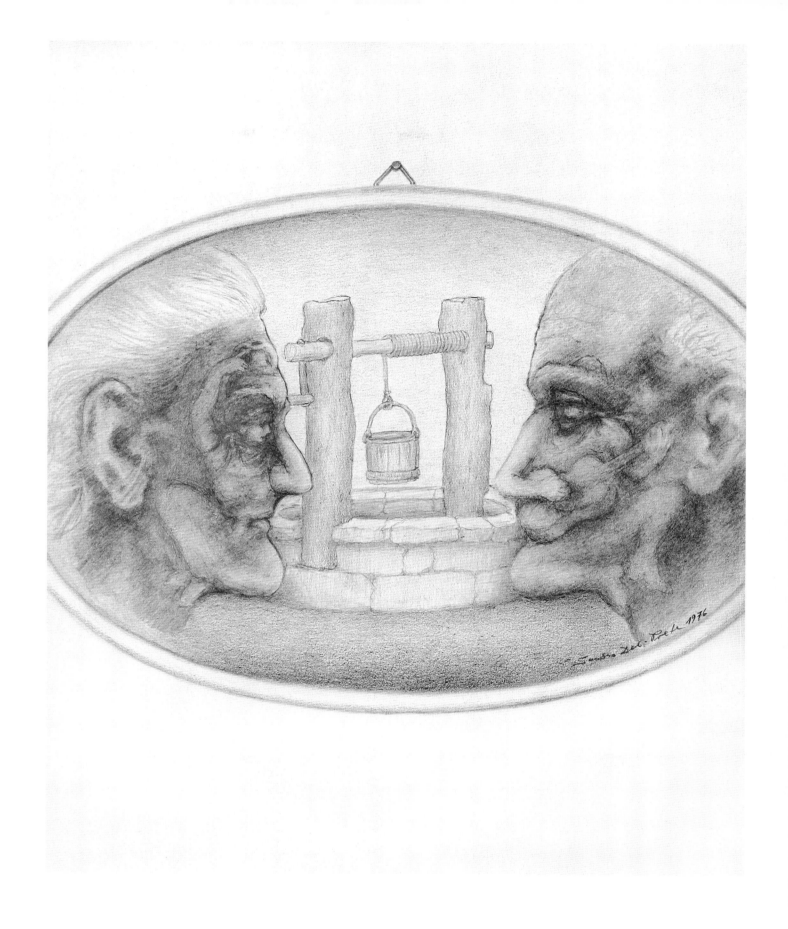

Bullfight

A satire in two scenes:

A bullfighter is standing in the arena as an unsuspecting house cat passes by. The bullfighter recognizes the head of a wild bull in the shadow of the cat. Skillfully, he thrusts his sword into the beast's neck. From his victorious attitude, we can deduce that he believes he has accomplished his objective. The impaled animal remains lying on the ground. The cat however, saunters away without its shadow, as if nothing had happened.

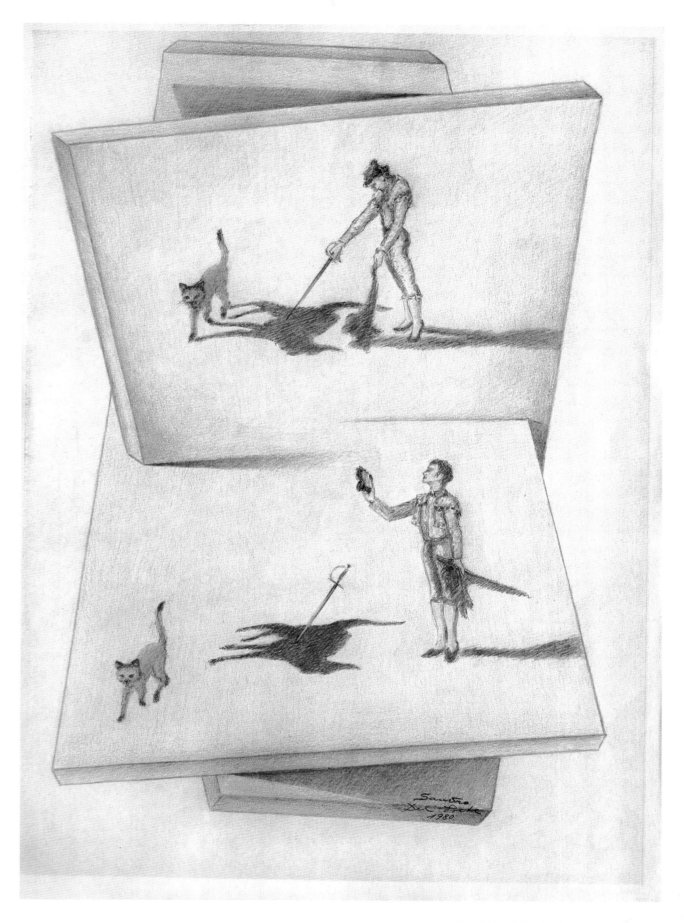

Love Poem of the Dolphins

This illustration incorporates a figure-ground perceptual reversal; it is also an excellent example of one's perceptions being primed through experience. If one is young and innocent, one will most likely perceive a group of dolphins. Adults, on the other hand, will probably see a couple locked in a suggestive embrace. If one has trouble perceiving the dolphins, then simply reverse figure and ground: what normally constitutes the ground (dark areas) then appears as a group of small dolphins (the figures).

"This image was also displayed in an illusion exhibit gallery at the Museum of Science in Boston. When asked if there was any controversy about displaying this image, the curators replied that once a group of nuns had objected, but were quickly silenced when told that one's perception is based upon past experience."

—from *Masters of Deception* by Al Seckel

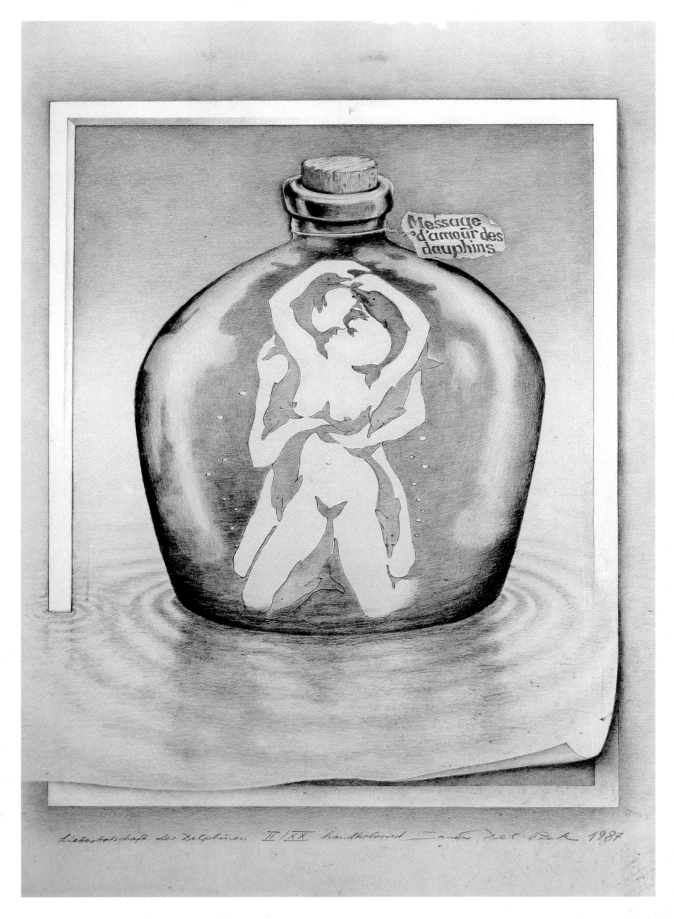

Liebesbotschaft der Delphinen II/XX handkoloriert Sandro del Prete 1987

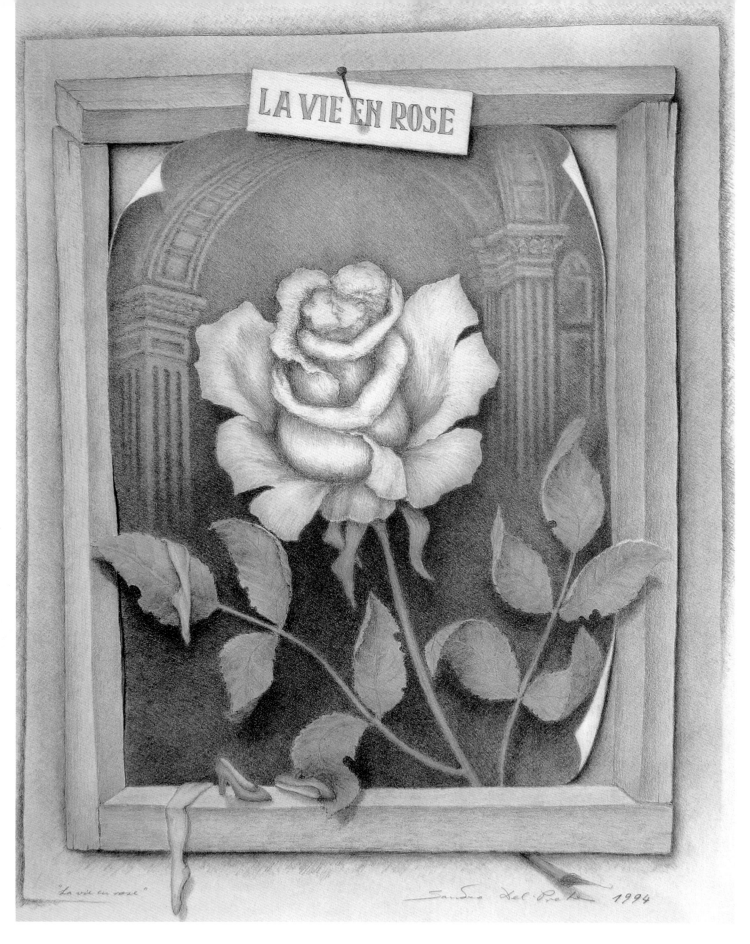

"La vie en rose"

Sandro Del-Prete 1994

THE BLOOMING OF LOVE, OR *La Vie en Rose*

Can you see the couple hiding in the rose petals?

The Goose Queen

Look closely—the woman's whole face is composed of geese; her mouth and the nose are a duck and her right eye is a swan.

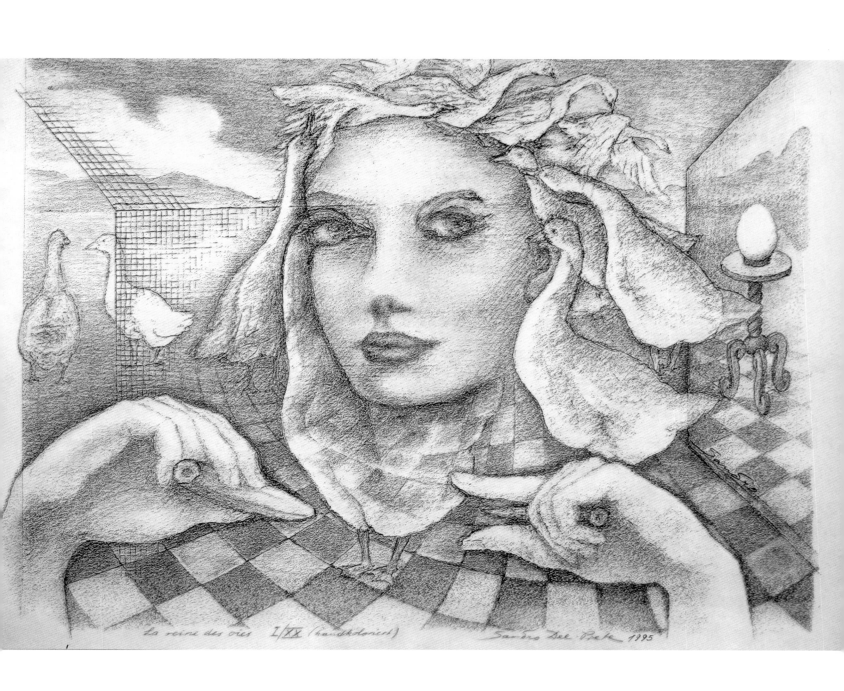

La reine des oies I/XX (handkoloriert) Sandro Del Prete 1995

Between Illusoria and Reality

A huge wall has been erected out of giant dilapidated stone blocks and serves as a physical border between two worlds: Illusoria and Reality. An illusionary building has been crafted out of heavy stone blocks that seem to disappear in a whiff of smoke. This monument to the past seems to ask the eternal questions: *What is illusion?* and *Where does reality begin?*

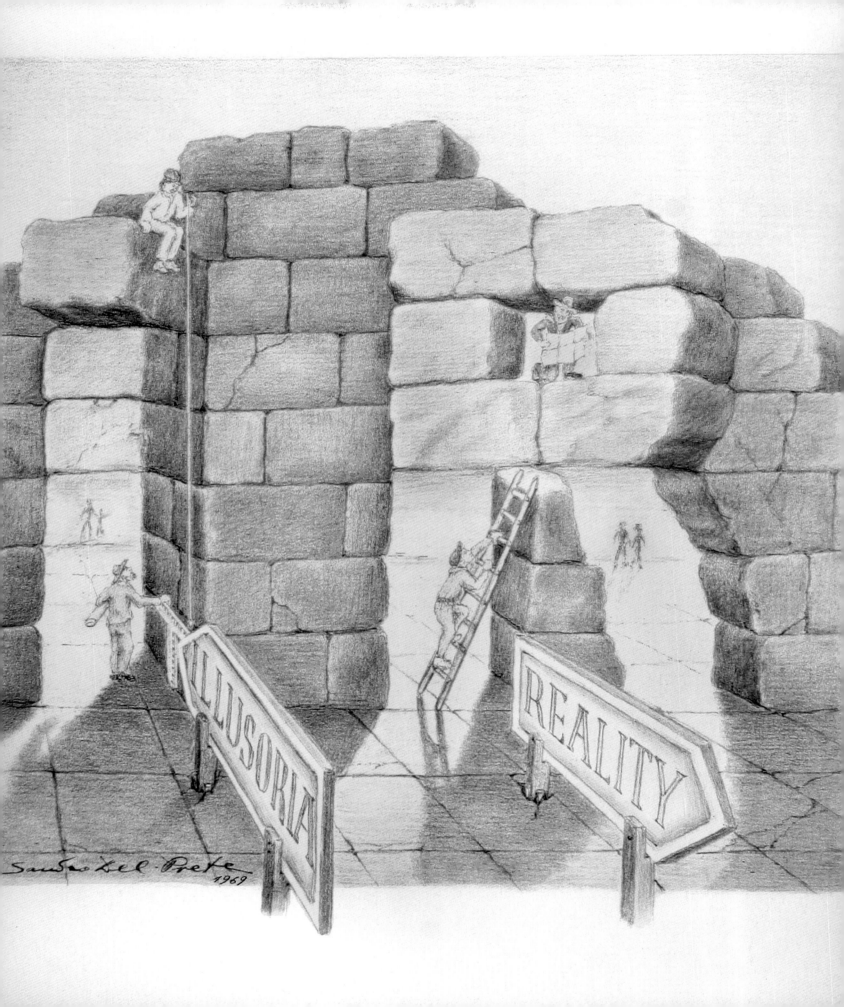

Saint George and the Dragon

Can you see both a portrait of Saint George and a depiction of him slaying the dragon? Look at Saint George's hair to see the battle scene.

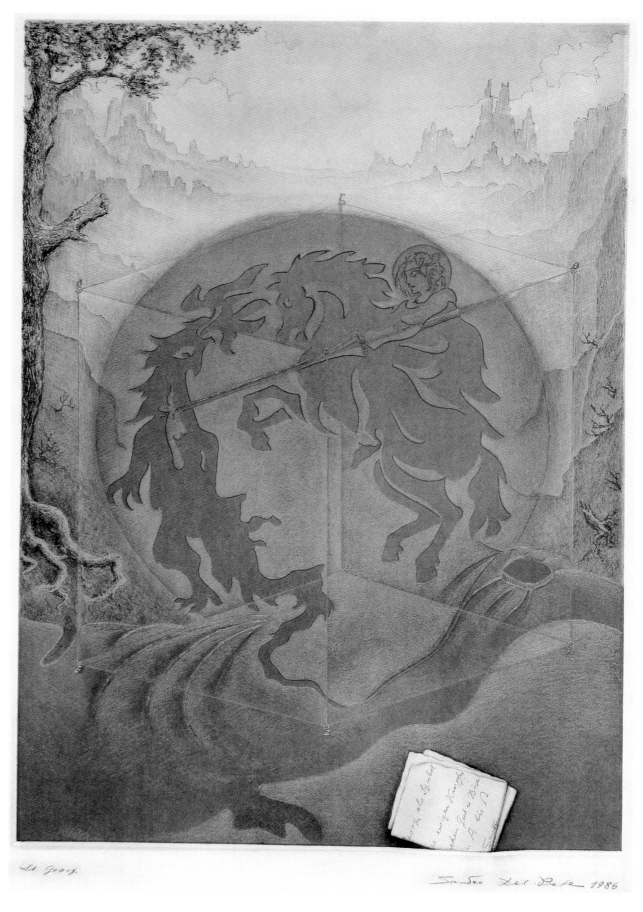

Secret Between Autumn Leaves

If one looks closely enough, one can spot a nude woman hidden among the leaves. The sign reads, "A dream, swept away by wind and time."

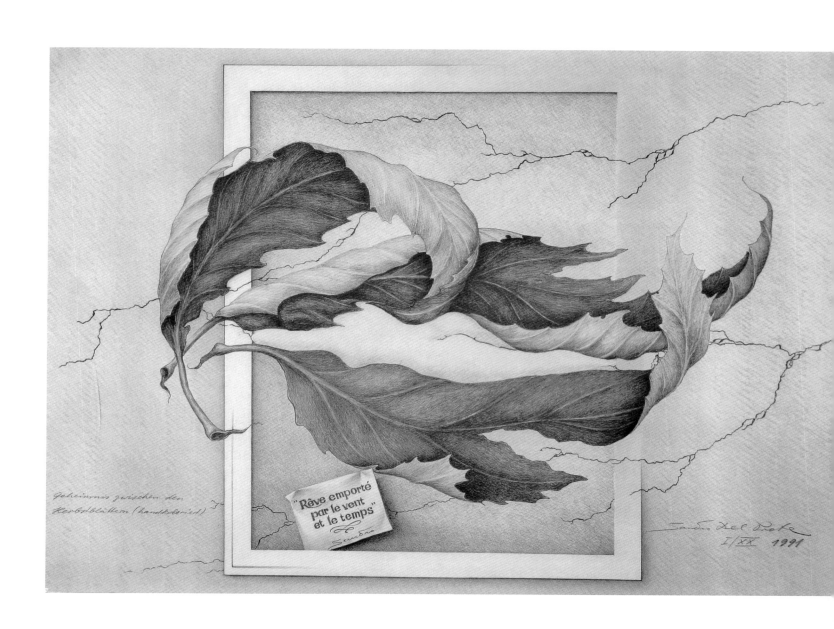

Geheimnis zwischen den
Herbstblättern (handkoloriert)

"Rêve emporté
par le vent
et le temps"
Sandro

Homage to Leonardo da Vinci

This ambiguous scene is based on Leonardo da Vinci's trip through the Alps on a mule in 1516. On this trip, Da Vinci carried some valuable paintings, including the Mona Lisa, which he intended to give to the King of France. During his ride, he imagines himself creating a painting that depicts his journey over the Alps. If you focus on his facial characteristics, you might even catch a glimpse of the inner workings of Da Vinci's mind.

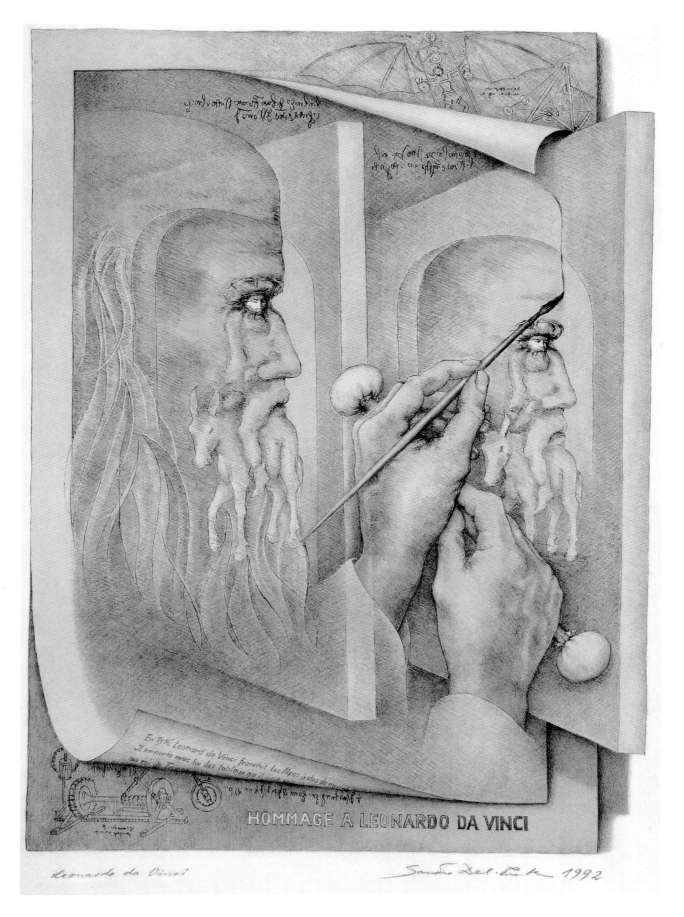

Leonardo da Vinci

HOMMAGE A LEONARDO DA VINCI

Sandro Del-Prete 1992

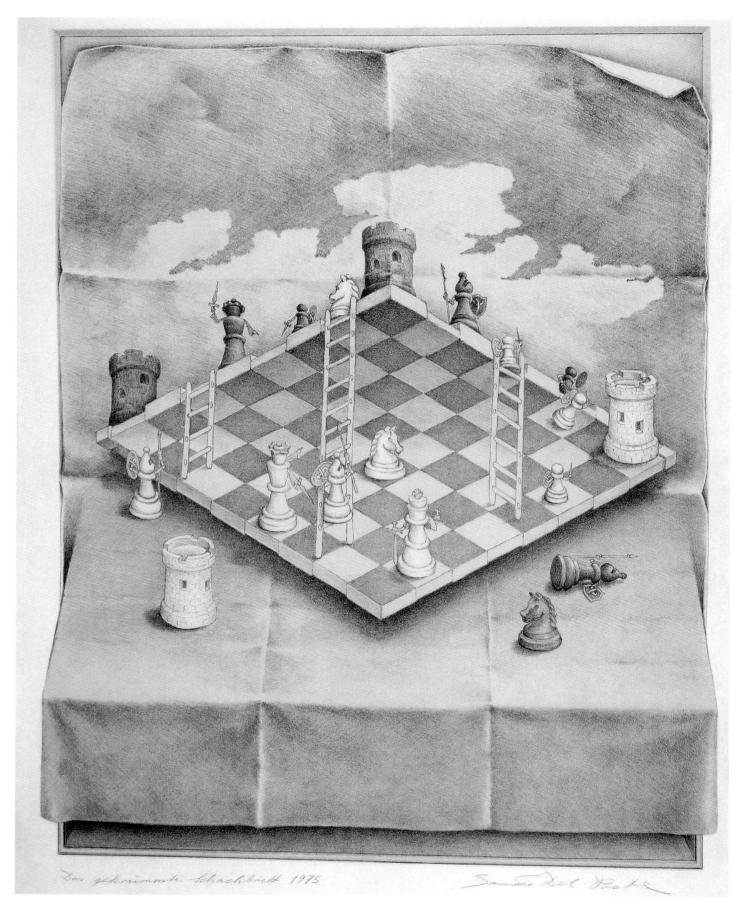

Das gekrümmte Schachbrett 1975

Sandro Del-Prete

The Warped Chessboard

This chessboard is seen to curve or warp in the middle, since on one side, the pieces are placed *under* the board, while on the other, they are placed *on* the board. However, all of the lines are perfectly straight and parallel. This illustration incorporates the same double-perspective in the chessboard and the ladders that was used in one of my first works, *The Window Gazers* (see page 51).

The Crazy Table

Three craftsmen are trying to assemble the elements of a prefabricated table by placing all its pieces of identical length in parallel with each other, each in their corresponding notches. The angles and junctions match the plan perfectly. However, the craftsmen are dumbfounded to see that the surface of the table is tilting sharply to one side. Pushing and bending does not help, so they decide to exhibit the crazy table as it is, to show that even useless things sometimes fit a useful purpose.

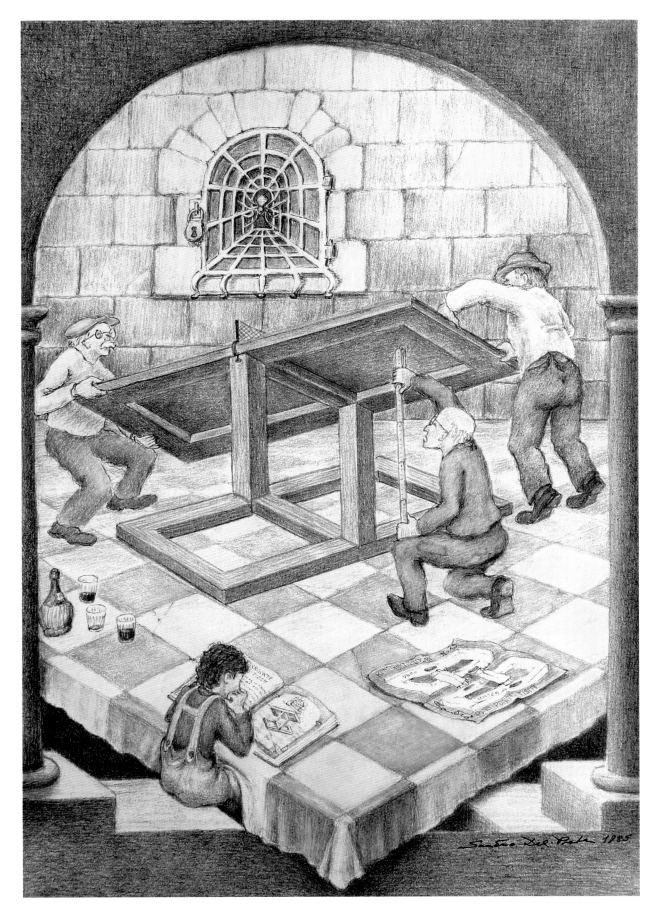

The Twisted Pergola

A rich man and admirer of impossible things wished to cover the pergola in his garden to provide more shade. However, because of the job's particular difficulties, the craftsmen have to overcome some very unusual problems.

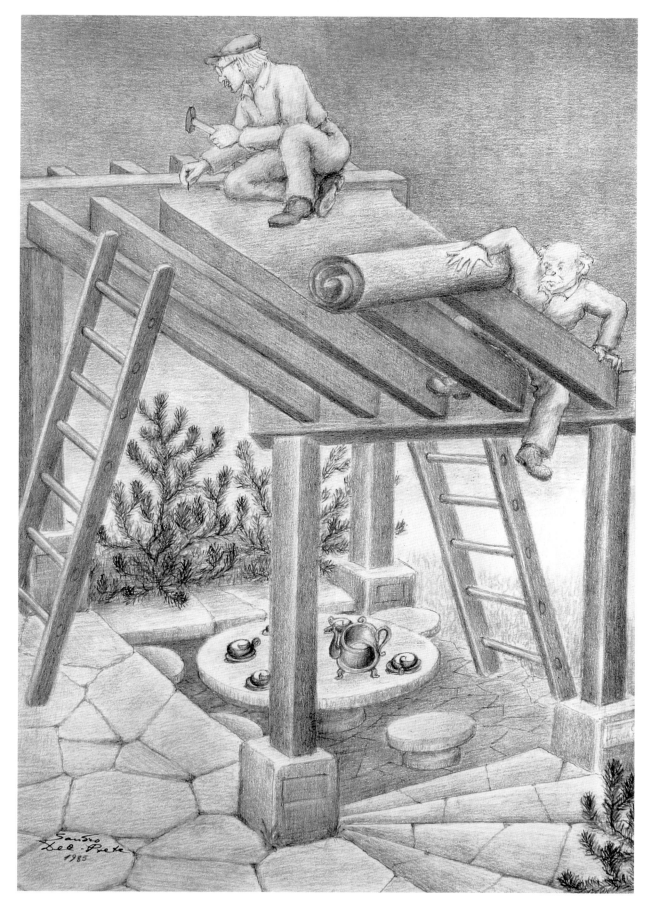

The Spiral Staircase to the Belvedere

The architect who invented this belvedere wanted to give his work a special touch, so he built onto it this impossible staircase. Unfortunately, his staircase was not very practical, so he installed a ladder, but the ladder ended up just as topsy-turvy.

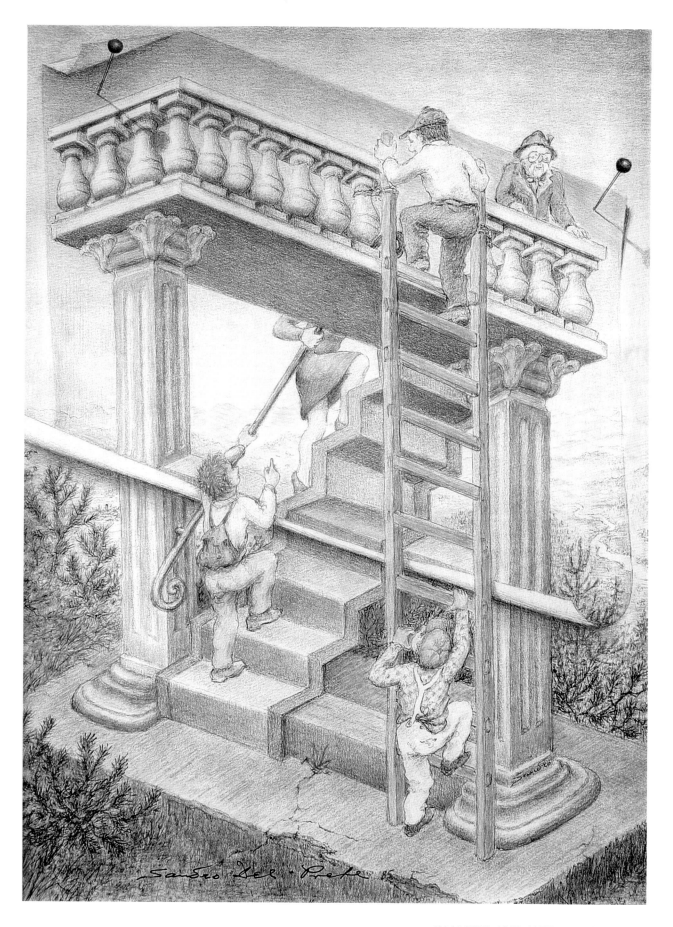

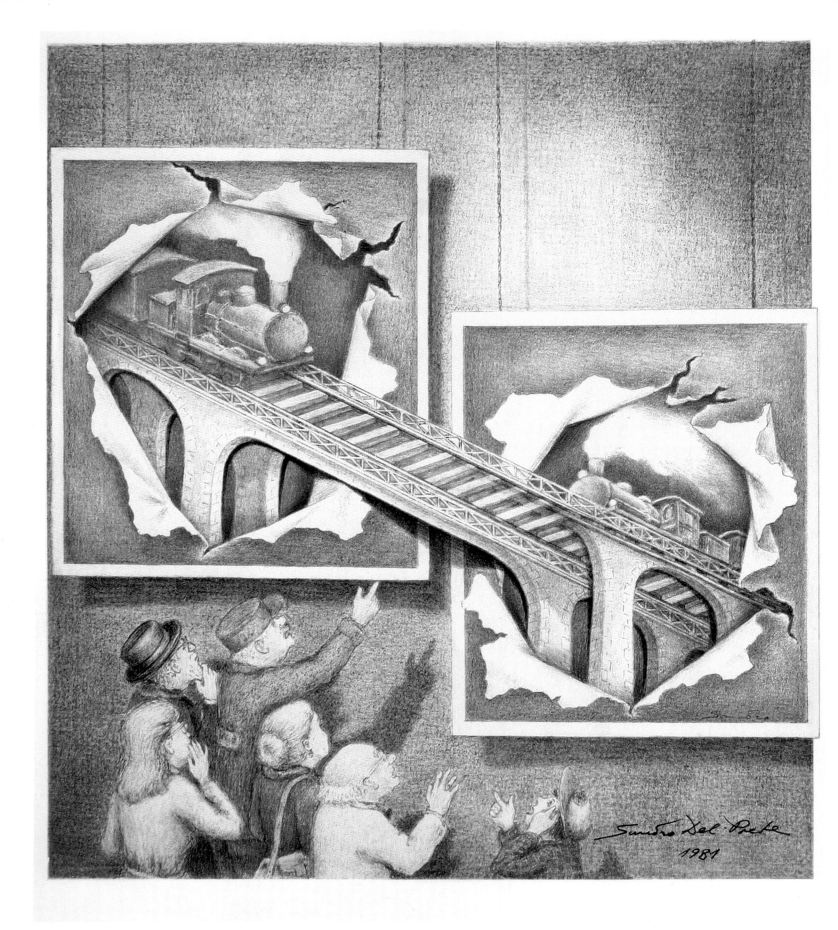

THE RAILWAY BRIDGE

Two illustrations are joined by a railway bridge. The bridge has only one track, which projects out from the first illustration and enters the second on the opposite side. Two steam locomotives race toward each other, but a catastrophe is averted since each locomotive will pass beneath the other—unless they crash to the ground below.

This illustration is an example of the use of double-perspective. Will the trains collide? The scene breaks out of its own frame—the trains will not crash, though: they are but a drawing.

The Astronomical Sundial

A brand new astronomical sundial needed to be prepared for shipment, but the enigmatic and unwieldy object was rolled up into itself, its exterior and interior faces overlapping, creating confusion among the craftsmen. The object did not seem to possess any three-dimensional logic. The men, lingering around the convoluted sundial, experience a sense of having lost touch with reality and become so disoriented as to be unable to maintain control over the shipping container. Each of the men is convinced that the others are tilting the wrong side of the container, so the sundial never makes it to its destination.

In this way, it serves its purpose, which is to measure the infinity of the universe. It also provides a way to reverse time: all one needs to do is to turn back the hands to revisit the past.

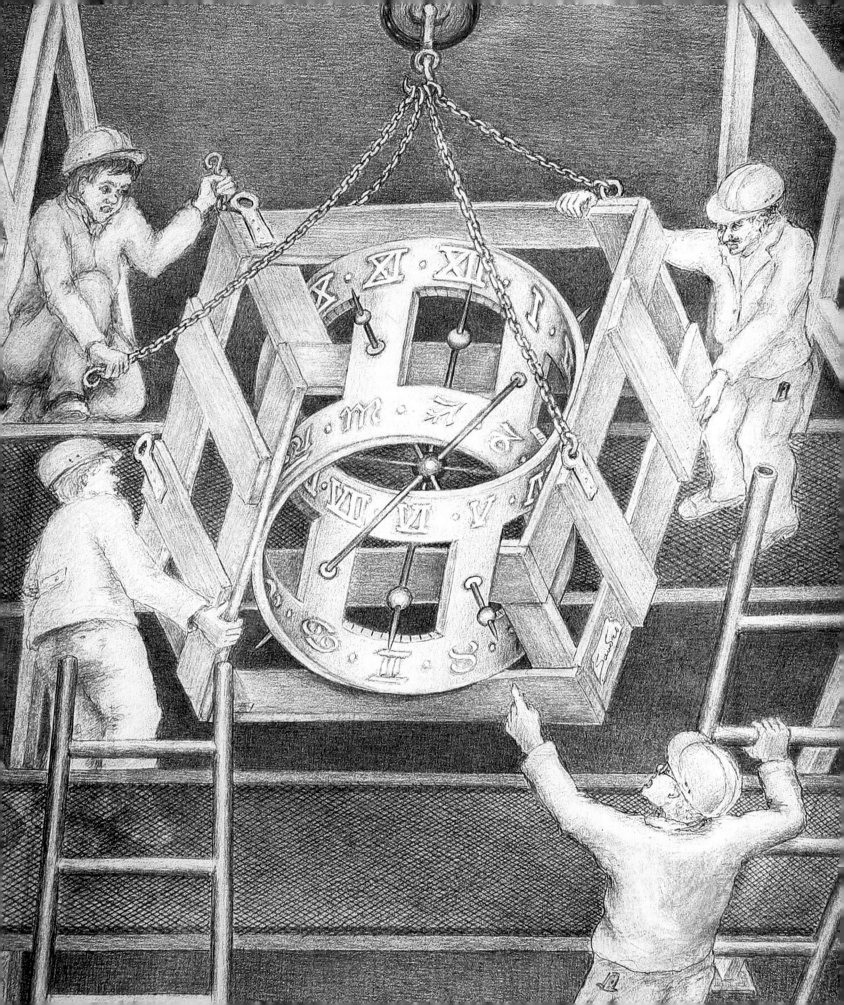

Invisible Neptune

The sight of this cover page fills one with a sense of unease. One almost feels transported to the depths of the ocean. An eerie and diffused light allows one to identify the outline of marine creatures, though we infer, more than we actually see, Neptune. Conversely, the shipwreck in the background is plainly visible. In the foreground, one can distinguish a coral reef, an octopus, and several dolphins.

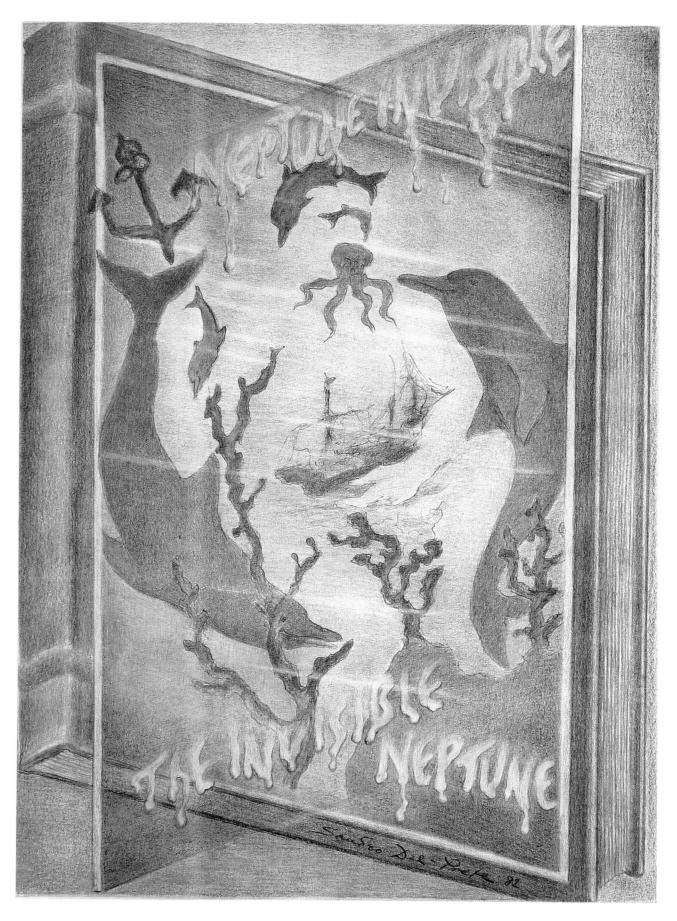

The Bath Towel

The woman hanging a bath towel to dry on a clothesline is unaware of the sensual illusion to which we have fallen victim—that the woman is really nude. The illusion is caused by the illustration printed on the bath towel: that of five dolphins playing in the sea grass.

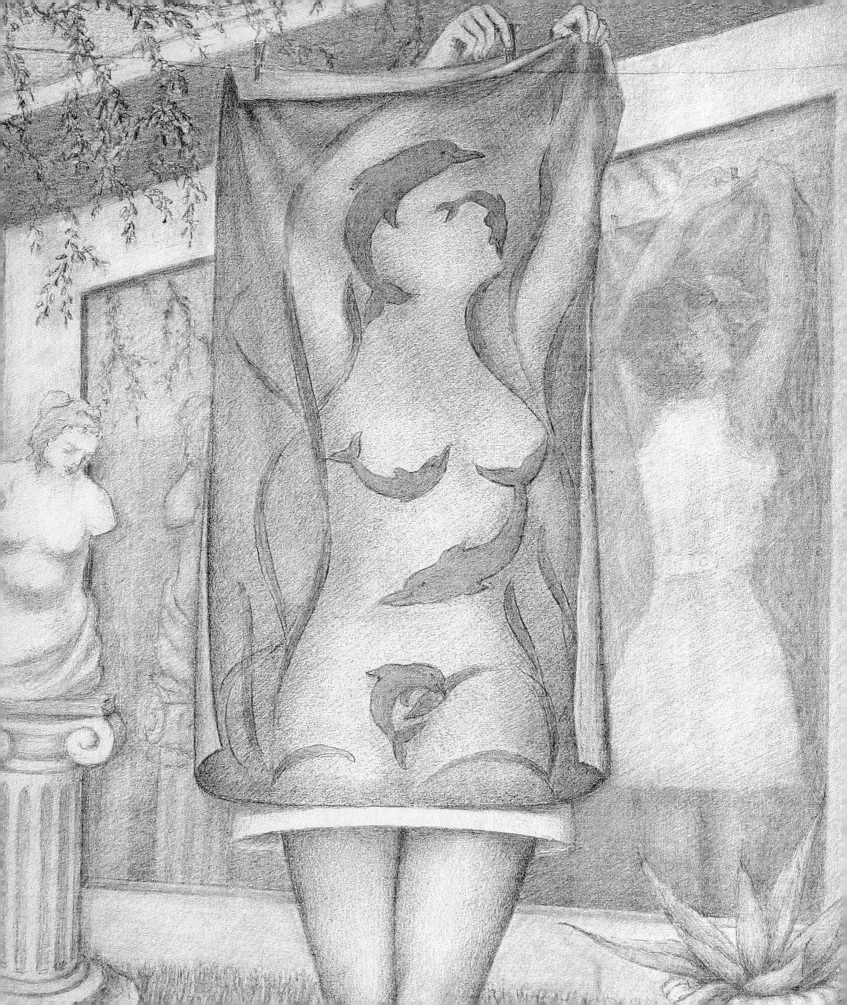

The Hand and the Dancer

One day, an artist drew an illustration of a dancer on a sheet of paper. To enhance the effect, the sheet was rolled up, but it always returned to its original shape. Noticing this, the artist drew a hand at the other end and on the opposite side of the sheet of paper, so as to prop up the dancer. He then hung the sheet on the wall and stepped back to judge the effect. Suddenly, the hand disappeared: in its place appeared a second dancer. When he approached the illustration, the hand reappeared. Meanwhile, the second dancer, perhaps wishing to be a bit more "real" than her counterpart, had slipped her feet through the bottom of the rolled sheet of paper.

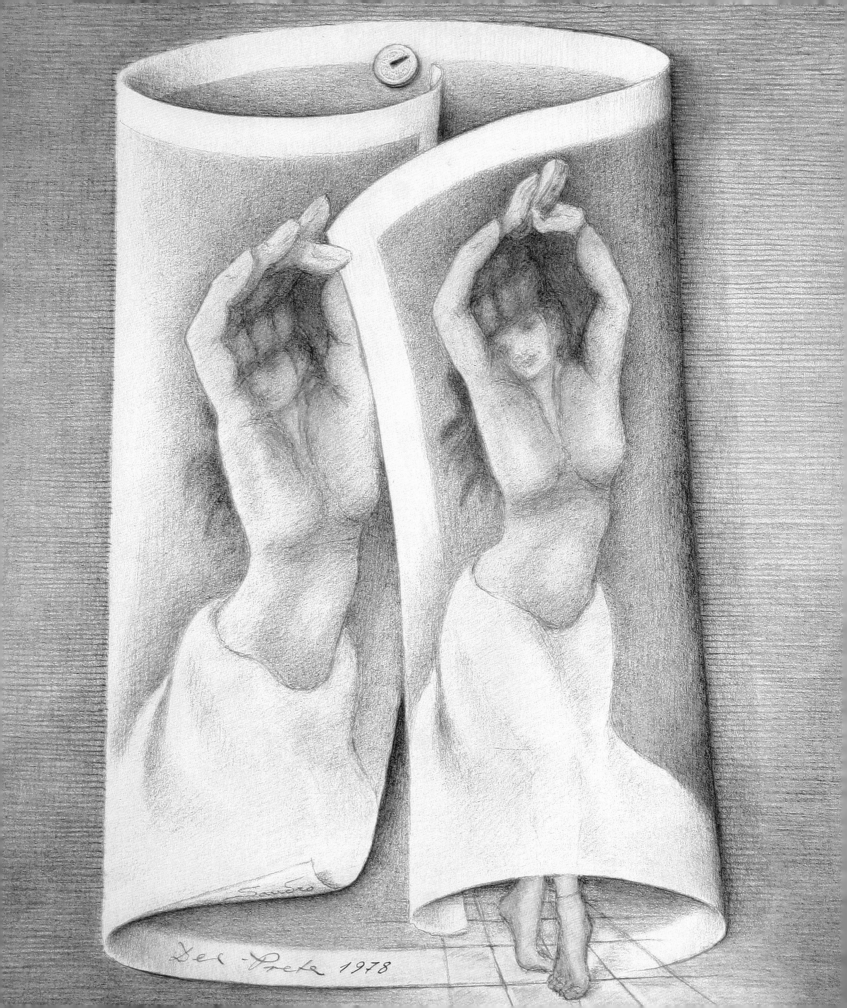

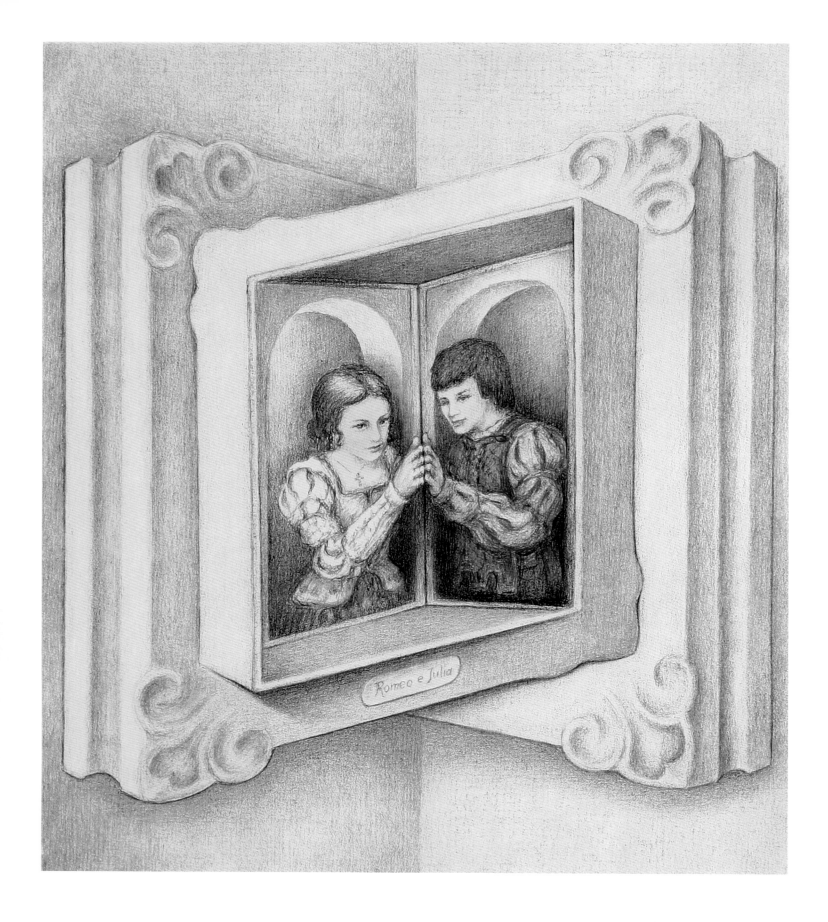

Romeo and Juliet

In the corner of the room, two small illustrations face each other: in one a lovely young girl, while in the other, a handsome young man facing her. They fall deeply in love. It is widely believed that love moves mountains, and in that spirit, they move closer and closer together until their frames merge. Unfortunately, the subjects never manage to blend like their frames do, as they are prisoners of a two-dimensional world. Only their fingers touch, not in the foreground, where one believes that one can see their hands join, but in the corner, behind the scene. In reality, the illustrations are placed side by side, each on the opposing surface of the corner. This picture demonstrates how our feelings and imagination oppose spatial logic.

Sunrise in the Nature Reserve

Early in the morning I took a photograph of the rising sun from the window of my bungalow. Unfortunately, my wife refused to believe that I was simply capturing scenes of nature and an empty chair with my camera lens. . . .

Who would believe that sketching a few peaceful birds could provoke so much trouble?

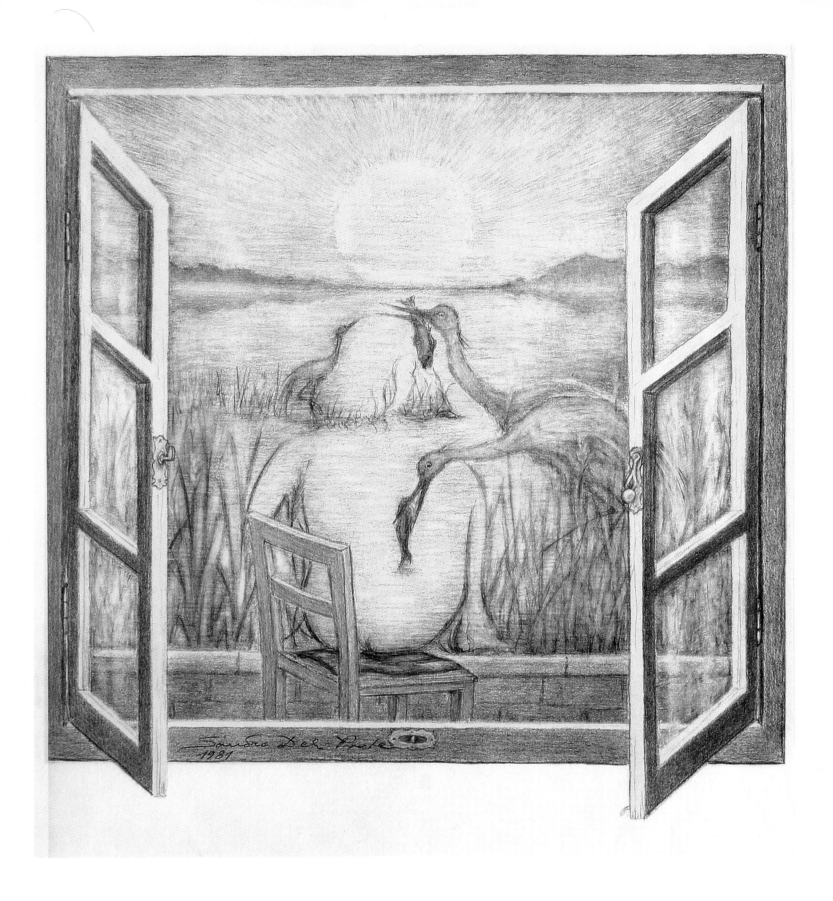

The Magic Window

From a distance, we can see a girl gazing pensively at a lake, with her face pressed against a window pane. Perhaps she is dreaming of a sailboat she would like to own. It would appear so, since the window pane is broken, and the missing pieces have assumed the shape of a sailboat. This is no ordinary window, however, but a magic one, and we are already beginning to fall under its spell. We are no longer outside, but in the young girl's place, contemplating the lake, the two sailboats in the background, the swan in the center, and the duck in the foreground flanked by a tree and a fisherman's net.

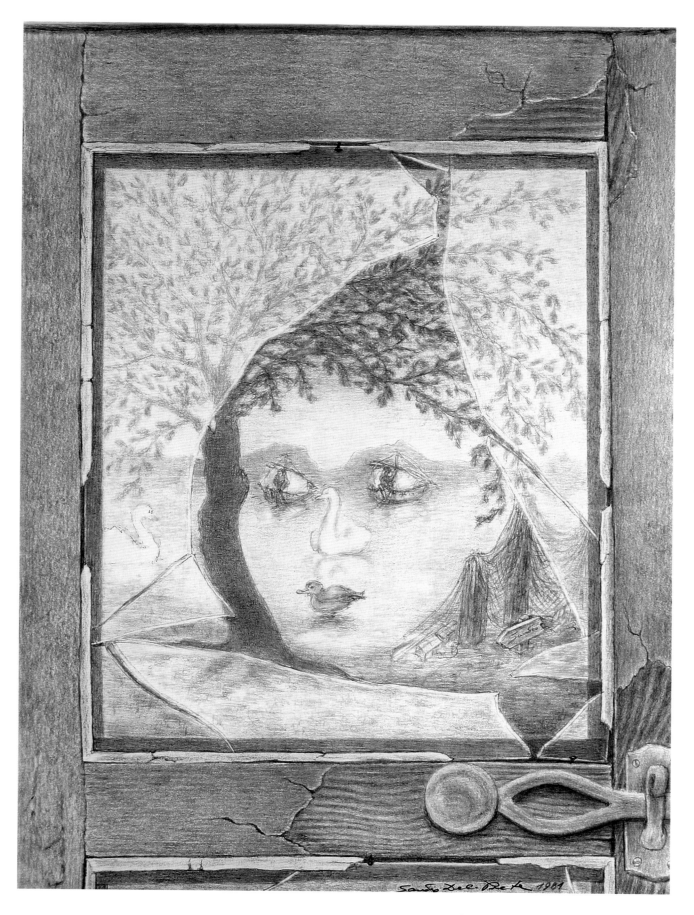

VIOLENCE AND TENDERNESS

Two symbols stand out, at first very similar, but in the top one, the discerning eye recognizes a fist, a symbol of violent destruction. The lower symbol, however, represents love and tenderness. It is the image of a mother holding her child tenderly to her bosom.

Two symbols, very similar in shape, though radically different in meaning; as with love and hate, these two emotions are related, and the borders between them are not always clear.

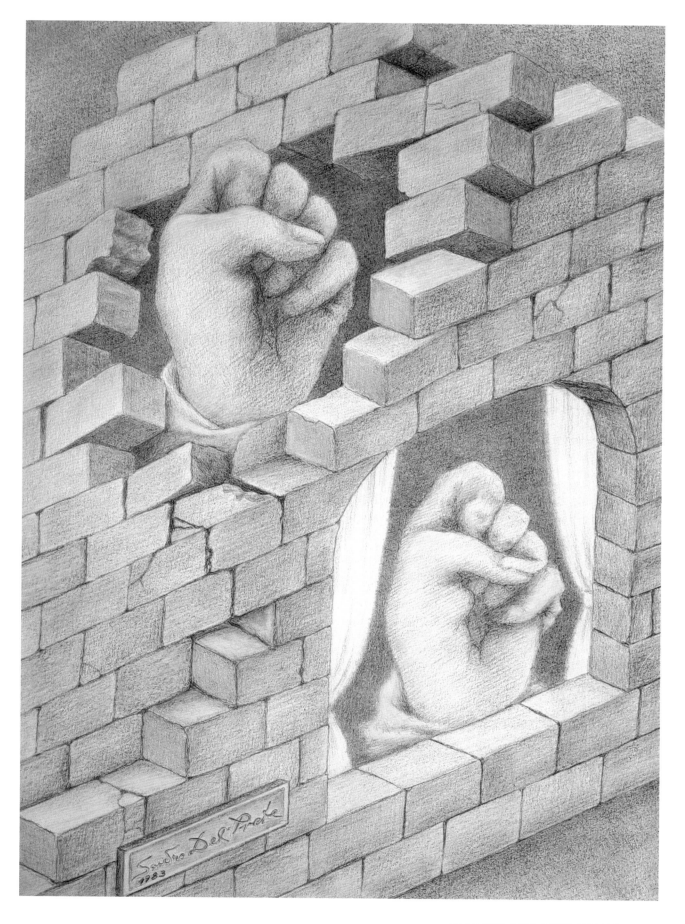

The Sculptor, the Dragon, and the Virgin

Thousands of years ago, a giant seized a great boulder in his three hands and hurled it into the present. A stonecutter was hired to free the beautious young maiden observed within the boulder. When he attempted to cut into the stone, however, the boulder became so hard that it prevented the cutter from working it. The stone mesmerized him so that he took a few steps back to examine it from a distance, and he then beheld a dragon that was hidden inside. The stonecutter approached, and with his chisel, struck the dragon in the heart, freeing the maiden within from thousands of years of captivity.

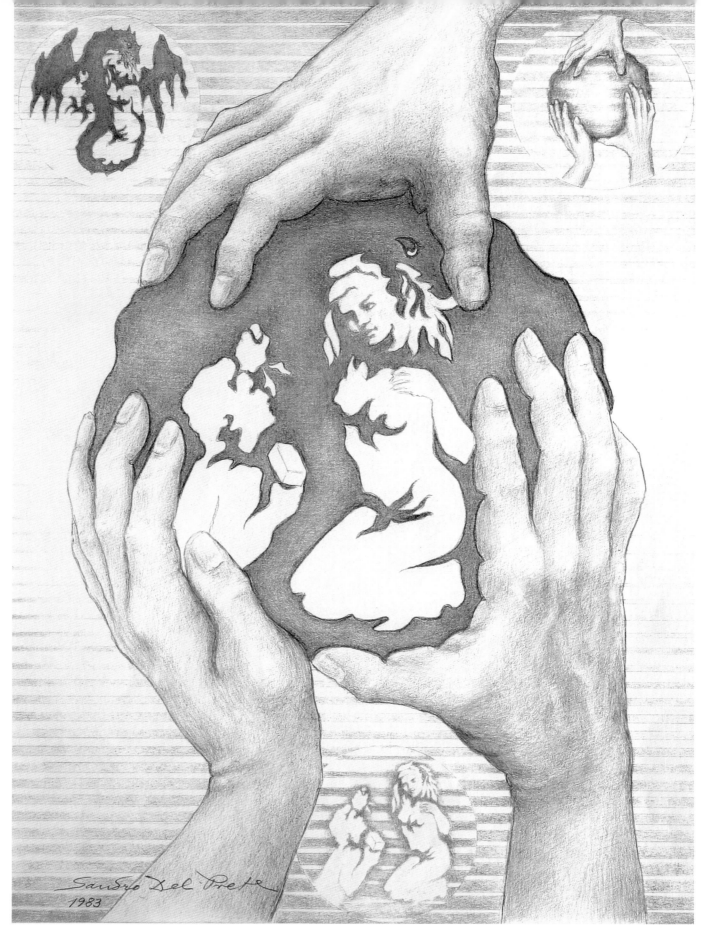

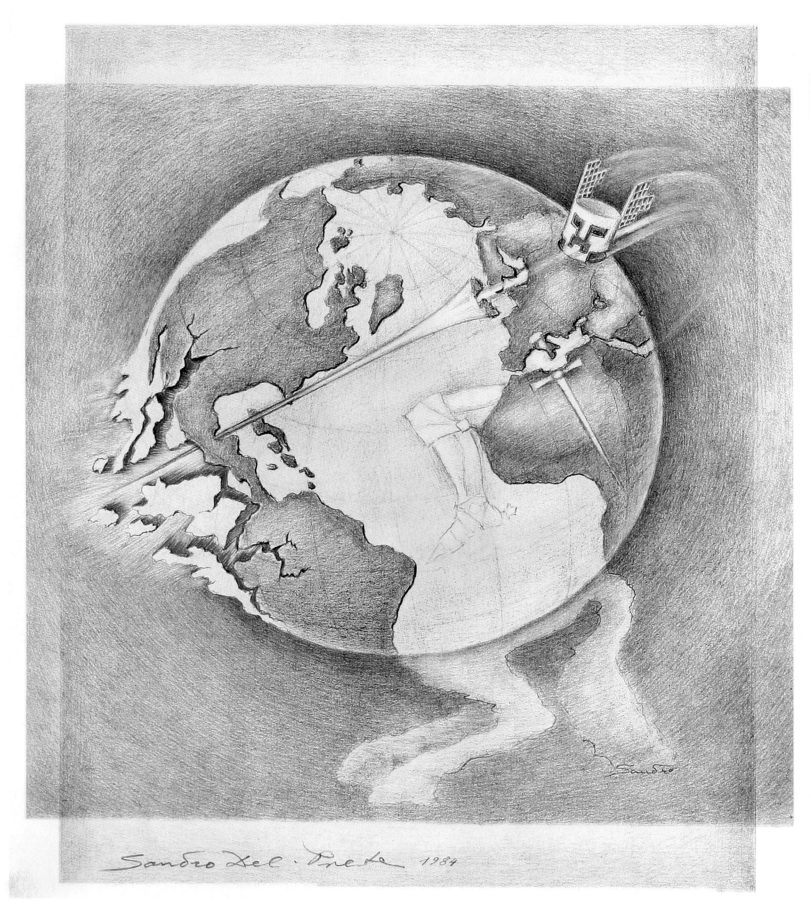

Sandro Del-Prete 1984

KNIGHT OF THE APOCALYPSE

The earth is a beautiful planet, but evil forces are trying to take it over and teach its inhabitants how to wage war with weapons that are ever more terrifying. First, fire rains down from the heavens; then, man uses weapons from space and lightning spears; these weapons will then become instruments of the Knight of the Apocalypse. It will be the end of humanity, unless humanity comes to its senses.

The Juggler and the Jester

From time to time, the illustration turns upside down, but paradoxically remains the same. The jester remains above the juggler. The juggler continues to throw the king of clubs toward the jester, but instead of the king, the queen of clubs takes his place, though the same side of the card is still displayed.

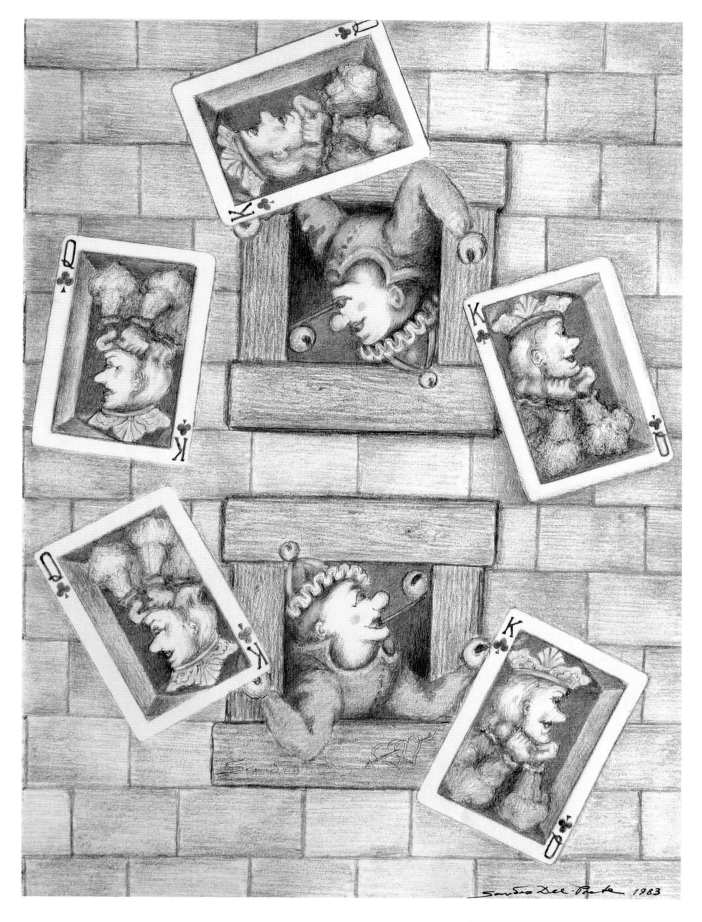

The Never-ending Story of the Image in the Illustration

We observe an artist at work on his drawing of a boy admiring a drawing. In this illustration within an illustration, the lad sees an art lover attempting to hang an image on the wall. That image depicts a scene in which a merchant sells a drawing to an art lover, the theme of which is an artist at work on a drawing of a boy admiring a drawing . . .

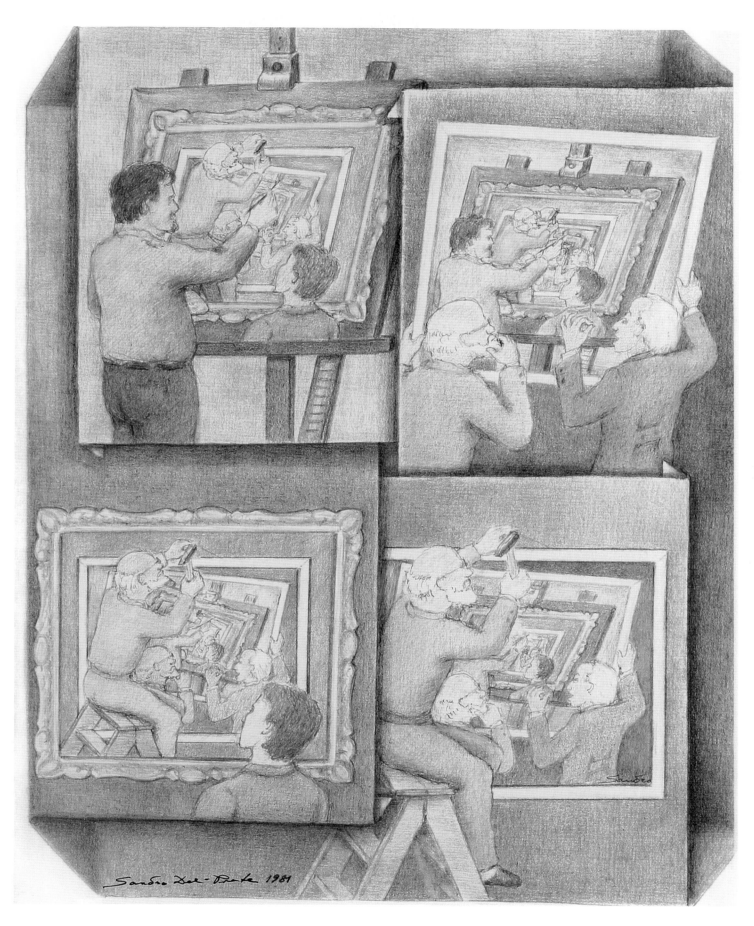

The Gamekeeper Narrates

To immortalize the animals of my territory, I took a photograph of two fine specimens: a beautiful ram and an ibex near a watering hole. When I enlarged the illustration, I realized that there was a strong resemblance to an old self-portrait I had made. Since that moment, these animals have been constantly in my thoughts.

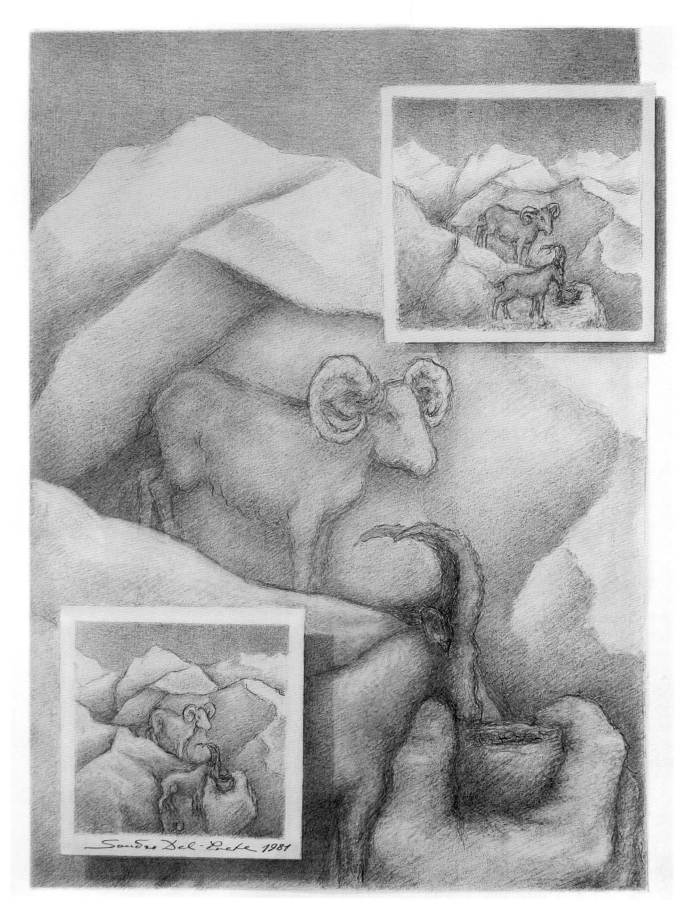

Three Lights

In this particular illustration, a hand emerges from the frame, and an angel is holding a double candlestick that holds three candles instead of two. The glow from these candles softly illuminates the room.

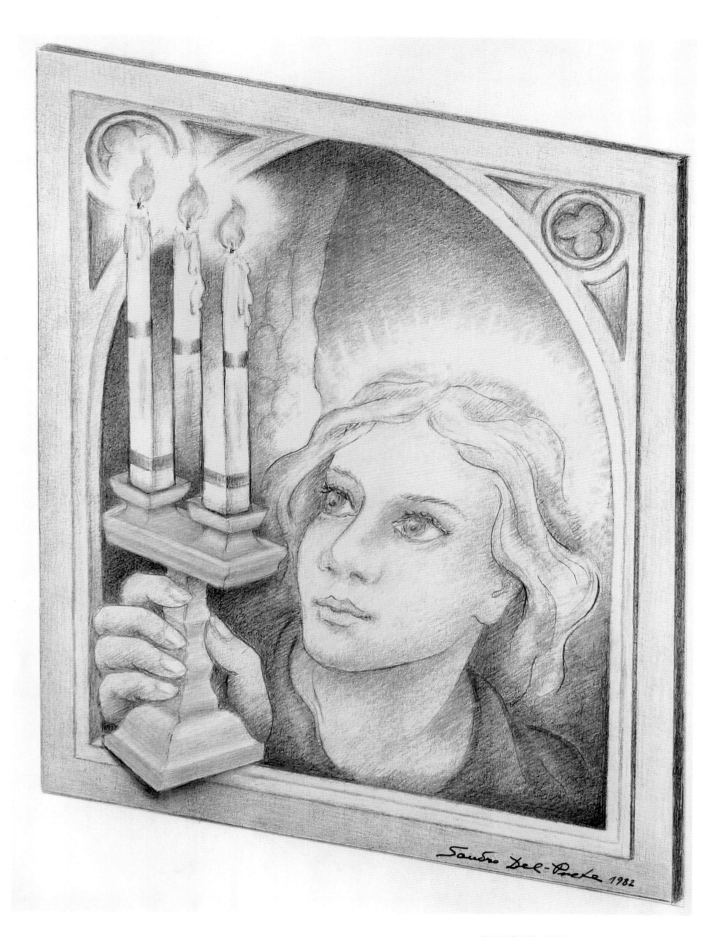

The Babe

To protect her newborn child from a sudden draft, the mother seizes the only thing within reach—the very sheet of paper upon which she is depicted. She gently lifts the corner to shield her newborn.

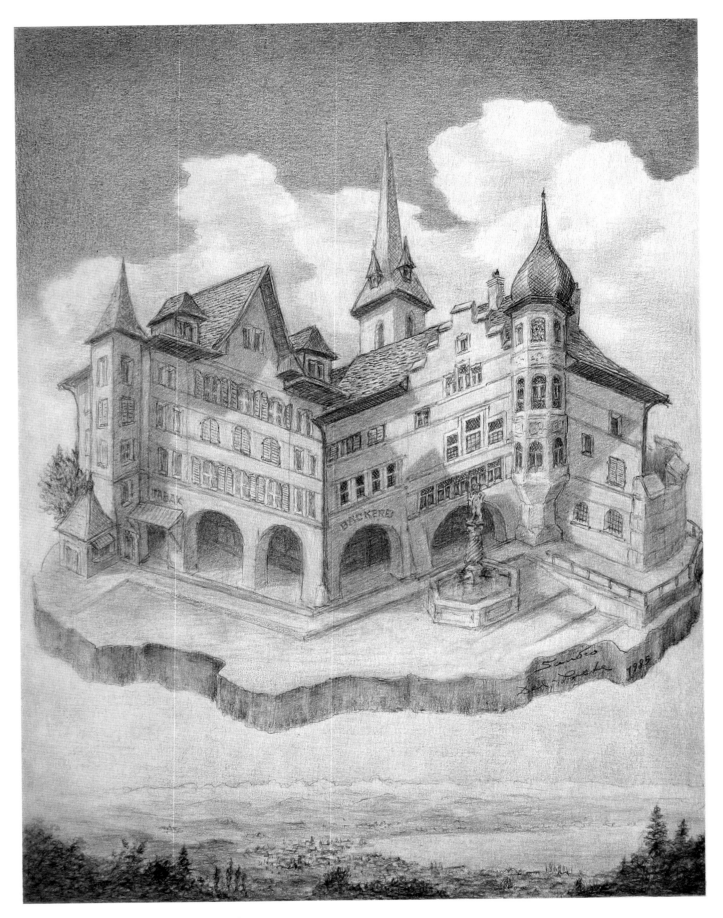

THE FLYING HOUSE

In the old city of Biel in Switzerland, a class of young students is busy drawing illustrations of old homes. The teacher stops in front of one of his students and asks, "What kind of house is this? It has neither front nor back! It is distorted and suspended in midair! Have you ever seen a house that flies?" He then corrects the student's illustration: "Now, this is what a house should look like! This one is solid!" A little later, the student folds the illustration into the shape of a paper plane and launches it. The teacher angrily asks, "And what are you doing, now?" The student replies, "You said that a house can't fly. I just wanted to see if it was true!"

The Wine Thieves

A little man is kneeling on a strangely twisted frame. Through a tiny basement window, his accomplice hoists up to him the wine bottles he attaches to a rope. Having overindulged in tasting the wines, the accomplice cries out to his partner, "Help! I got out of line—I have fallen out of the frame!"

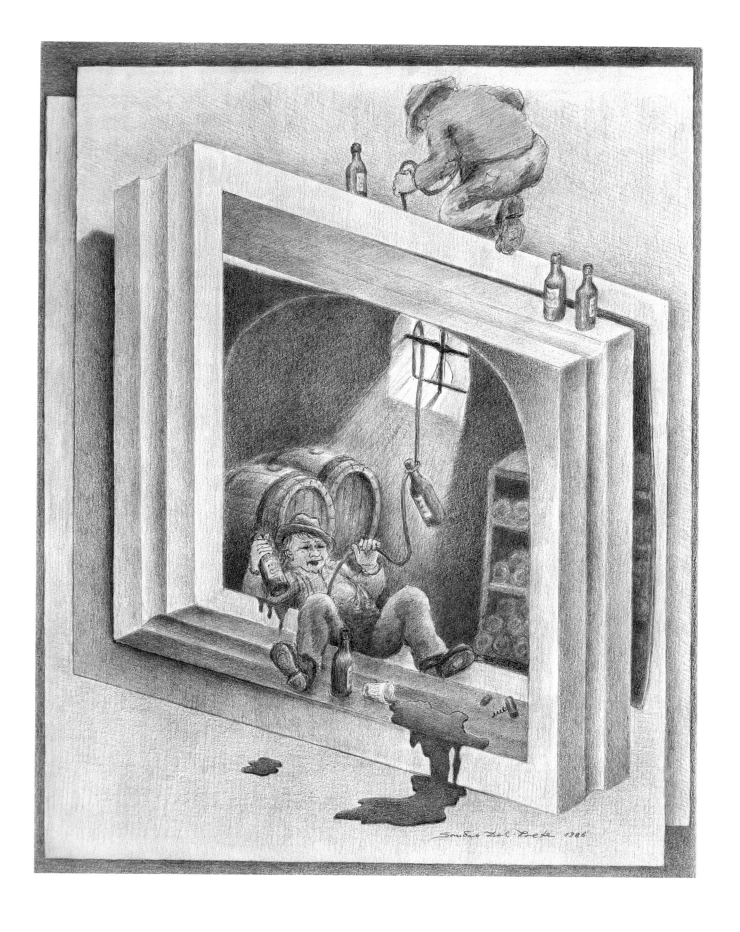

The Erotic Zipper

This special relief illustration suggests that a woman is hidden behind the curtain. At least that is what the little boy who wants to see for himself thinks. Will he discover the illusion, or will he be disillusioned by his discovery? He is about to learn that things are not always as they appear.

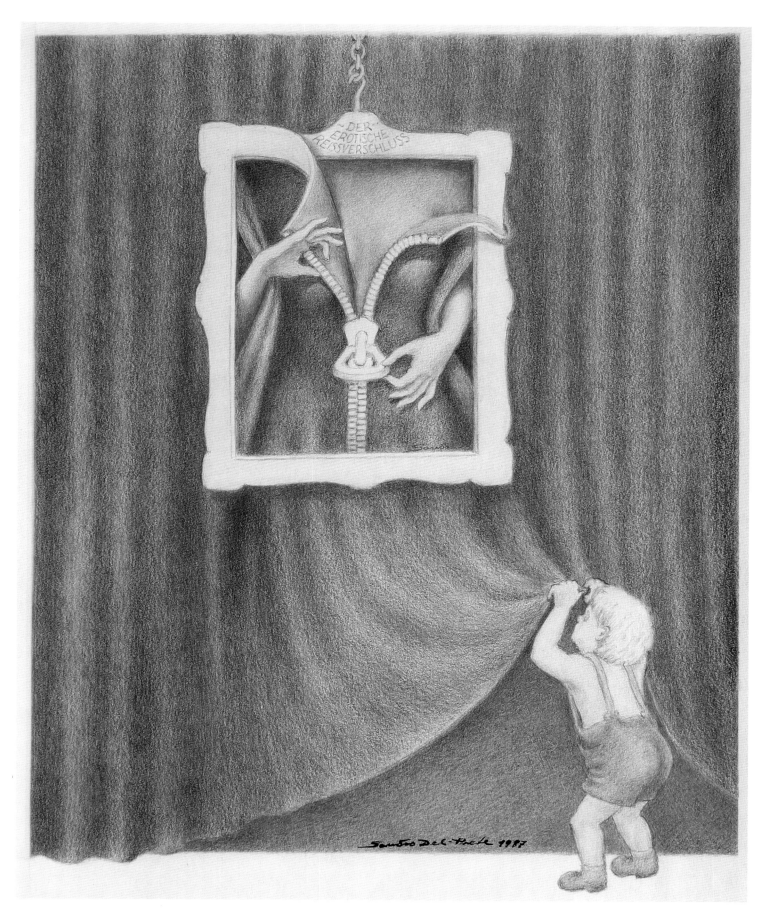

The Polarization Grid

Two painters have come up with the idea of catching day and night with the help of a special "polarization grid," because they want power over day and night. Since the giant cage was too limiting, they agree to cover—with corresponding dark or light paint—the part of day or night that remains in the heavens. They hope to use this to gain fame and to cross the gates of the history of creation, covered in glory. From the moment the sun and the moon are each placed under lock and key, time stands still, giving birth to eternity. Since then, the sun and the moon have regained their freedom, but the two painters were never heard from again.

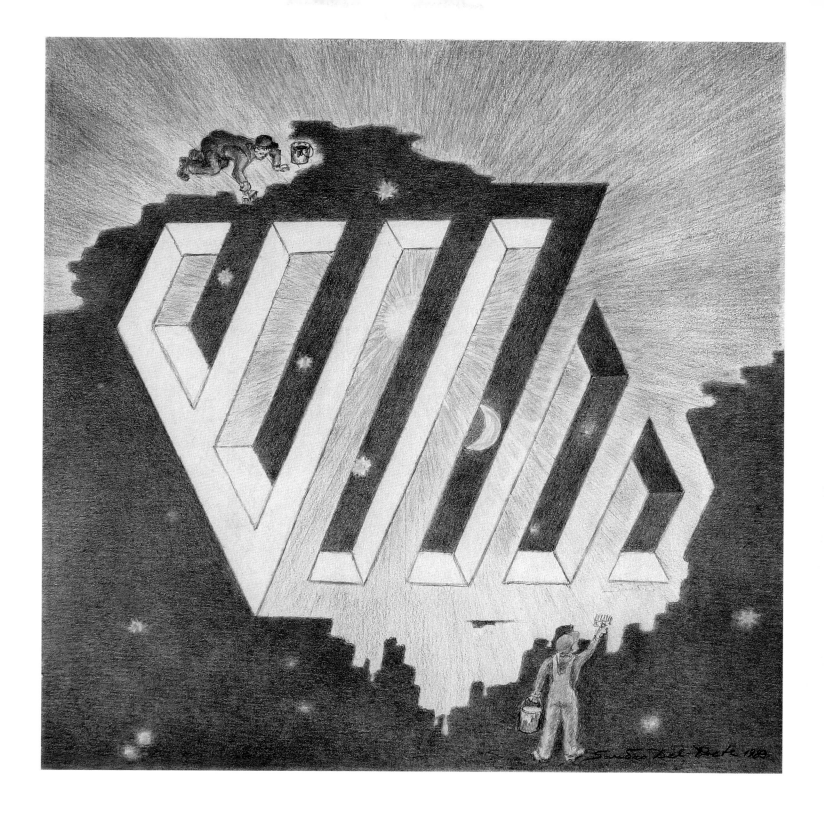

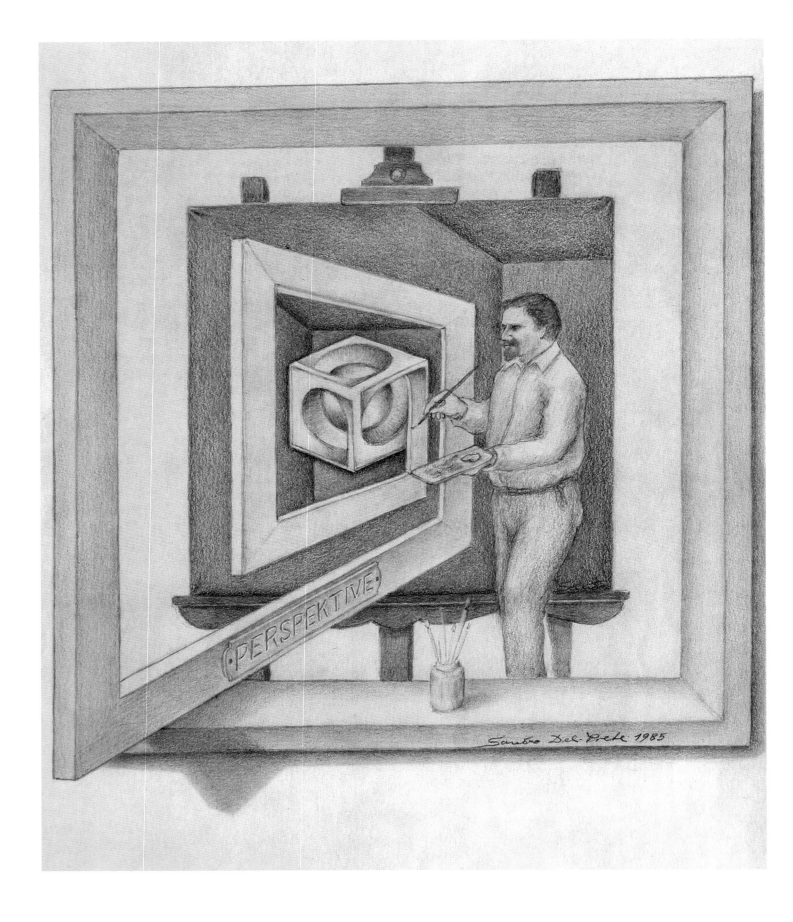

PERSPECTIVE (opposite)

This artist encountered enormous difficulties creating a realistic sense of depth in his paintings in spite of his best efforts. One day, he decided to add a frame to the canvas, and painted it so that it appeared to be placed in the foreground, in front of the canvas. He pulled at the right angle of the frame and placed it in front of the canvas in such a way that he could no longer remove himself without the risk of creating a hole in the composition. A victim of his own imagination, he remains confined between the frame and the canvas, where he can still be seen today.

MISSinterpretation (next page)

This artist is on his way home, carrying his canvas over his shoulder. An attractive lady crosses the street. For most men, a discreet glance would seem a natural reaction. But is he staring at the beautiful girl, or is he just carrying an illustration of a landscape with a bridge? Note the double-perspective at the bottom of the roll of parchment, as well as the little dog that is walking out of the scene, beyond the edge of the parchment roll.

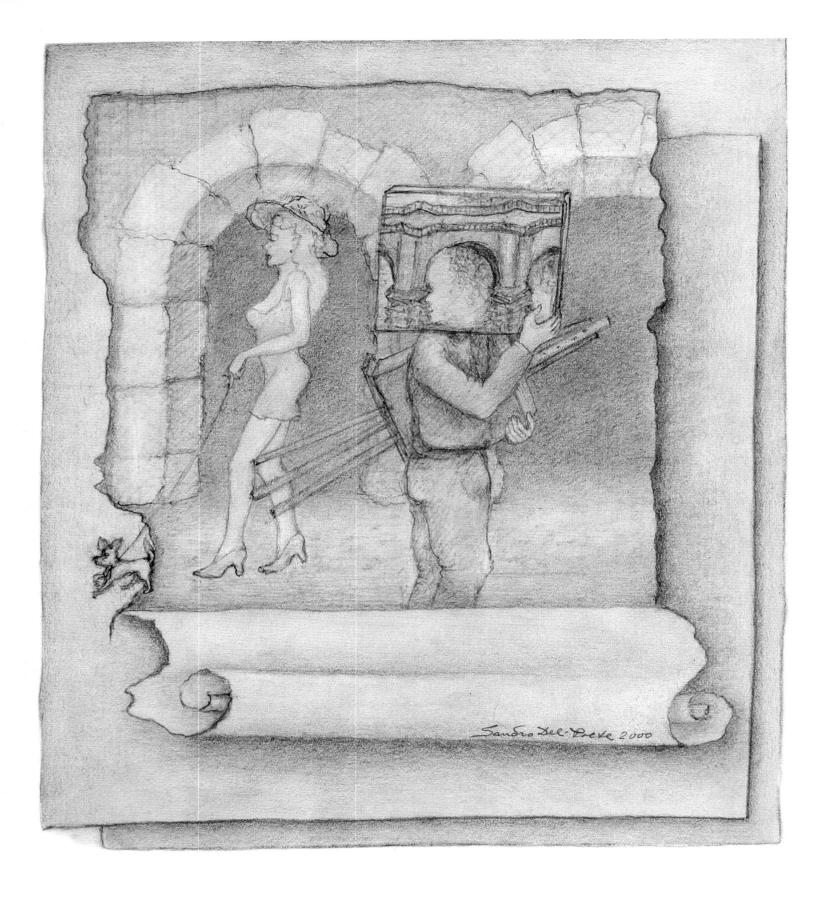

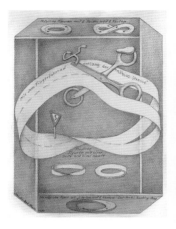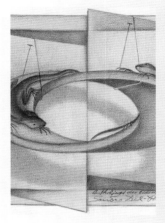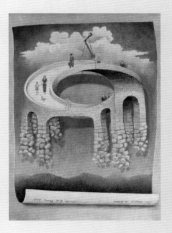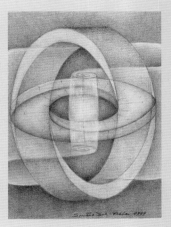

A NEW SHAPE IS DEFINED AND INTERPRETED

Some shapes that exist within the realm of the possible remain mysterious—for example, the Möbius strip. A multitude of shapes can be designed but not built in a three-dimensional world. Oscar Reutersvärd, the creator of more than a thousand such impossible constructions, was considered to be their absolute master, drawing them with straight lines and angles.

It remains unknown whether or not he experimented with round shapes. In any event, I have developed one of these shapes to illustrate a complex problem, that is, to illustrate the fourth dimension and time lapse using a non–three-dimensional figure.

The Bridge of Life was based on this shape.

Definition of a New Figure

The following figures are generally recognized:

A Ring

An object moving forward on a ring-shaped plane proceeds in a circle in a clockwise or counterclockwise direction.

A Roller Coaster

On a roller coaster, the object travels from the left bend to the right bend. It moves forward, then away from the observer, and passes over the following objects:

The Möbius Strip

The Möbius strip (discovered by the German mathematician August Ferdinand Möbius in 1858) can be demonstrated by taking a paper strip, giving it a half-twist, and then attaching the ends of the strip together to form a single unit. It will form a surface with only one side and only one boundary component. It has the mathematical property of being *non-orientable*. If you try to split the strip in half by cutting it down the middle along a line parallel to its edge, it becomes one long strip with two half-twists rather than two separate strips. If you cut this one down the middle, you get two strips that wind around each other.

Alternatively, if you cut along a Möbius strip about a third of the way in from its edge, you will get two strips: one is a thinner Möbius strip; the other is a long strip with two half-twists in it. Cutting a Möbius strip, giving it extra twists, and reconnecting the ends produces unexpected figures called *pandromic rings*.

New Figure: The Impossible Ring Disk with Two Sides and Two Edges

This new shape, though different from the one above it, has the same qualities as the other figures. An object would travel a full cycle along its path in a clockwise direction—and once again in a counterclockwise direction—without passing over the other objects on the ring disk. The object moves toward the observer or in the opposite direction, away from the observer, but this to-and-fro motion is illusory. It relies on a temporal element, and could therefore be called four-dimensional.

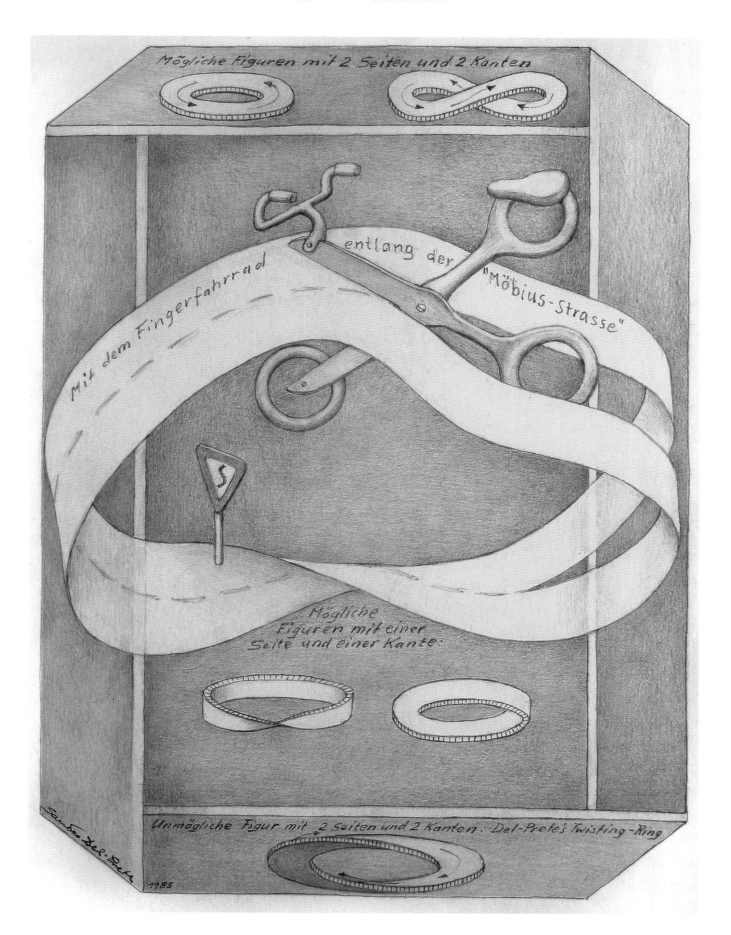

Mögliche Figuren mit 2 Seiten und 2 Kanten

Mit dem Fingerfahrrad entlang der "Möbius-Strasse"

Mögliche
Figuren mit einer
Seite und einer Kante:

Unmögliche Figur mit 2 Seiten und 2 Kanten: Del-Prete's Twisting-Ring

1985

The Pursuit of the Lizards

At first sight, this image of infinity has a certain similarity to familiar shapes like a ring, a roller coaster, or a Möbius ribbon. If the lizards were to move in the same direction on a ring or a roller coaster, we would see them once from the front and once from behind. On a Möbius ribbon, each would walk upside down. But this figure is different: it is Sandro Del-Prete's paradoxically twisted ring.

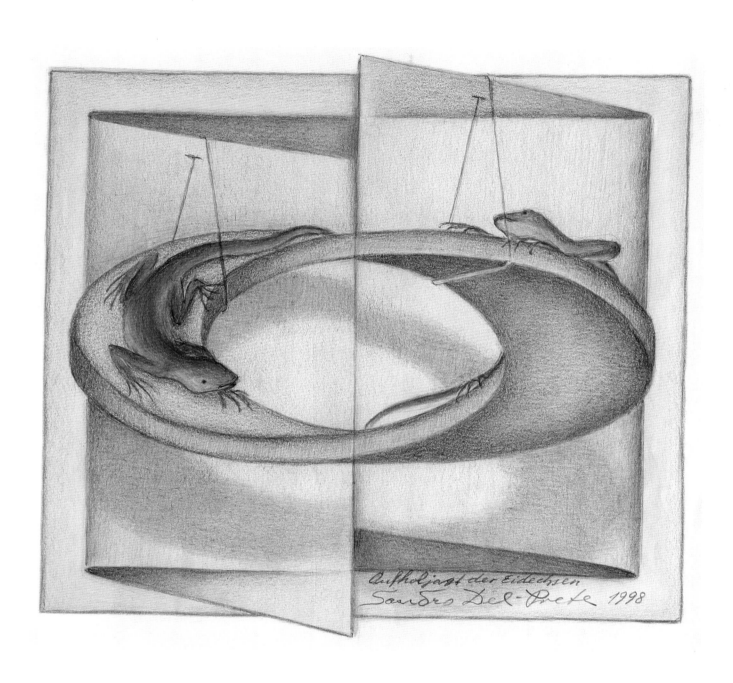

Aufholjagd der Eidechsen
Sandro Del-Prete 1998

THE BRIDGE OF LIFE

This is an oil on canvas, 55 x 39 inches (140 x 100 cm), 2002.

Using the principle of the paradoxically twisted ring, these people perpetually move forward, toward the observer; they are never seen from behind.

Where is the past? Where is the present? Where lies the future? Examined objectively, where does the path begin and where does it end? This figure illustrates one of the secrets of the universe: the inexorable passage of time in twisted space.

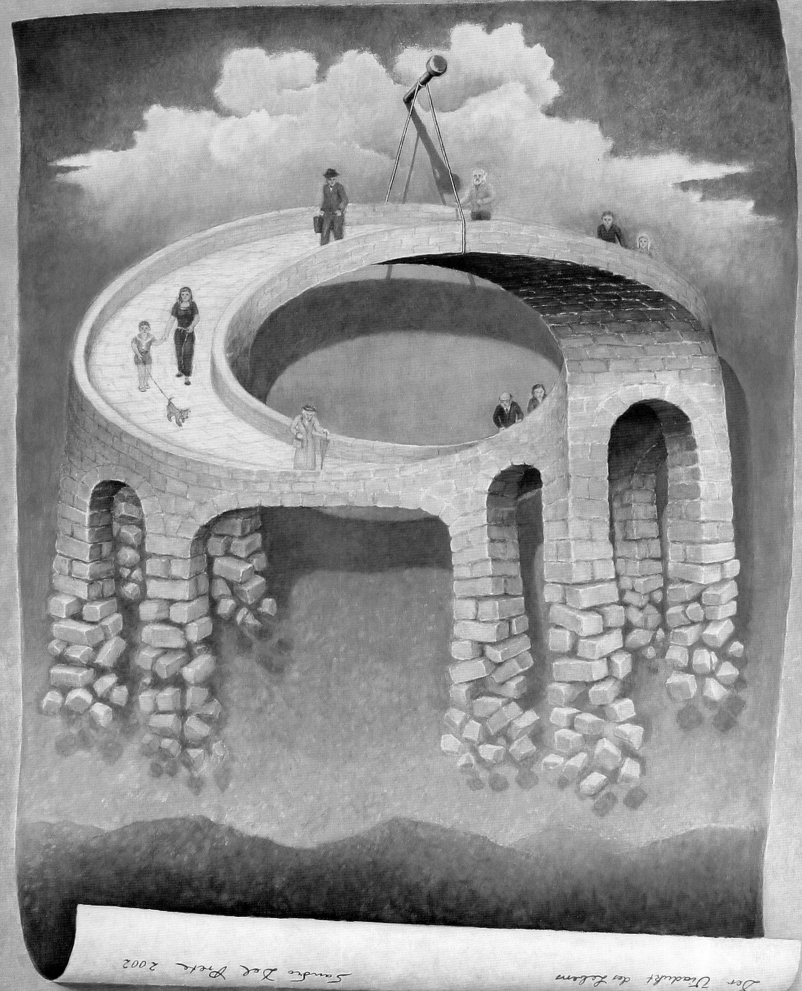

Der Wischhaft des Lebens

Sandro del Prete 2002

Transcendental Energy Flow in Space, Motion, and Time

The reality of the universe exceeds the limitations of experience and perception, its energies traveling on multiple planes to a common and inexorable destination.

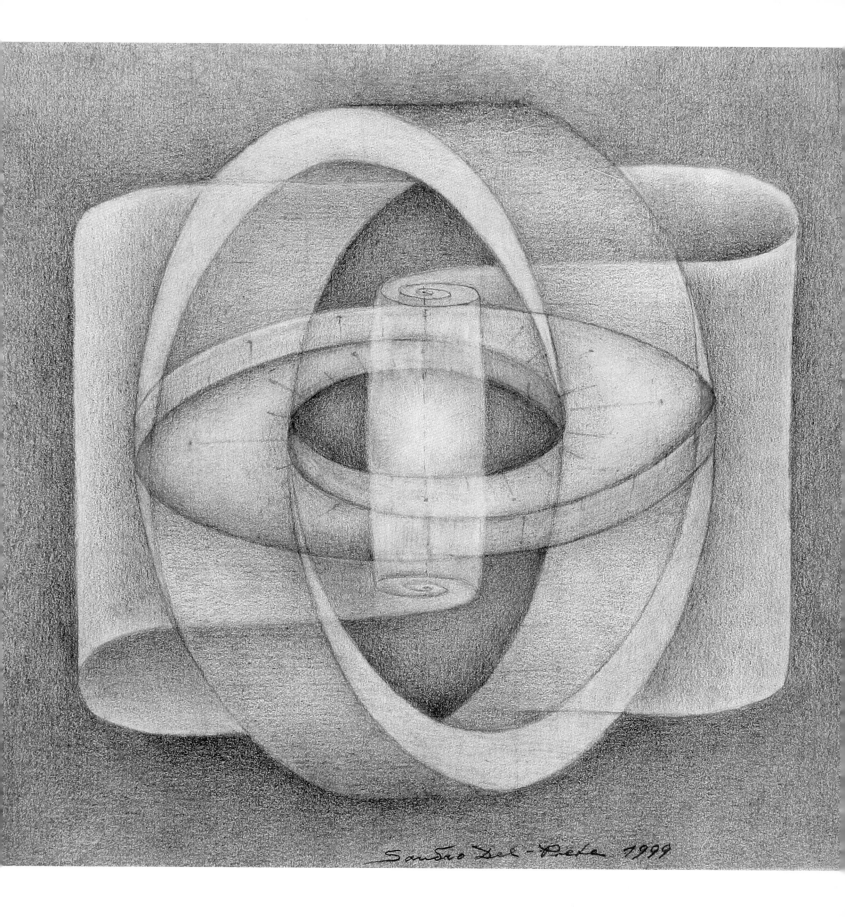

Sandro Del-Prete 1999

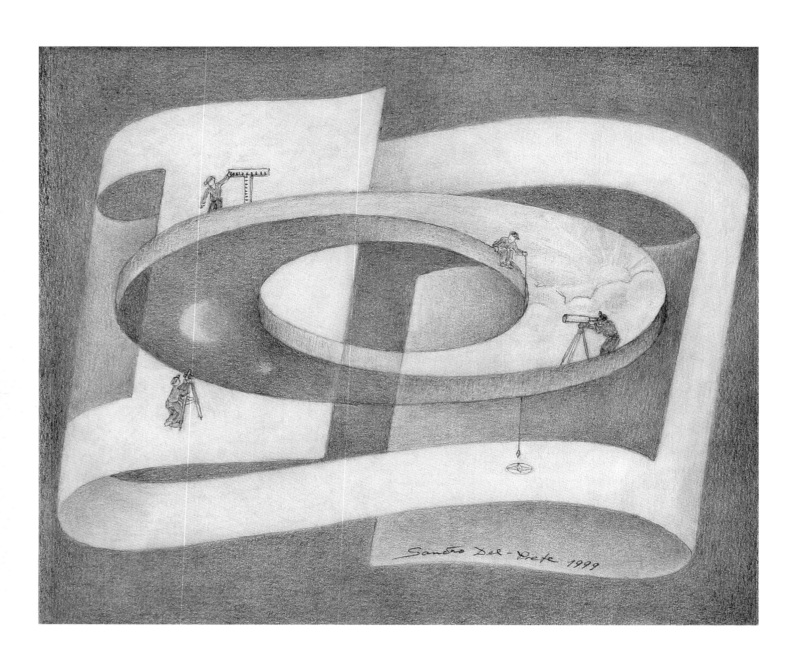

The Transparent, Hollow Ring Disk (opposite)

Measuring a hollow ring disk through several perspectives.

Is this Möbius ring a ring disk—or is the disk merely a hole? And how is the hole in the middle delimited?

The Time Trauma (next page)

Symbolic of the four seasons, four carnivorous fishes are wrapped around a track for hurdlers. A giant time snail darts its tongue in and out, threatening the hounded hurdlers. However, the longer they run, the older they get; paradoxically, their sense of time is getting more compressed. It looks as if these carnivorous fish eating each other up were shortening the racetrack. With each tour, the yearly episode is shortened and accelerated. The only element at rest is a towel hanging in the picture, which establishes the connection between the virtual world in the picture and the real world in the frame.

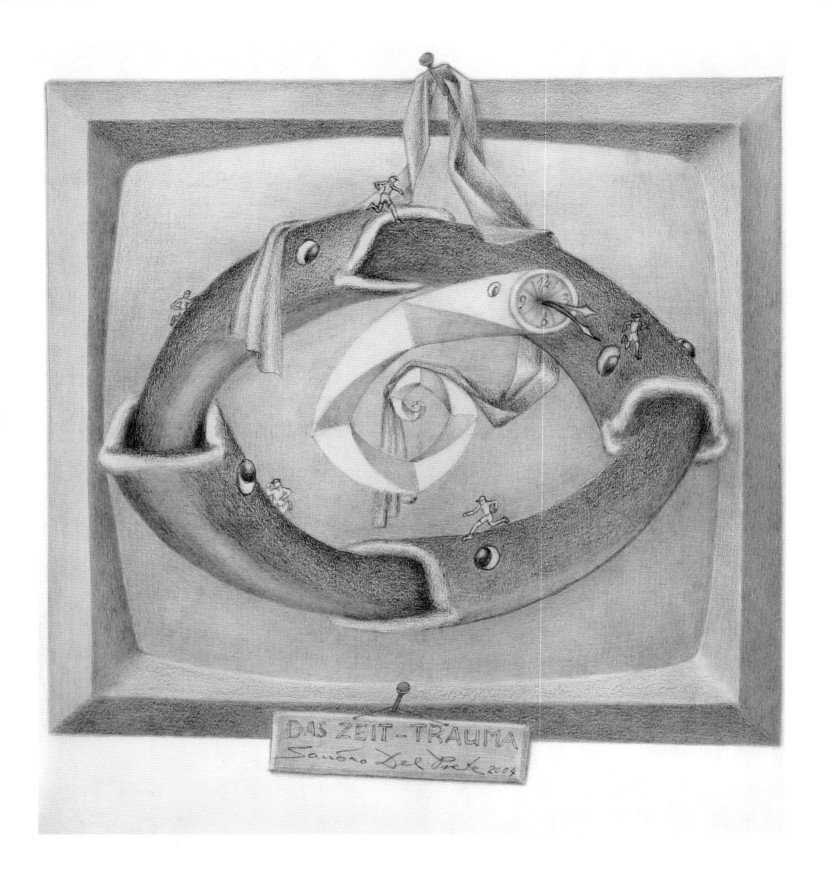

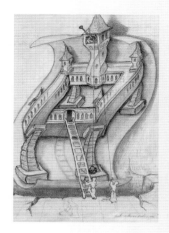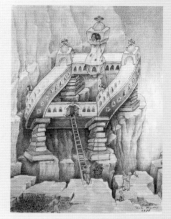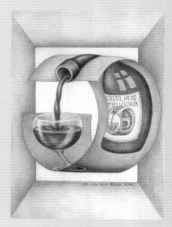

STUDIES OF IMPOSSIBLE TOPOGRAPHIC DISTORTION

As regards topology, I prefer to remain at the level of child's play. I simply wanted to know what would happen if I drew a simple, straight shape, for example, a four-edged column, on a piece of paper, bending it in the upper-left corner and in the lower-right corners in the front and then tearing the left upper edge as well as the lower right one, then a bit toward the outside.

Looking at it from the side, it looks like a twisted C shape. If, instead of a simple column, one draws a twisted monastery fortress, the result is a complex shape whose lines meld into one another, deceiving the eye and making them difficult to identify.

Once I had finished, I was left with a twisted monastery fortress without the folded paper underlay.

"Topology is a special branch of geometry; its purpose is to analyze planes and areas, to determine how they are twisted, bent, pulled, imported or transferred from one shape to another. At times, it uses surfaces impossible to build, and other times, impossible surface area concepts; for example, one-sided objects. This special world that is based on mathematics ranges from the very simple to the most complex abstractions."

—David Bergamini, from his book *Die Mathematik Wunder der Wissenschaft* series; Amsterdam: Time-Life Netherlands, 1965)

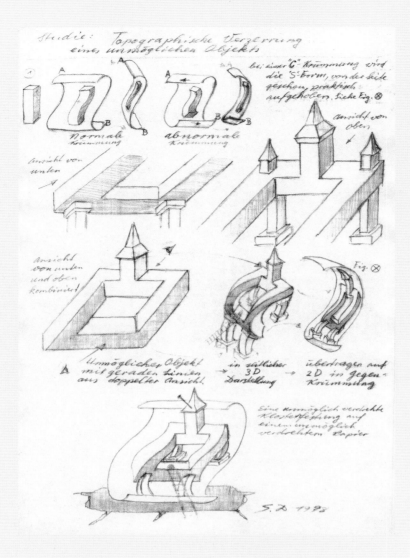

Studies of an Impossible Topographic Distortion

This blueprint depicts an impossible monastery fortress. When the ladder is drawn in, the fortress seems to become impregnable. In the initial draft (facing page), the monastery hangs over a deep abyss and is secured by a single nail, while the supporting columns and foundation are resting on a parchment scroll, which symbolizes intellectual insight. A three-dimensional object is presented in a two-dimensional way, projecting itself into the fourth dimension. Here, none of the concepts of direction apply, because a change in direction implies movement, and movement presupposes time.

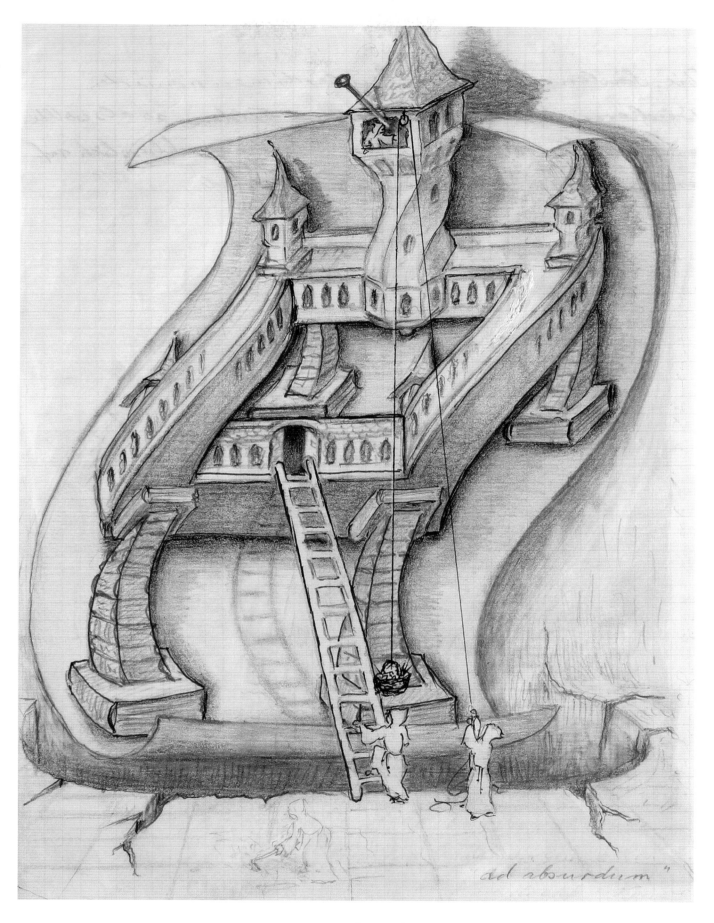

ad absurdum

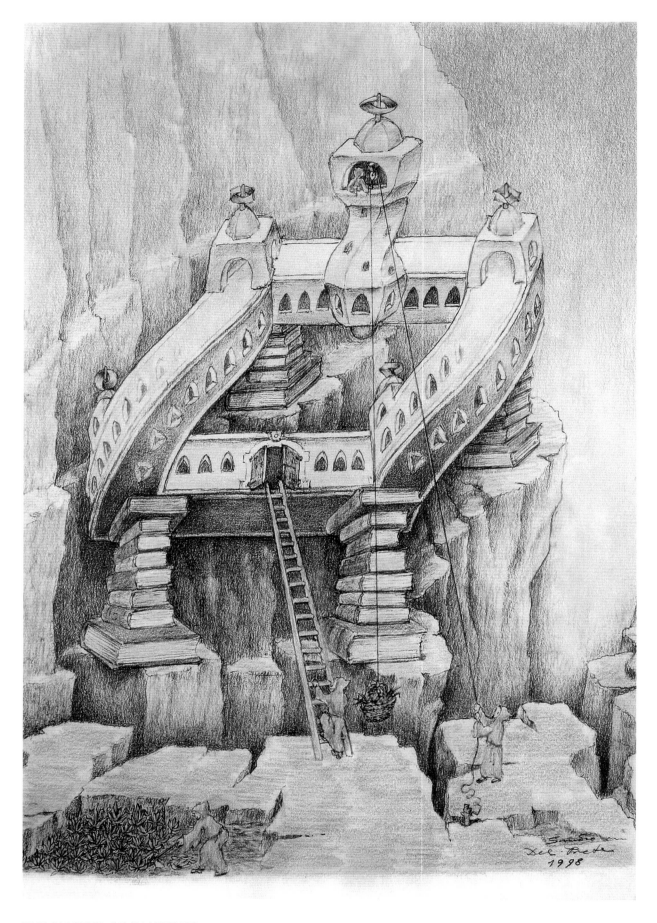

The Twisted Monastery Fortress (opposite)

Using one of the elements developed in the study of an impossible topographic distortion, one can see that the fortress battlements can be observed simultaneously from multiple perspectives: on both sides, they twist in a double-perspective. The rear or top portion can be seen from a bird's-eye view, whereas the front battlement plays tricks on the eyes and projects multiple perspectives simultaneously.

Self-Pouring Bottle on a Twisted Page (next page)

Elements of reality are combined within the framework of a twisted page. The body of the wine bottle and base of the glass are on one side of the ribbon of paper, while the neck and spout of the bottle are connected to the top of the glass via the wine, which flows from one into the other.

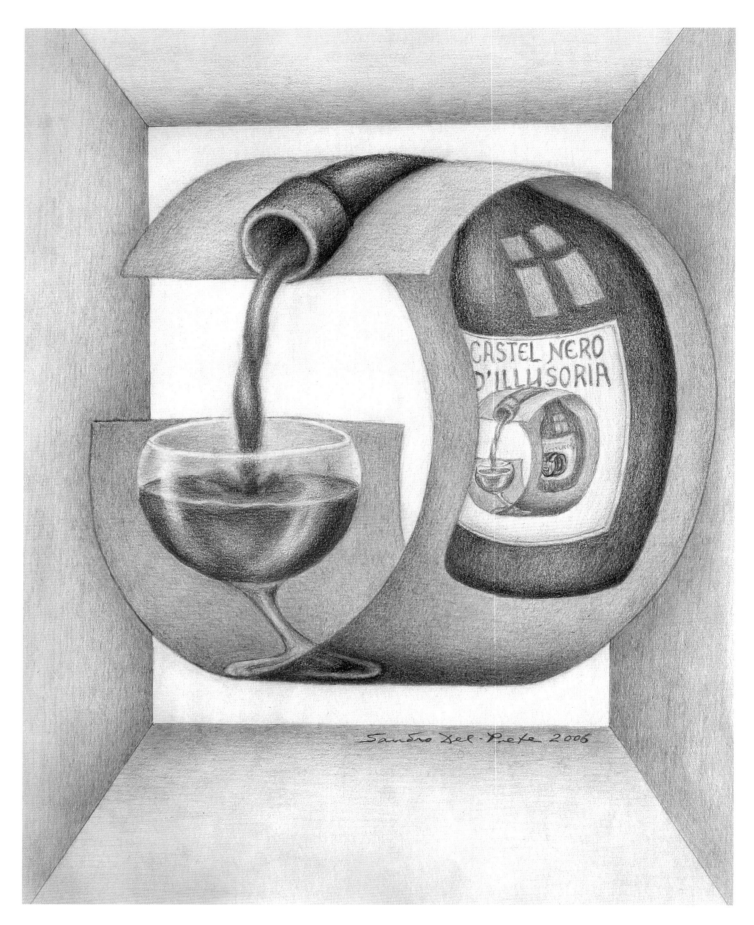

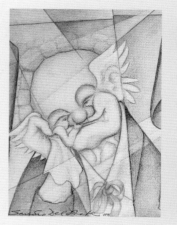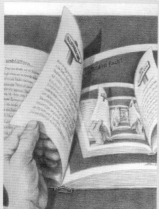

VARIOUS ILLUSORY AND SURREALISTIC IMAGES

As shown in *The Discovery of Illusorism* (page 28), illusory and surrealistic images share many things in common. This concept has been thoroughly demonstrated by René Magritte and Salvador Dalí. In my artistic illustrations, you will always find games based on optical illusions. Sometimes they are but a distortion of reality, while at other times they can represent an impossible building or shape, a game of double-perspective, or a conflict of interpretation. In all images, however, the challenge is to discover wherein lies the optical deception.

The following images were drawn since the publication of my second volume in 1987; they have not yet been published.

The Golden Cage

The golden cage symbolizes the beautiful house that a husband builds for his wife. The door to the house, like the door to a cage, should always remain open to illustrate her freedom. A bird, like a wife, will always return to where it feels comfortable and free.

One might ask, "Shouldn't the wife also build a wall around her husband?" But in the final analysis, neither can really possess the other.

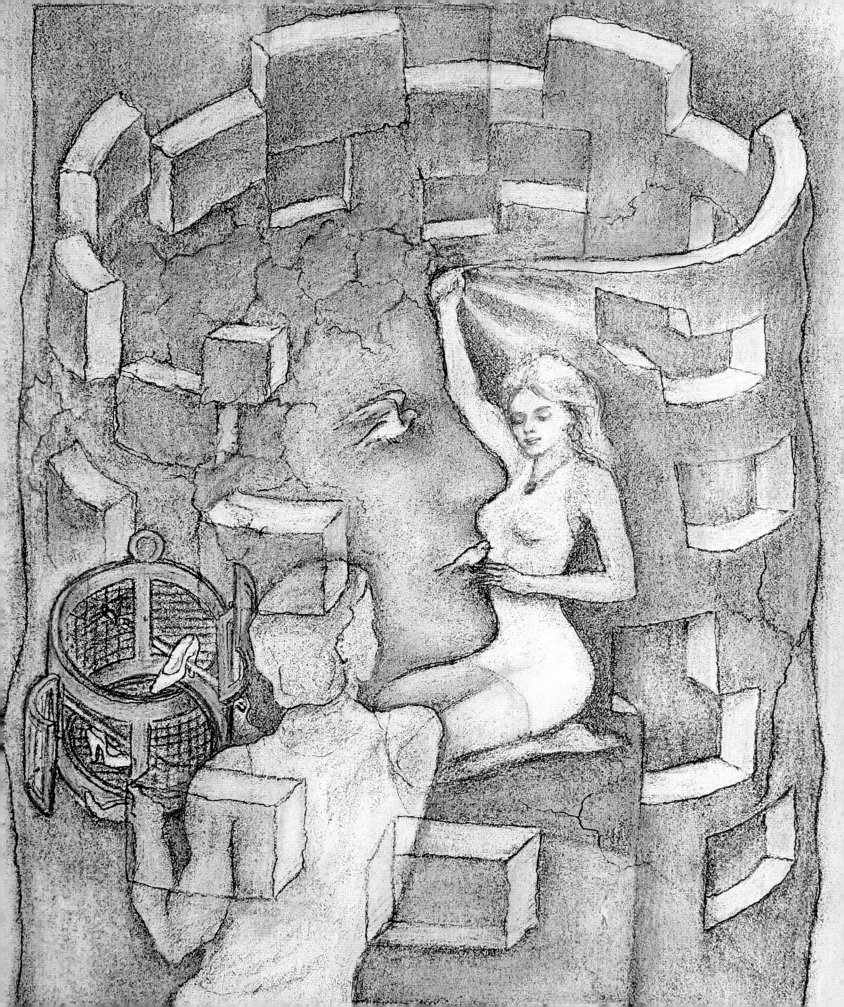

Circus Nostalgia

In this nostalgic composition, a multitude of geometric shapes are combined with numerous subjects in a mesmerizing amalgamation of illusion and perspective.

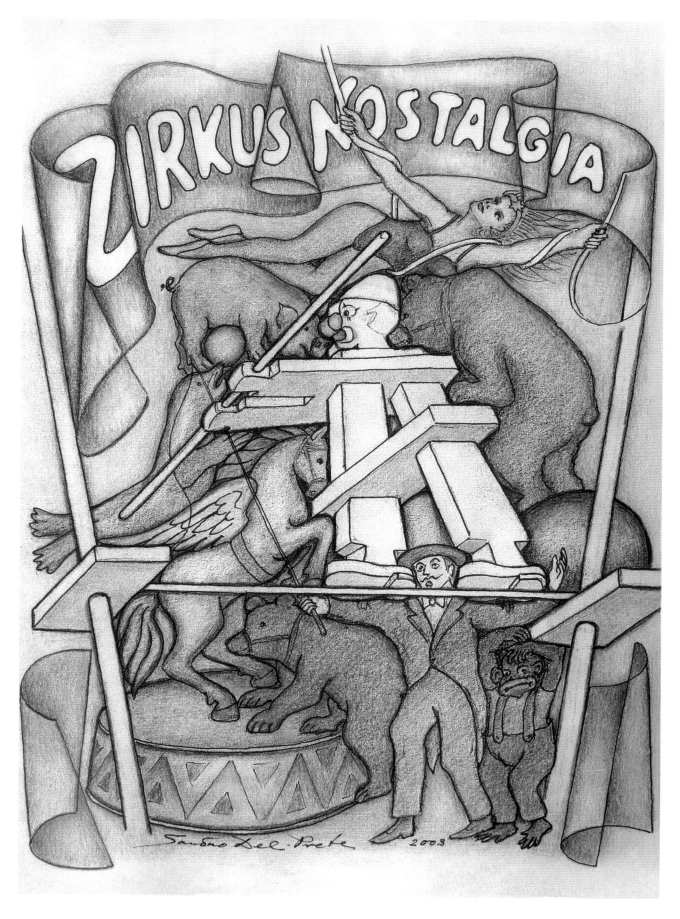

THE LIGHT-DISPENSING FAUCET

As in a surrealistic image, two worlds have merged. The central image is dominated by a huge faucet emerging from a cloud. A bulb has been twisted into the spout of the faucet. Consequently, the faucet is not dispensing water but drops of light, which illuminate the scene. In the bottom right-hand quadrant, a puddle delimits the main image. On the left side, a street sweeper, whose face is composed of numbers, holds up the surface of the water as though it were a rug under which to sweep the garbage. The street sweeper belongs to the surrounding background image, though he stands superimposed on the water.

An aqueduct snakes through the central image and vanishes. Water is flowing through the aqueduct, which also has rails to allow a steamboat/locomotive to drive over it. A fisherman is sitting on it, fishing in the air for one of the fish hanging from the mobile, since all the fish in the lake are dead.

In the foreground, a statue of Hermes can be seen. The gods have sent him to protest against careless waste disposal. The sword he holds symbolizes the dangers of abusing nature. If we do not begin to treat nature with care and respect, not only will we destroy her, but we could compromise the very survival of mankind.

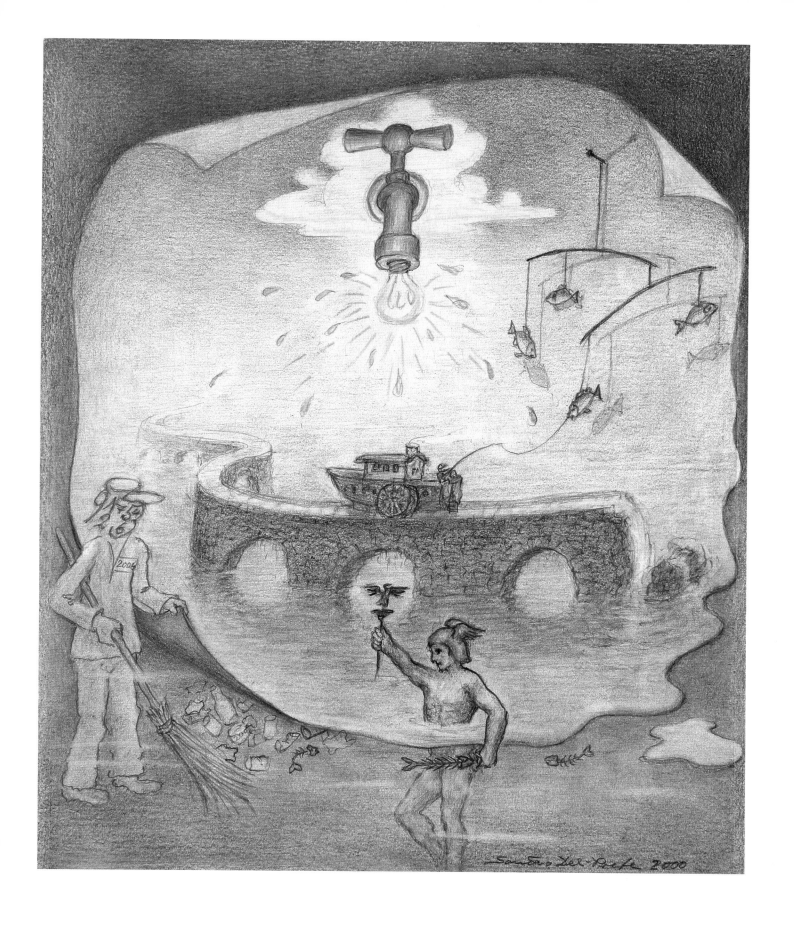

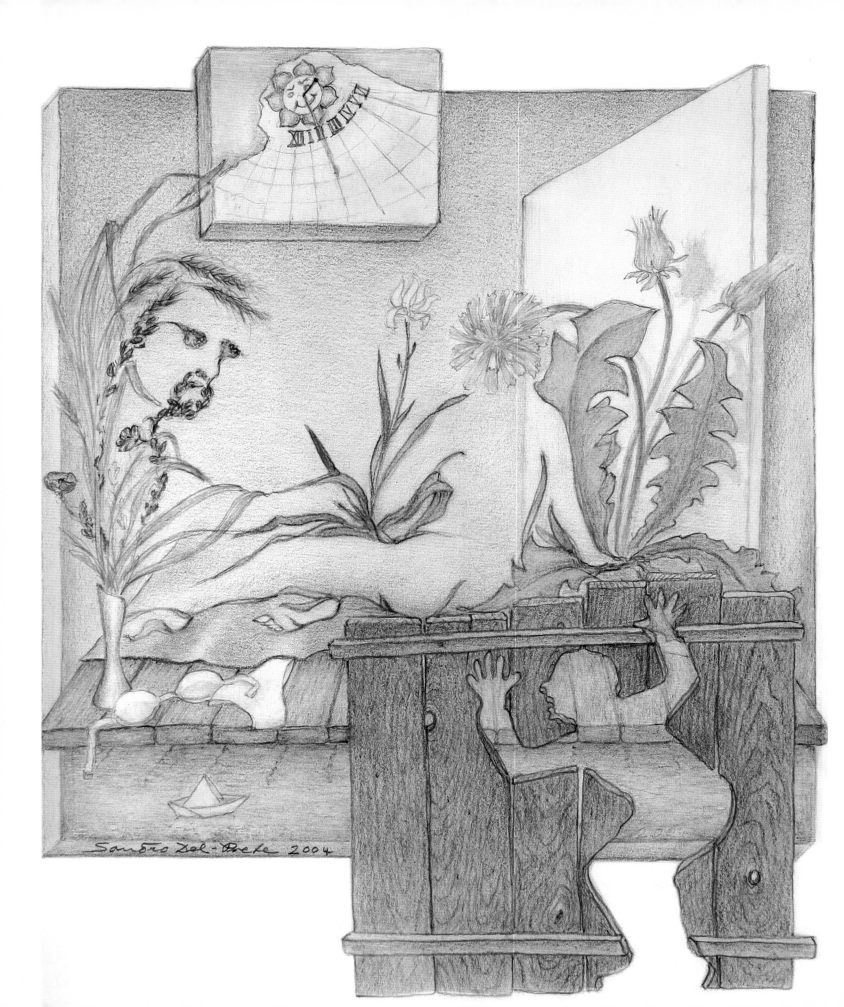

Natural Body Painting

This illustration depicts an artist (a cameo appearance of mine) in the process of painting his model, but if examined more closely, one notices that both the artist and his subject are in fact a natural canvas, composed of reeds and flowers. The voyeur behind the fence is but a spectral cutout.

Venice Carnival

What a strange bird lives in this cage! He is living it up at the carnival in Venice instead of enjoying his golden cage at home.

Below the cage, the text reads: "I have flown the coop! By the time you read this, I'll be rejoicing at the carnival in Venice."

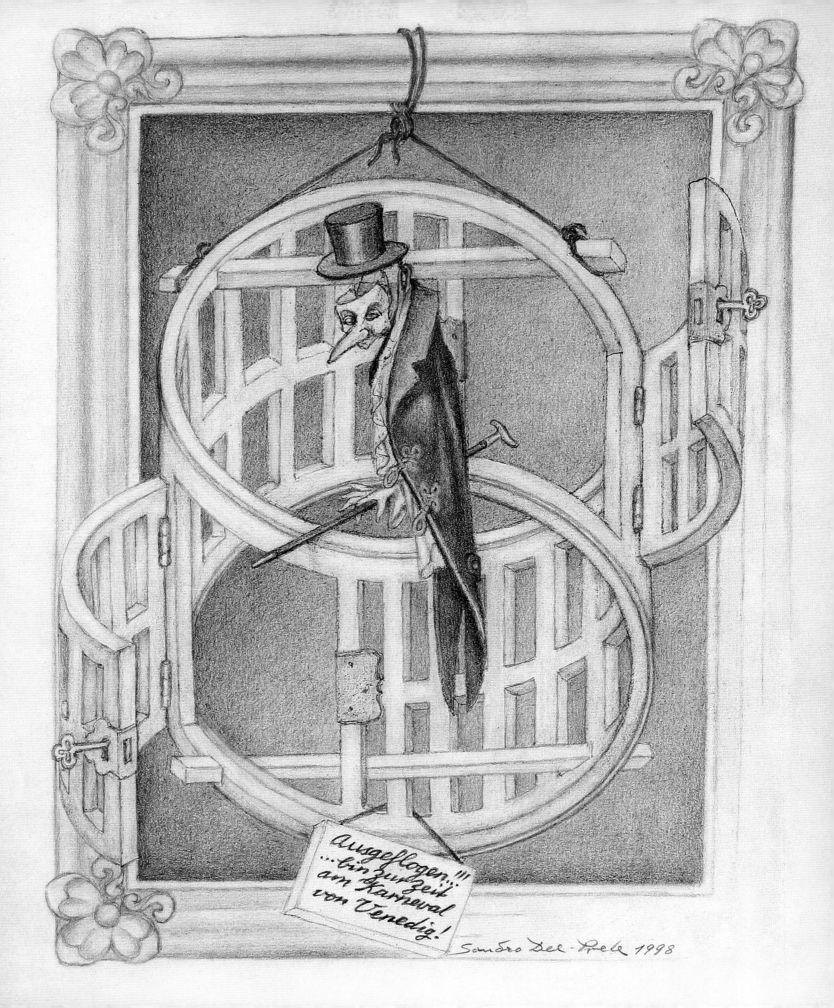

Ausgeflogen!!!
...bin zurzeit
am Karneval
von Venedig!

Sandro Del-Prete 1998

The Match On or In the Box

Is the match inside, outside, or on top of the box?

In the topmost illustration, one can see the matchbox from below. One of the matches can be found outside the box, while the other is held inside the box to anchor it to the frame from above.

In the bottom illustration, one can see the matchbox from above, and the match is clearly inside the box.

In the center illustration, both situations are possible.

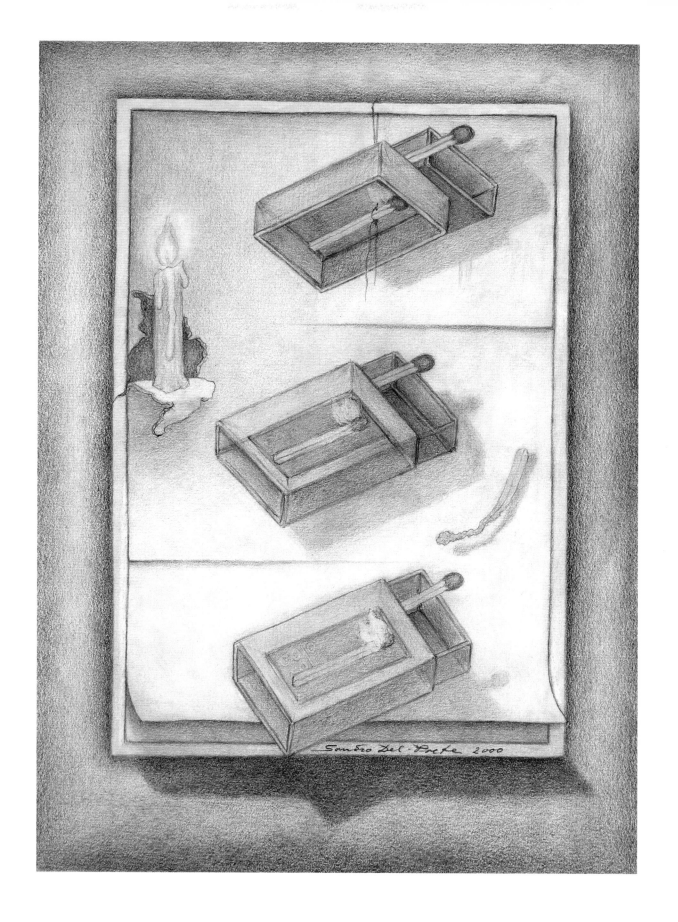

Limited View of Long-Forgotten Cultures

The partially obstructed telescope allows but a limited view of three principal subjects from the past, each harboring a naked beauty. Can you spot the third, darker one?

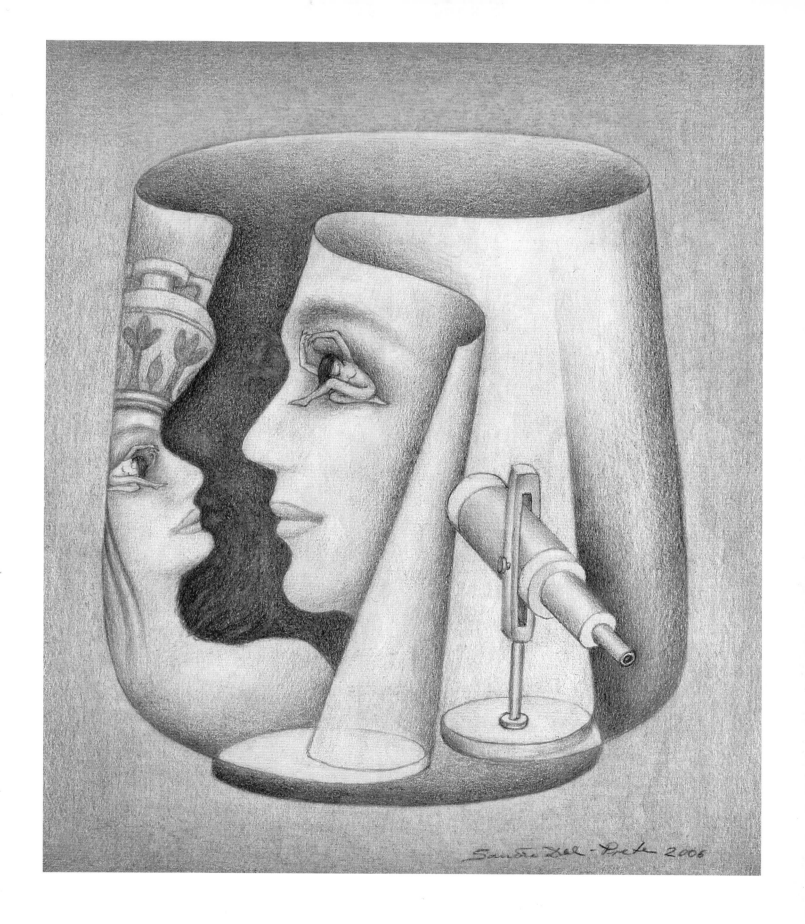

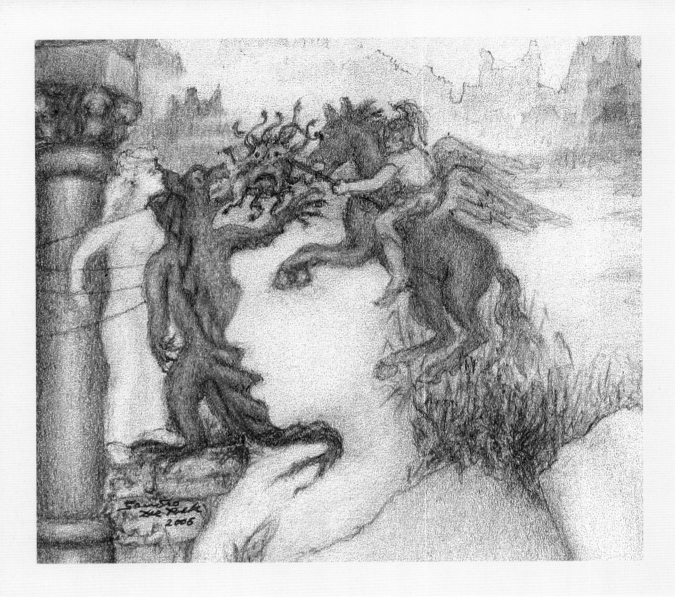

The Liberation of Andromeda

With help from Pegasus and the head of the decapitated Medusa, Perseus liberates Andromeda from the monster Cetus. In the foreground (opposite), queen Cassiopeia anxiously watches the fight. She is Andromeda's mother and partly to blame for her daughter's tragic fate. Upon closer scrutiny, one begins to wonder whether Cassiopeia is really there, or whether this is not just another illusion.

The detail (above) of Cassiopeia's head reveals that of the decapitated Medusa, whose gaze transmogrified everything into stone.

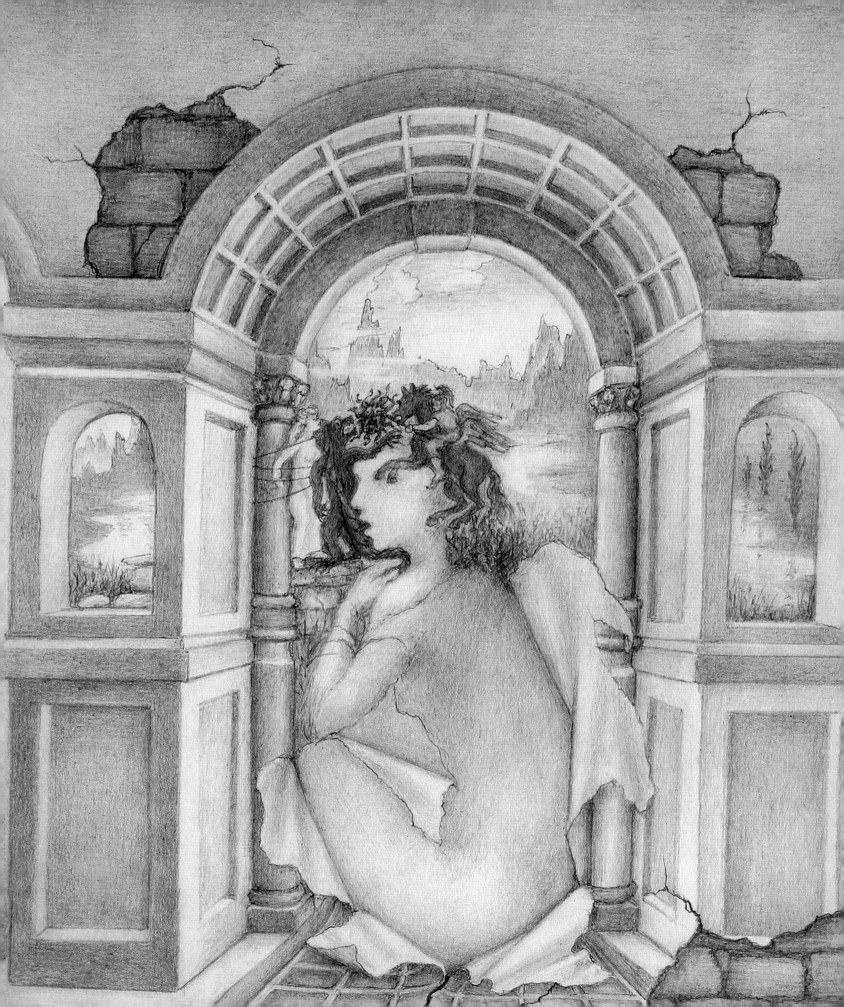

Cathedral with a Surrealistic, Paradoxical Perspective

Within a masonry framework, one can see a cathedral in four sections, opening up like a box with hinged sides. On each side of the box is depicted a different illustration of a wall, in which the columns and window frames interweave between illusory planes and their respective backgrounds. Water is dripping from the wooden floor of the foreground, but when one looks further, the surface water goes to the background, turning into a stream that winds its way through the cathedral, where it blends into the horizon. The body and roof of the midsection are semitransparent; allowing the background and frame to show through the structure.

The cathedral appears to reach out from the illustration, giving an open invitation to explore its wonders.

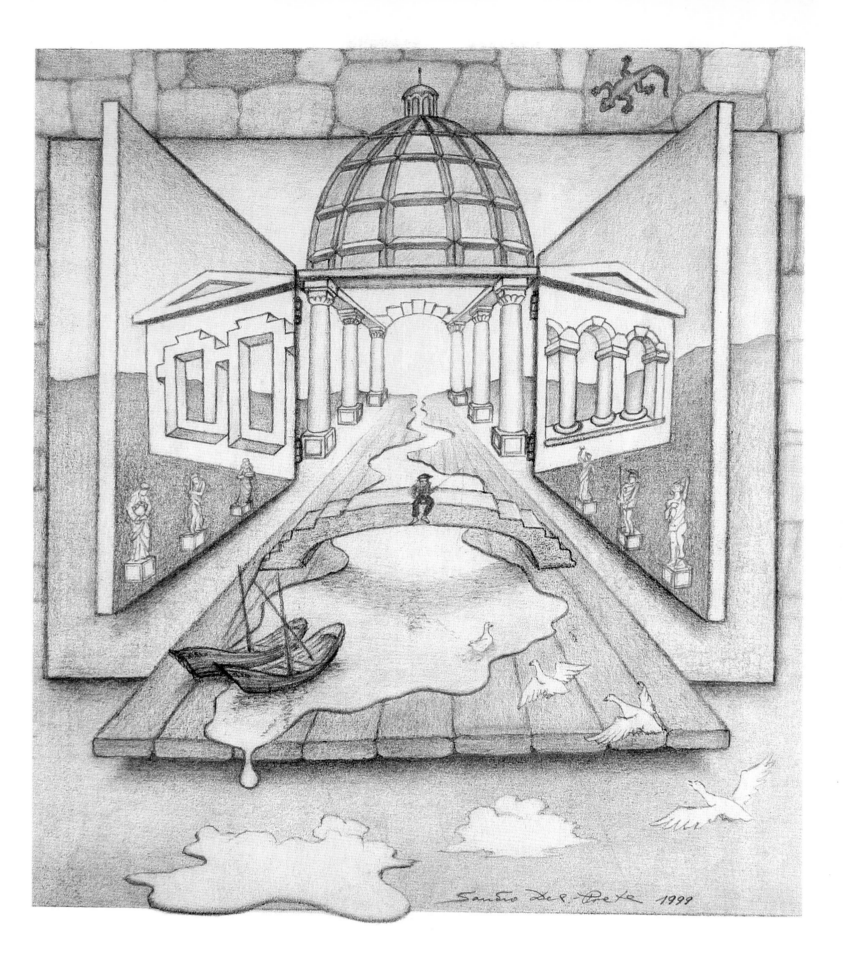

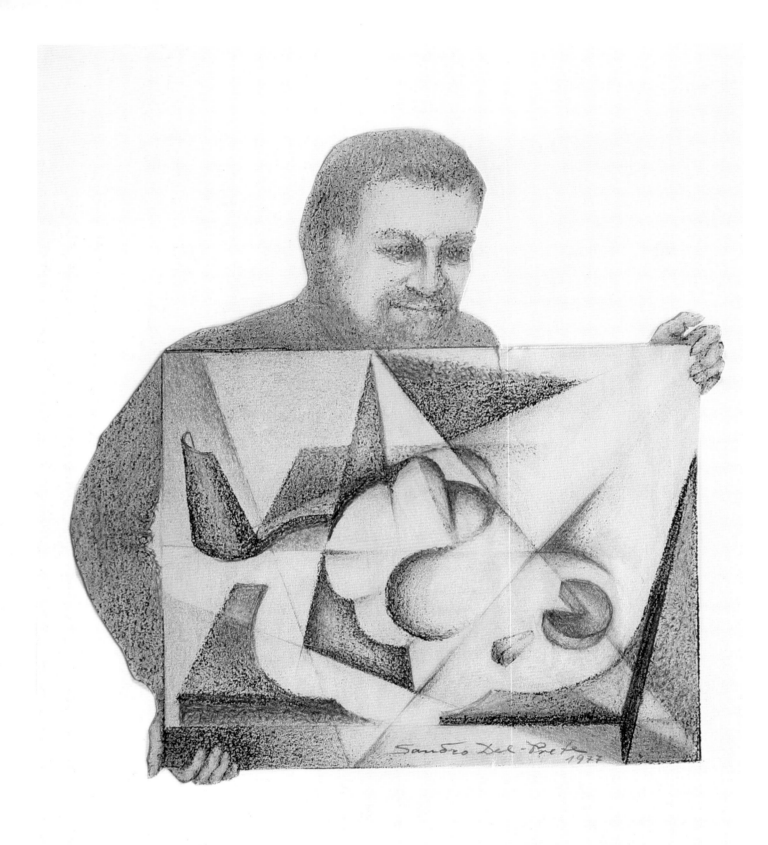

Not a Kandinsky—Only an Anamorphic Illustration

Viewed from the left side, you can recognize the face of the Pierrot.

Playing Angels

Two angels facing each other appear to be playing—one with a ball and the other with a horn—in the grimacing face of a clown. Upon closer scrutiny, one sees an old man wiping his eye with a handkerchief. The illustration plays with perspective as the surfaces twist and turn.

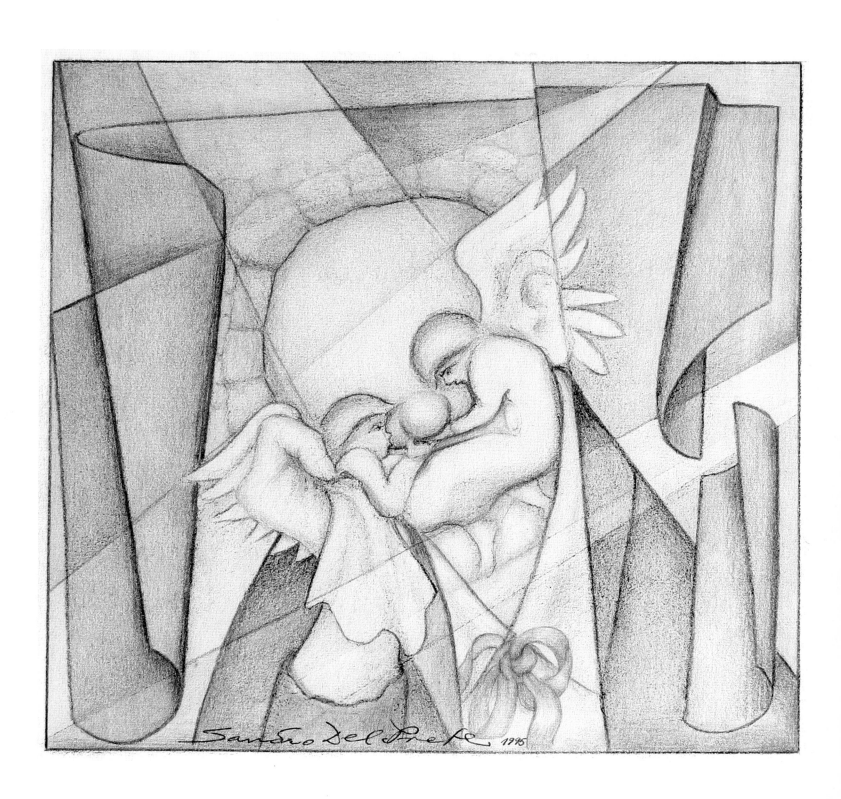

Mishap, with Causal Correlation

Have you ever fallen victim to a suite of consequences that stem from placing an image on the wall the wrong way, and you mistakenly drive a nail through the middle of the image, thereby breaking the glass and causing the wall to cry because you hit a water pipe? Then you should not be surprised if the "victim" thumbs its nose at you.

This phenomenon is known as "causal correlation."

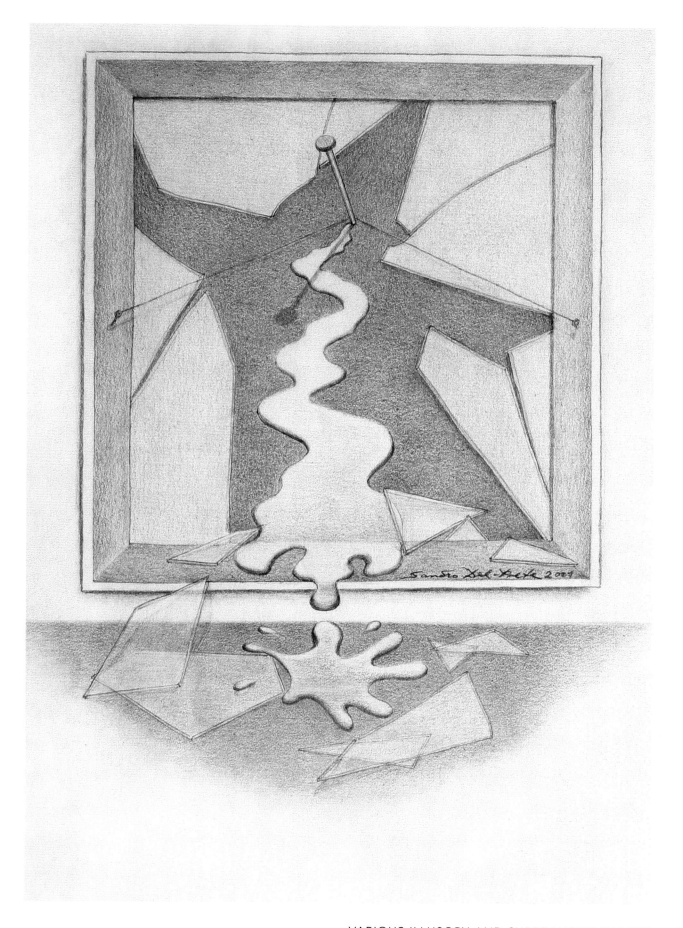

Turn, Please

On the table lies an open book. The illustration represents a hand turning a page. You can recognize the image on subsequent pages: a reproduction of the same image, getting progressively smaller and smaller, creating an impression of depth. The accompanying text of the first page is in striking contrast to the image depicted: it reads, "This is a flat image"!

But should you feel dizzy while looking at the picture, just follow the instruction in the title, and: "Turn, please!"

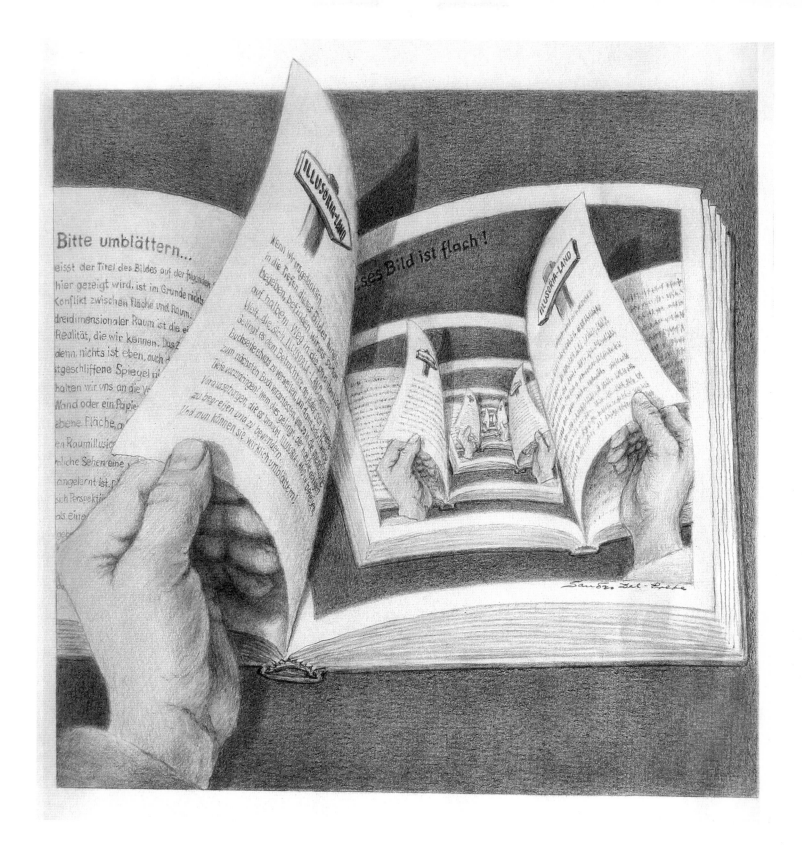

Napoleon Bonaparte

Napoleon is depicted here as a scholar in a closet surrounded by memorabilia and historical accounts of the period in which he reigned. One of the thick volumes depicts a sculpture of the revolution—the taking of the Bastille. A red shawl drapes over one of the volumes and is suspended over the globe. Before the Emperor sits a tub filled with old world maps. His head is a composite of warring soldiers, wielding flags and weaponry on a battlefield. Napoleon's image comprises four elements: a sculpture, a book, a towel, and maps.

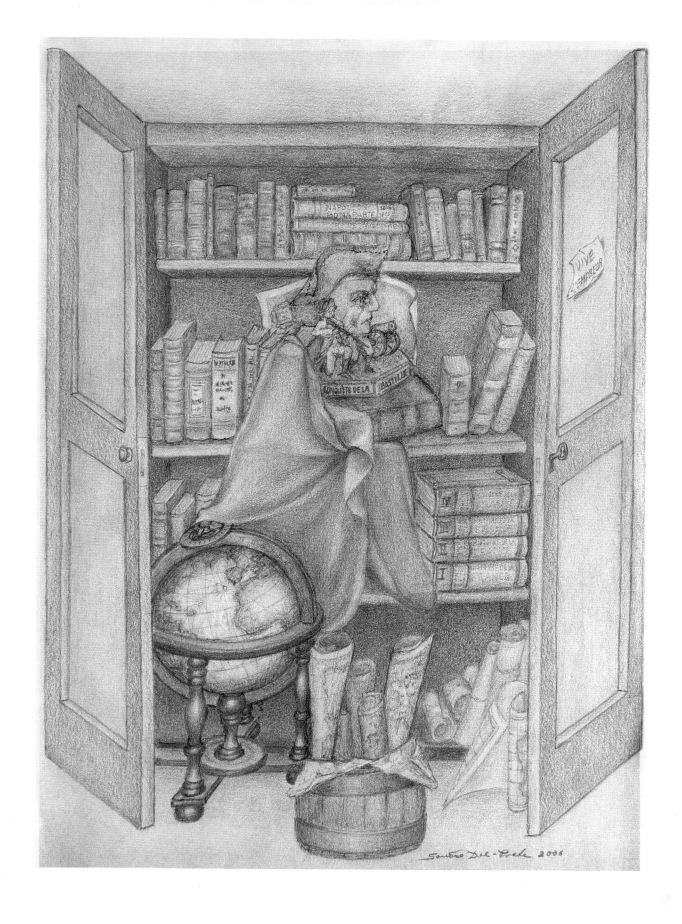

The Torn Virtual Book

The torn piece of paper appears to be doubled; one section is folded upward, while its counterpart lies flat. If it were, in fact, a doubled piece of paper, it would be impossible to draw the book on the lower leaf. This is an impossible book design. Note that on the left side, part of the book is poking out of the frame, while on the right, the design is incomplete.

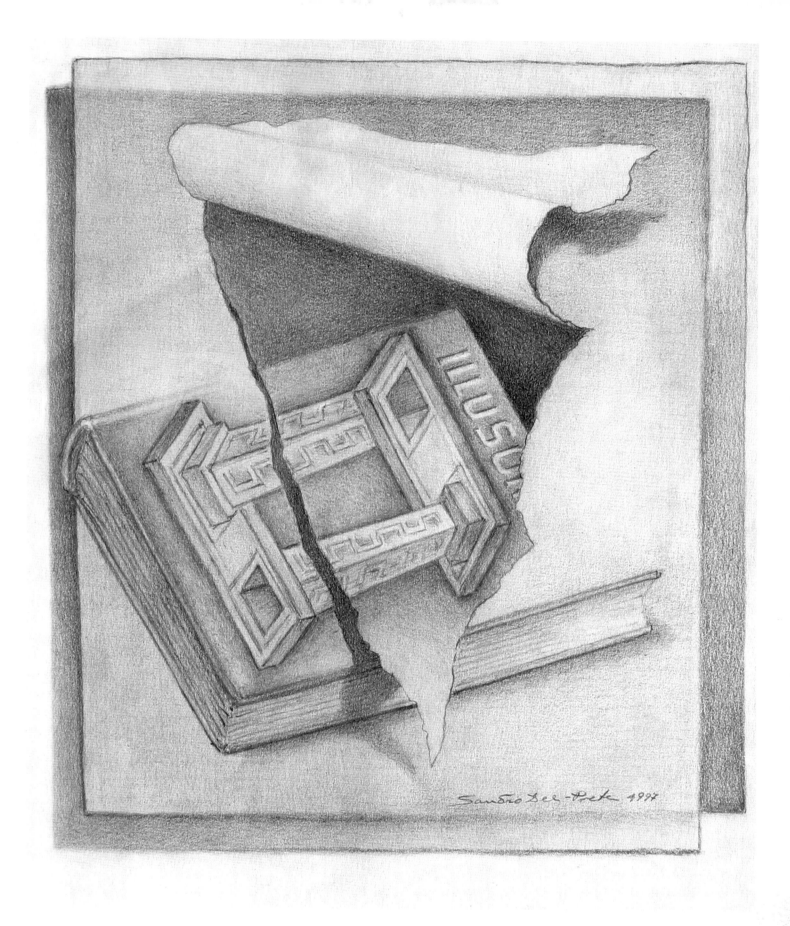

Safety Attempt

This illustration symbolizes the decay of material items. It is the memory of those things that survive through our representations.

Material things are transitory—perishable, as demonstrated in the first image, which depicts the head of a woman. If you look closely, you will see that her head is shaped by the outline of a knight and a woman. They both reach out to each other because they wish to remain together. The decay is represented by cracks that will eventually cause the different pieces to fall apart. They do not, of course, drift apart in the second dimension but in the third, which appears in the lowermost image.

Although the knight is in the background and the woman is sitting in the foreground, the original image of the woman's head is still visible. As in daily life, when material things decay, the spirit of a person continues to exist; it is still present.

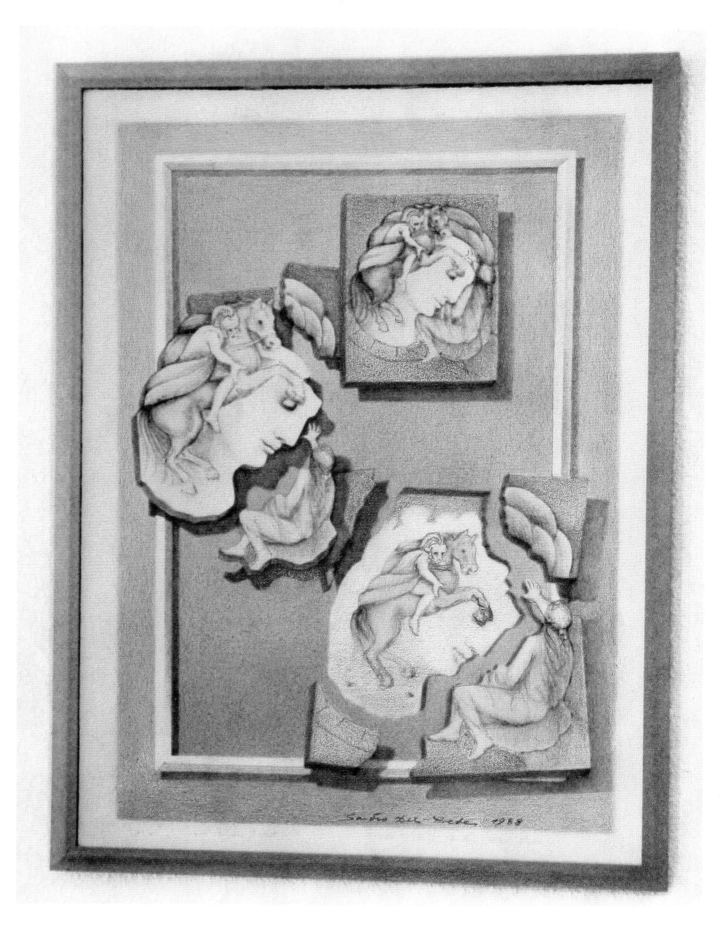

Quaint Images and Stories from the *Illusoria-Land* Collection

Actually, all illusorisms could be named curiosities. The German adjective *kurios* comes from the Latin word *curiosus,* meaning inquiring carefully and inquisitively. In German, to say that something is *kurios* or *curious* means that it is quaint, unfamiliar, odd, or weird. In the French language, the word *curiosité* can be used in the tourist trade to indicate features of particular interest to a visitor. All the aforementioned apply to the images in this book. In this section (pages 198 to 207), some illustrations will depict specific curiosities, sometimes related to an unusual story or one possessing strange qualities.

Klein's Bottle Trap

Our little devil, dependent on the material laws of the physical world, falls in love with a beautiful angel in a bottle. He dreams of joining her there, so seeing his chance, he slithers under the base and into the bottle. Once there, the fallen creature realizes that there is still a wall of glass between him and his angel. Since the luminous being has no wish whatsoever to meet with the devil, she takes a step back and exits the bottle. For a heavenly dweller, glass is no obstacle. The devil, however, now finds himself trapped in the bottle.

The German mathematician Felix Klein (1849–1925) invented a bottle that has only an outside but no inside.

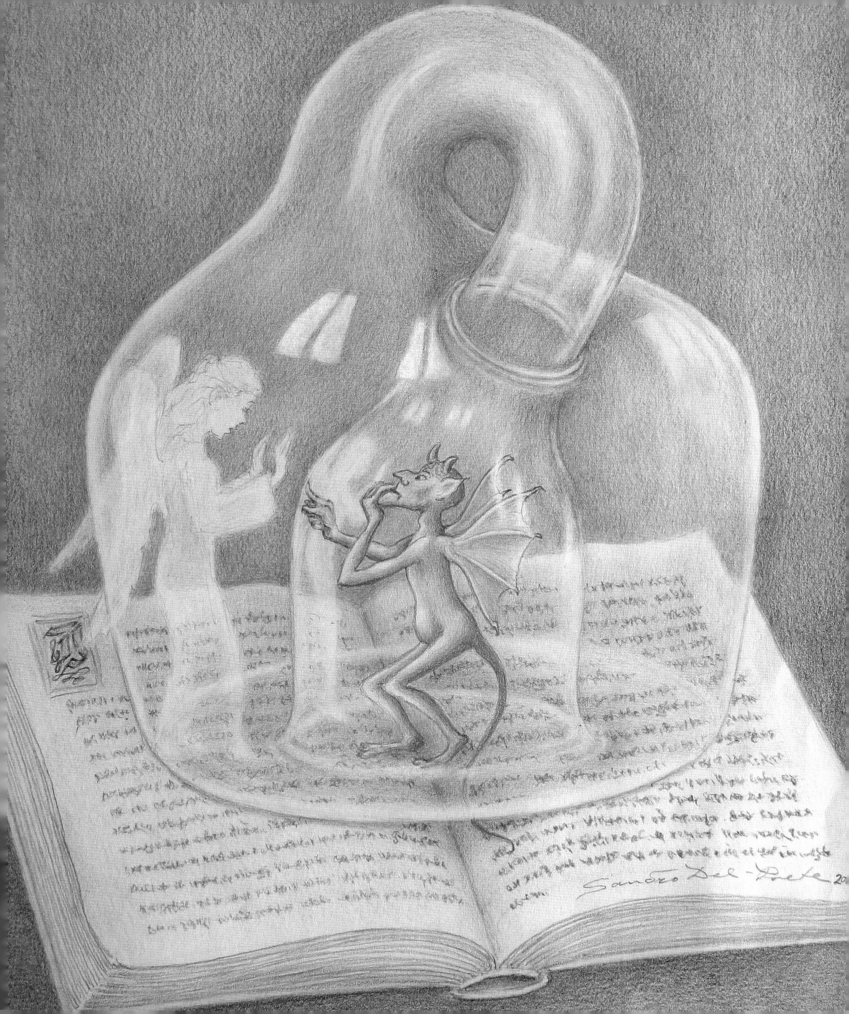

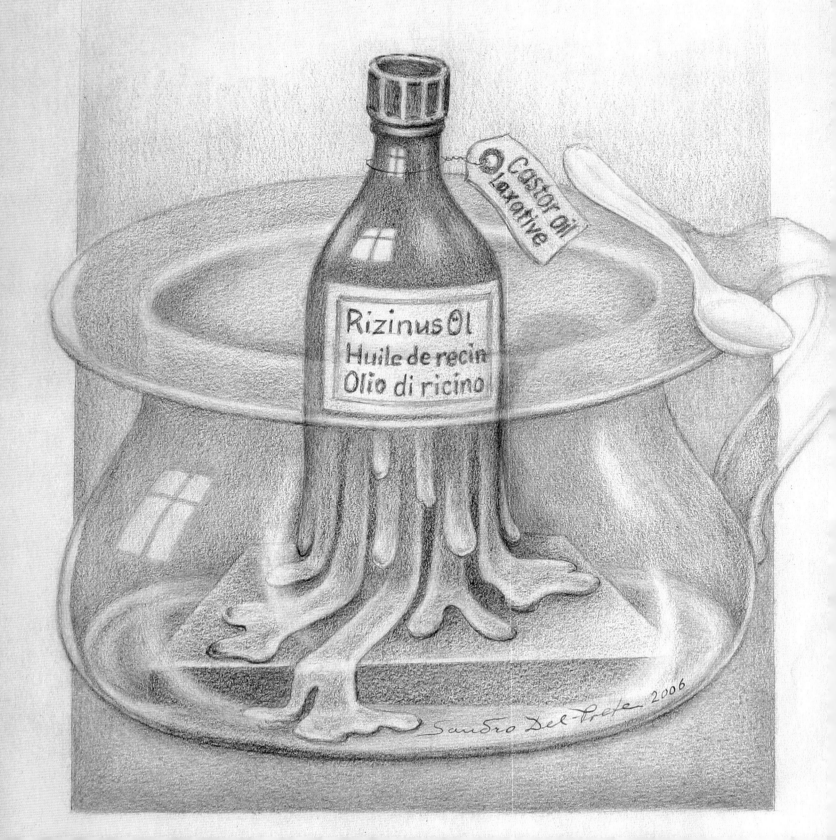

THE BOTTLE WITH A "LIQUIDITY PROBLEM"

During my youth, my family often spent the summer holidays with my aunt and grandmother in the canton of Ticino, in the Italian part of Switzerland. As on any farm, there was always a lot of work to be done, turning my summer holidays into a virtual summer work camp. Various tasks were assigned upon our arrival, so that work began forthwith.

On sunny days, it was harder for me to turn the hay than to go for a refreshing swim at the nearby lake. To be excused from my daily chores, I complained that I was not feeling well and that I was plagued with recurring tummy aches. Back then, people relied more on nature's remedies than on modern medicines to relieve common ailments. "No problem," my aunt said, quickly coming to the rescue. "I've got something that'll chase those tummy aches right back to the city. Go to bed now, and I'll bring you something that'll make you feel better in no time!"

So I obeyed and trudged on up to my room. She came upstairs, armed with a mysterious bottle, a spoon, and a piece of chocolate. At first, she only showed me the chocolate, taunting me with the likelihood of a delicious treat: "You'll get this if you're a good boy; now, open your mouth and swallow what's in the spoon." To be on the safe side I inquired, "What's in the spoon, Auntie?" She replied, "It's called castor oil: a wonder remedy for everything, but it doesn't smell too good. So pinch your nose and swallow it down quickly." I swallowed the spoonful of oil, but that disgusting stuff stuck to the roof of my mouth for the longest time, and even the chocolate could not appease the nausea that overcame me. My aunt smiled lovingly, covered me with the blanket, and showed sympathy upon seeing my contorted expression. On her way out, she showed me the cutest little glass chamber pot, mentioning that I would surely need it within the next few hours. I whined, "A chamber pot? I'm not a baby!" and gasped for breath. "I know," she replied, "but you probably won't have time to go downstairs to the toilet. You'll be in a hurry, you'll see!"

I won't describe all the feelings that overwhelmed me during the next few hours, except to say that it felt like all the devils of purgatory were in my intestines and that the apocalypse wasn't far behind. Now I really did have a tummy problem, and what was worse: I was no longer master of the situation. Angrily, I stared at the bottle. I reasoned that the remainder of its contents was going to end up in the chamber pot anyway, so why take the tortuous route through my intestines? Why not simply send it there directly? No sooner had the thought crossed my mind than it became a fact! I emptied what remained of the contents into the chamber pot and placed the now empty bottle among the night crockery. Later, when my worried aunt looked in on me, she saw the terrible mess . . . but before she could say anything, I explained, "You see Auntie, even the bottle couldn't hold back this horrible poison. It also needed the pot . . ."

The Matterhorn

Dear Mr. Walt Disney,

The other day, I had a really crazy idea: to steal the famous Mount Matterhorn and to send it to you at Disneyworld. I tried to disguise it with glacier glasses so that people would think it was some kind of crazy Disney chicken, but then I learned that you already have a plastic reproduction of the famous peak in your parks, so I put it back!

With best wishes from Switzerland,
Sandro Del-Prete

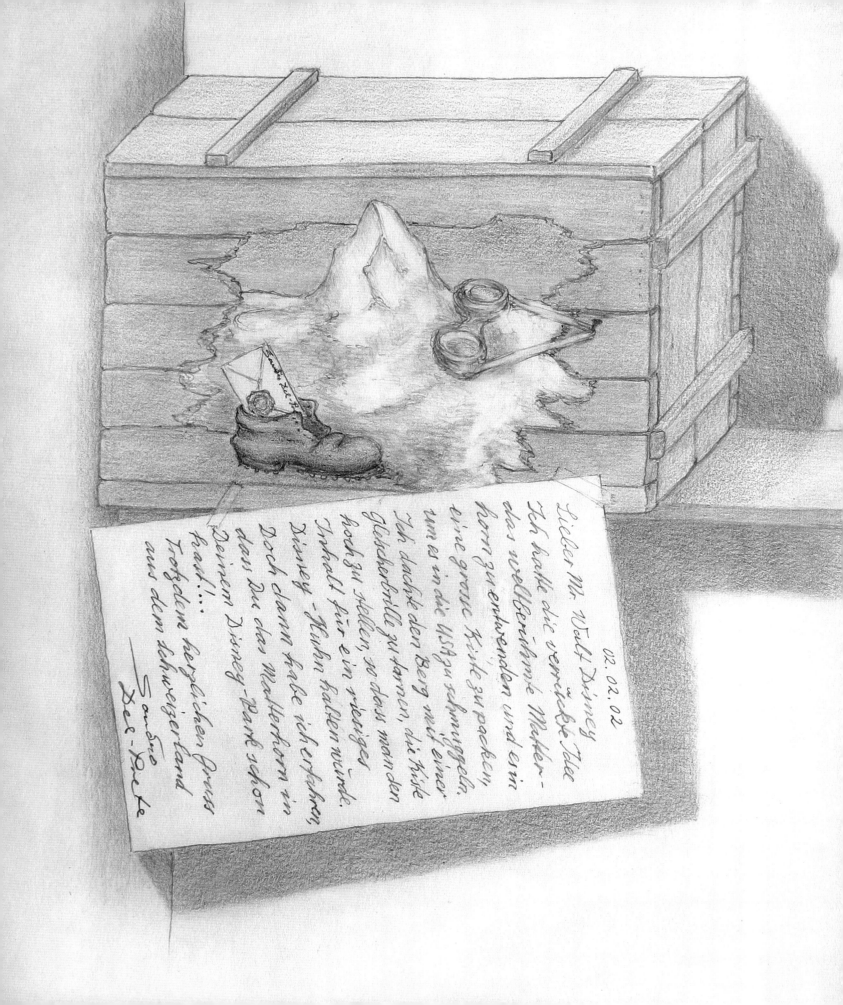

. . . To Maintain Her Virginity

In Switzerland, there is a famous mountain called the Jungfrau, meaning "the Virgin." The name of the mountain inspired me to draw this illustration.

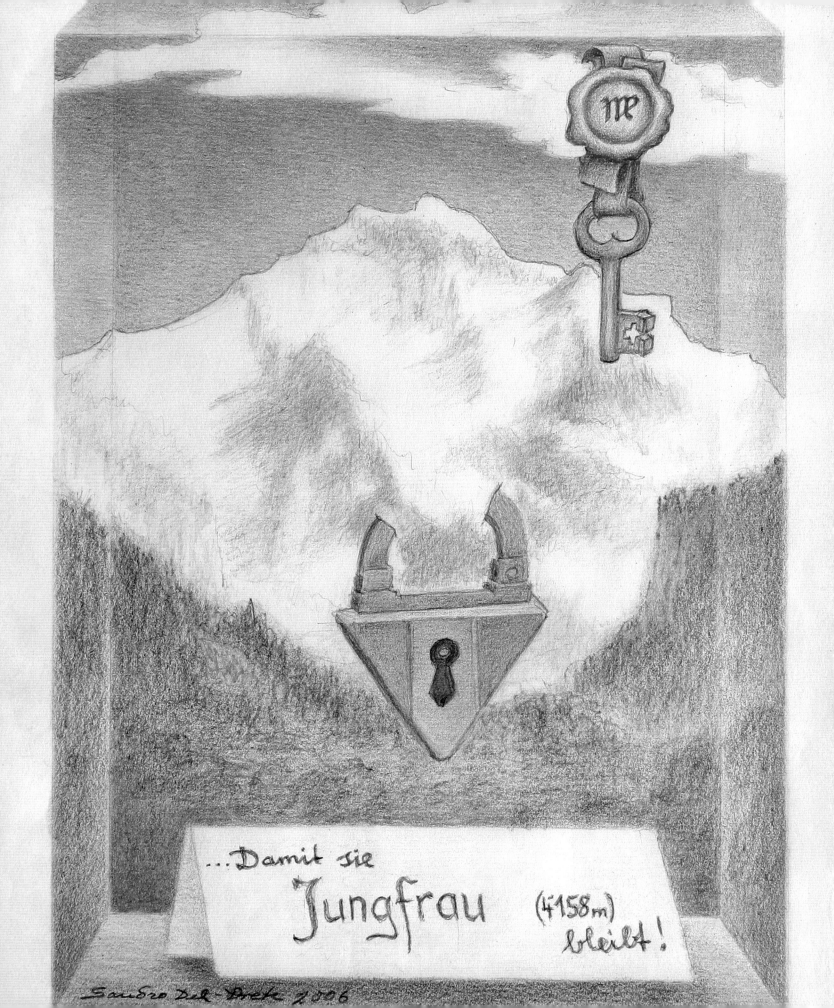

The Efficient Baby Milk Funnel

This particularly witty funnel could have been invented at the end of the nineteenth century, at a time when people still believed in large families.

The corresponding advertisement in the papers would probably have looked something like this:

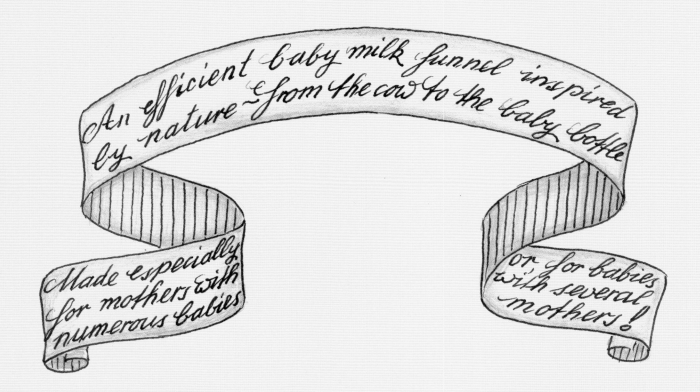

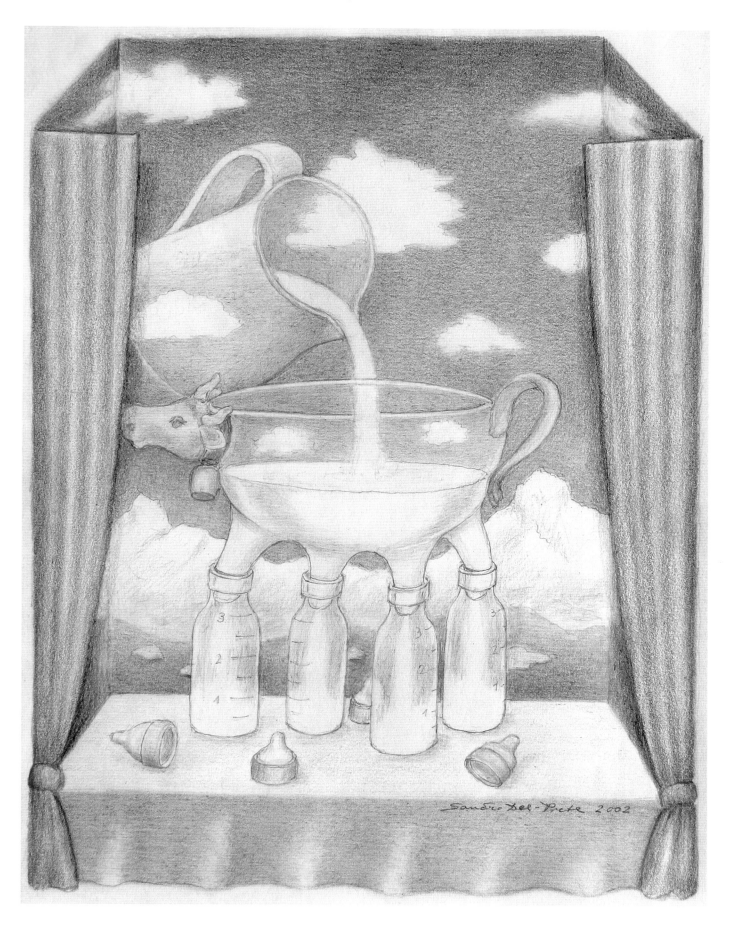

Three Essays—The Ever-Flowing Wine or Water

It is always a challenge for inventors or "brilliant minds" to study unsolved perpetual motion problems (in Latin, *perpetuum mobile*), or just to fiddle around with this concept. It is in playing around with this very notion that my idol and mentor, M. C. Escher, created *Waterfall* with the help of the now famous impossible triangle.

I was also tempted by this challenge, and tried to solve it in three different ways (pages 208 to 213).

First Attempt: In Vino Veritas

The wine is flowing! Is this possible, or not?

This was nothing less than an attempt to outwit the physical laws of nature with the inexorable logic of gravity. Many have tried to create a perpetual motion machine, but until now, with little or no success. The inventor of this one, however, believed that wine would flow from the bottle forever, without the assistance of any external source of energy.

The funnel to the right contains a greater quantity of wine than does the stem, on the left. The inventor surmised that the weight of the wine in the funnel would push the volume of wine on the left into the bottle, in proportion to the difference in weight of both sides. Once in the bottle, the wine would simply replace the fluid that was flowing out, and the cycle would repeat itself indefinitely.

Physical laws, however, do not always obey an inventor's logic. In this case, it is not the amount of wine in the funnel but the height of the funnel that is important. The funnel will fill to its rim; the excess wine will flow over it and be lost. The level of the wine in the bottle will sink to the level of the funnel's rim, and it will finally cease to flow.

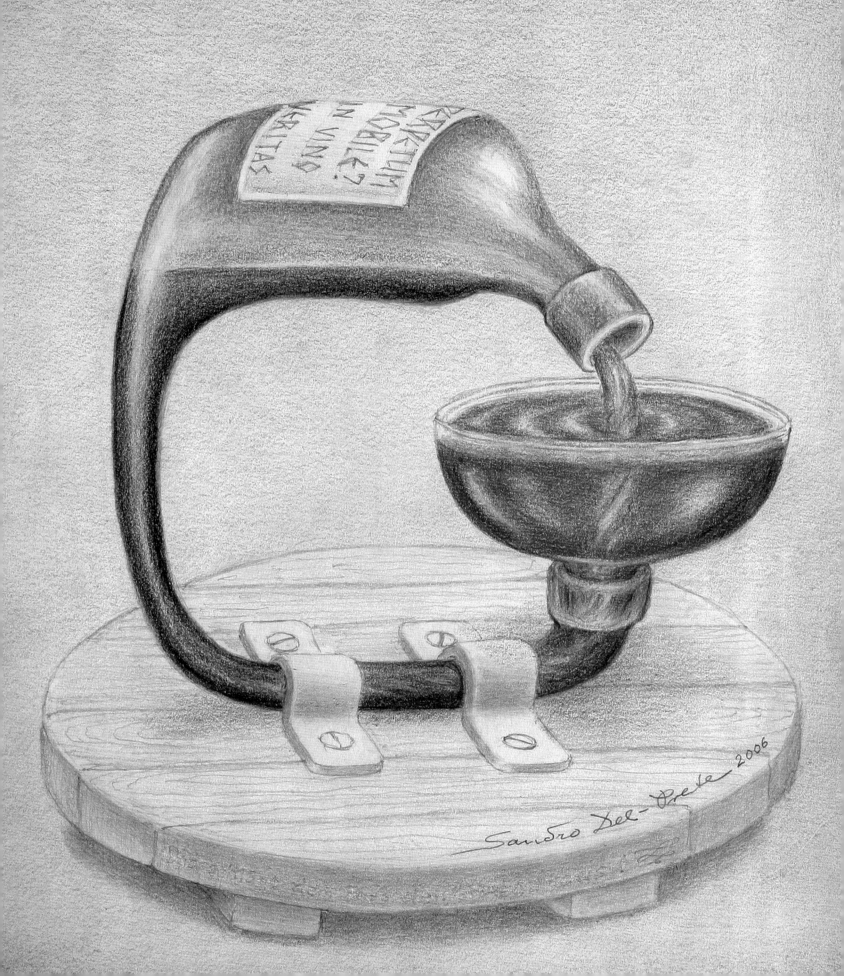

Sandro Del-Prete 2006

Second Attempt: The Water Stairs

The challenge: to illustrate, with the help of an impossible object, the illusion of perpetually flowing water.

Translation of text in the image: Is it possible to recover drained water that has escaped through the cracks?

This is an homage to M. C. Escher and Bruno Ernst.

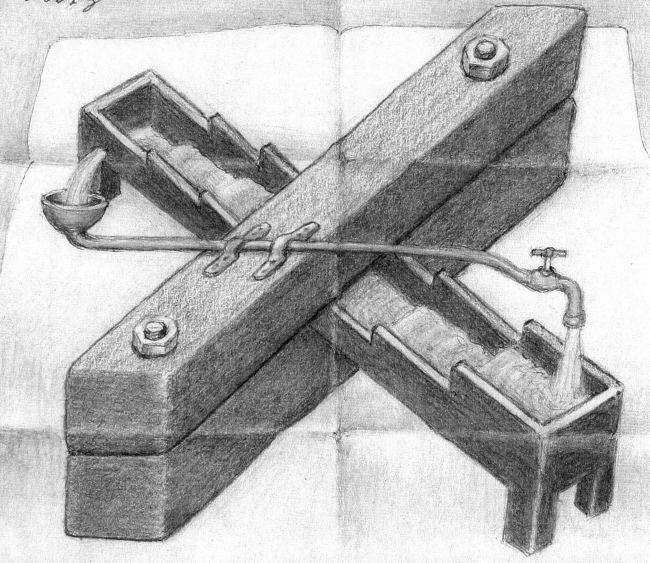

Kann man vorbeigeflossenes und durch
Ritzen versickertes Wasser zurück gewinnen?

Hommage an M.C. Escher
und Bruno Ernst

Sandro Del-Prete 2006

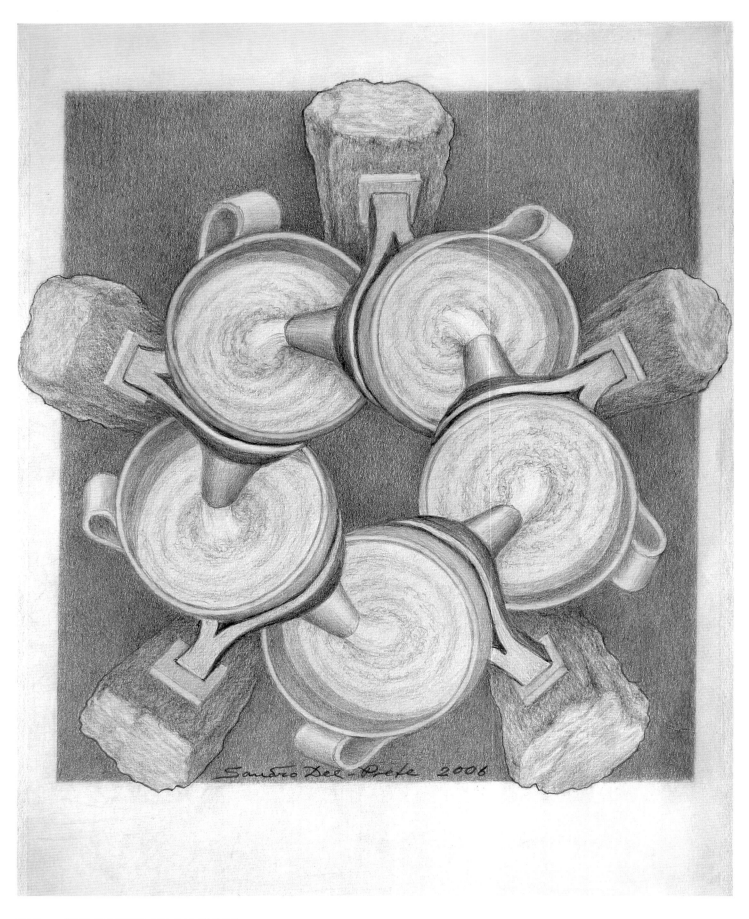

Third Attempt: The Perpetual Flow of the Five-Funnel Fountain

Because of the central perspective, the actual height of the funnel cannot be judged correctly but is "interpreted" according to the overlapping funnels. This creates the illusion that the next funnel is progressively lower.

Impossible Inventions and Stories

Some people say that I am obsessed with a blooming imagination—and who knows, they might be right! Sometimes, they might even be tempted to qualify my fantasy as "absurd." I would like to present some of these ideas in words and images, even if this exercise is intended only to amuse you and to dismiss the notion of absurdity (pages 214 to 221).

The Paradoxical Botanical Box

Nothing is impossible, thanks to the impossible zipper. The invention of the zipper made it possible to show the advantages of the newest botanical box. This box was advertised as having waterproofed and integrated mountain shoes with flippers, which are considered to be practical, since they do not need to be removed before diving into a mountain lake after a long walk.

The botanical box is very practical for collecting various types of mountain vegetation and water plants, as well as small animals, insects, live fish, birds, butterflies, plants, and lizards. Owing to an integrated bubble-shaped glass dome that helps control internal moisture, they have a great survival rate. The inventor claims that every possible contingency has been thought through.

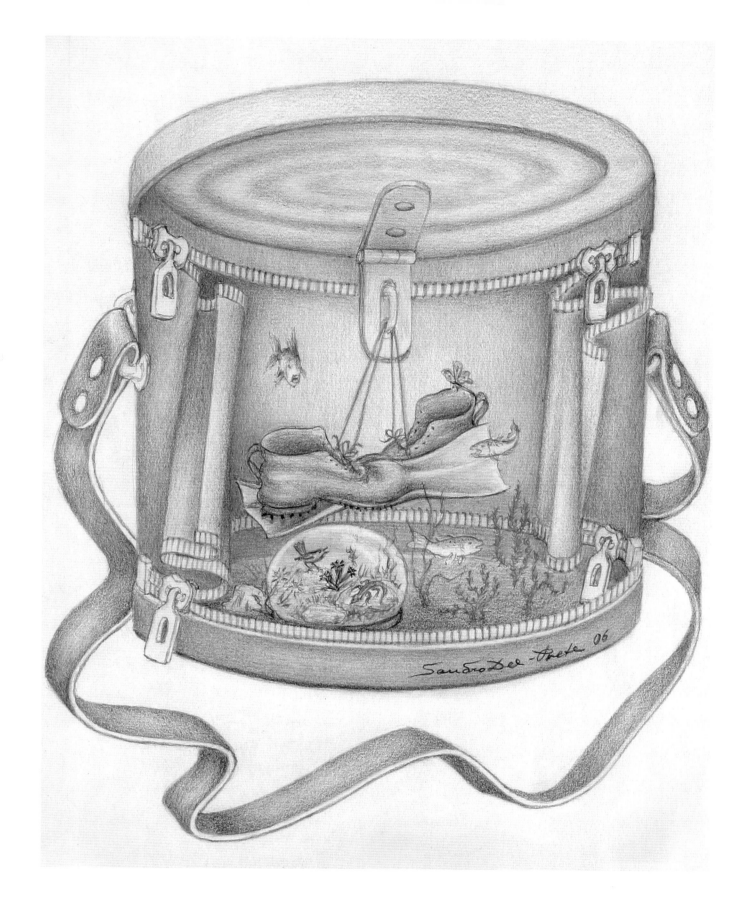

THE ART OF THE DRUNKEN WINEGLASS

The drunken wineglass has turned into an artist, with the wine as the paint. If one looks closely, the drunken wineglass has painted a woman.

Although it seems absurd, art remains art. It is not derived from knowledge—at least, this is one school of thought (pardon the pun). Thus, art can be created by anyone!

"I can do something others can't, but I'm not sure that I'd call it exactly . . . art," reasoned the drunken wineglass, referring to the image of a woman with a wineglass in hand lying before him. She did not materialize out of thin air, of course. She was created through clever design; but that is probably why it would not be called Real Art.

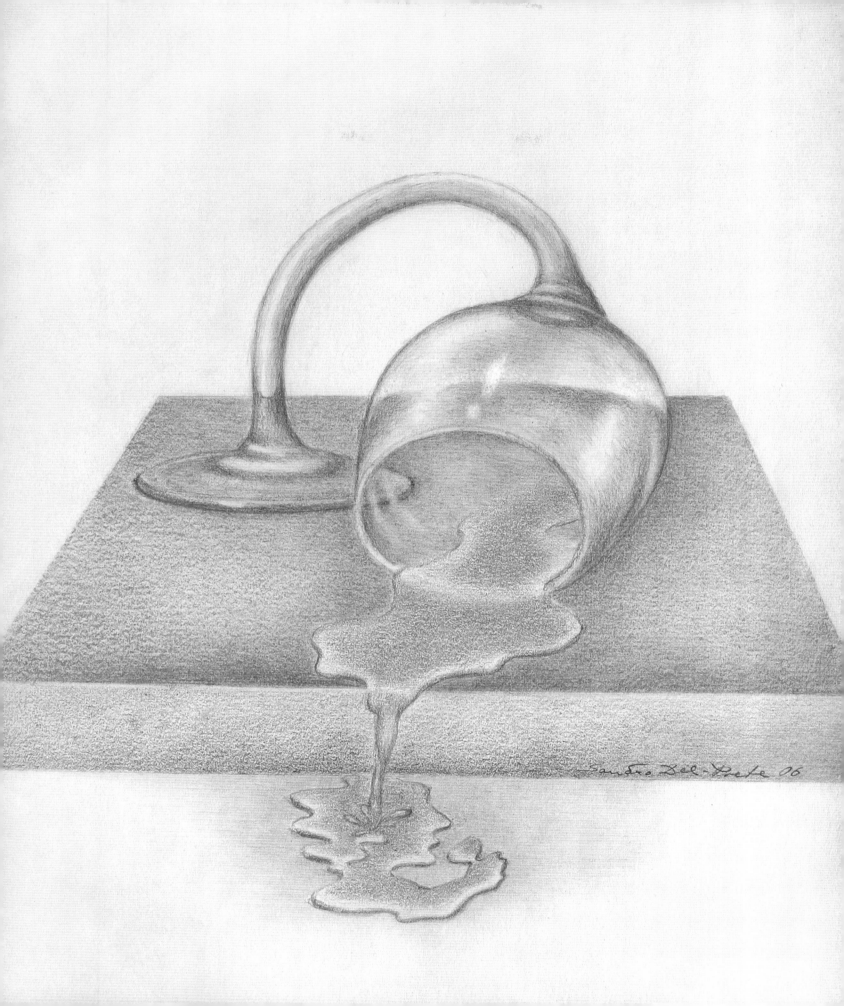

THE DRUNKEN WINEGLASS IN LOVE

Illusions do not end in the optical world but often persist through oral and written language. Optical images, like music, are universally understood. Sadly, the same cannot be said of the written and spoken word, which, in response to common and widespread linguistic diversity, requires a process of translation to relay a precise meaning. The designs on the opposite page have both optical and linguistic meaning; this time, however, the double-meaning is lost in translation. Please then, consider the following simple language lesson, to help you better appreciate this illusion:

Frucht = fruit

beFRUCHTen = fructify; in the text below, it means to drop some fruit into the glass. The real meaning, in English, is: to become productive or fruitful, or to bear fruit

Wein = wine

beWEINen = weep; in the text below, it means to pour wine into the glass. The real meaning, in English, is: to weep, or to cry

The Love Story of the Drunken Wineglass

The dipper in the punch bowl has seen many parties and is a master in the art of seduction. This time, he was smitten by a seductively transparent drinking glass, shaped like a tulip. He tried to seduce the beauty, inquiring politely if she would allow him to "bewine" her, to which she shyly nodded in reply. She simply could not resist this "Sangria." Shortly after having been "bewined," the glass began to feel the sweetness of the spirits in her head and lost control. Her leg suddenly became weak. The dipper rushed to her aid and caught her, asking the slightly inebriated glass if he could "befruit" her, or deposit some sweet pieces of fruit into the glass. She again nodded in acquiescence, having a weakness for fruit, but the "bewining" and "befruiting" had a visibly enhancing effect! Meanwhile, the glass got completely drunk and fell totally in love with the gallant dipper. In her condition, she could no longer resist and fell head first into the bowl, straight down to the bottom, to join the dipper. Tenderly she snuggles up close to her lover and allows herself, again and again, to be "befruited."

In the end, they become a couple, and unless they have since been violently separated, they are still together today, fruitfully united.

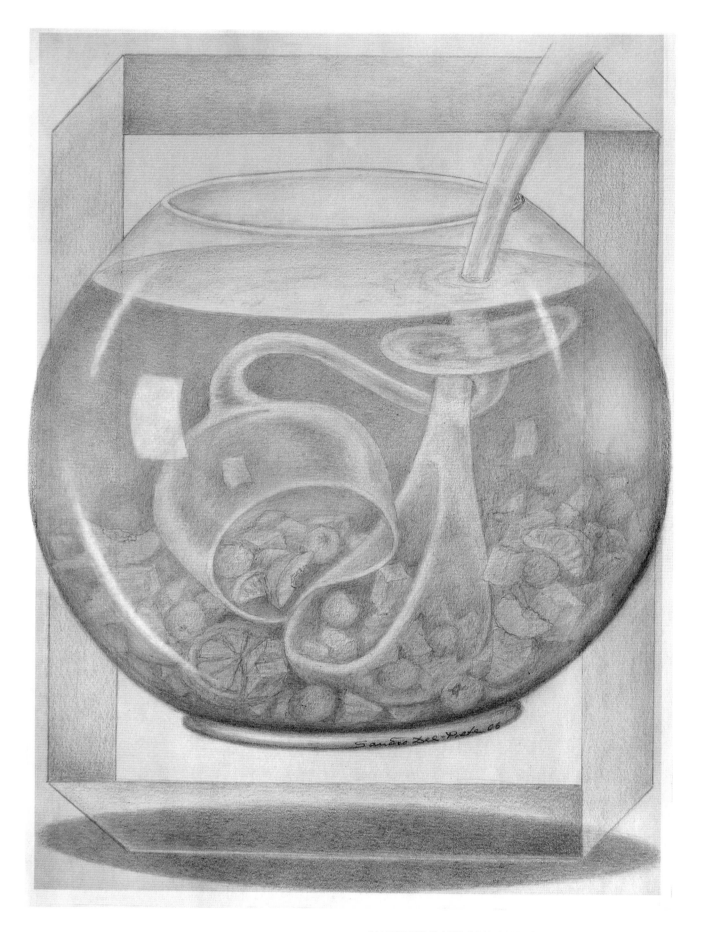

VARIOUS ILLUSORY AND SURREALISTIC IMAGES

Unknown Amphibian Species

"Ladies and Gentlemen, may I please have your attention? On a recent expedition, a group of divers discovered a completely unknown form of life. It is a new species, undoubtedly a member of the amphibian family. What you see is an illustration of a giant, newly hatched sample which is still in a metamorphic state . . ."

 "Excuse me, Mr. Curator, I think your illustration was hung upside down by mistake."

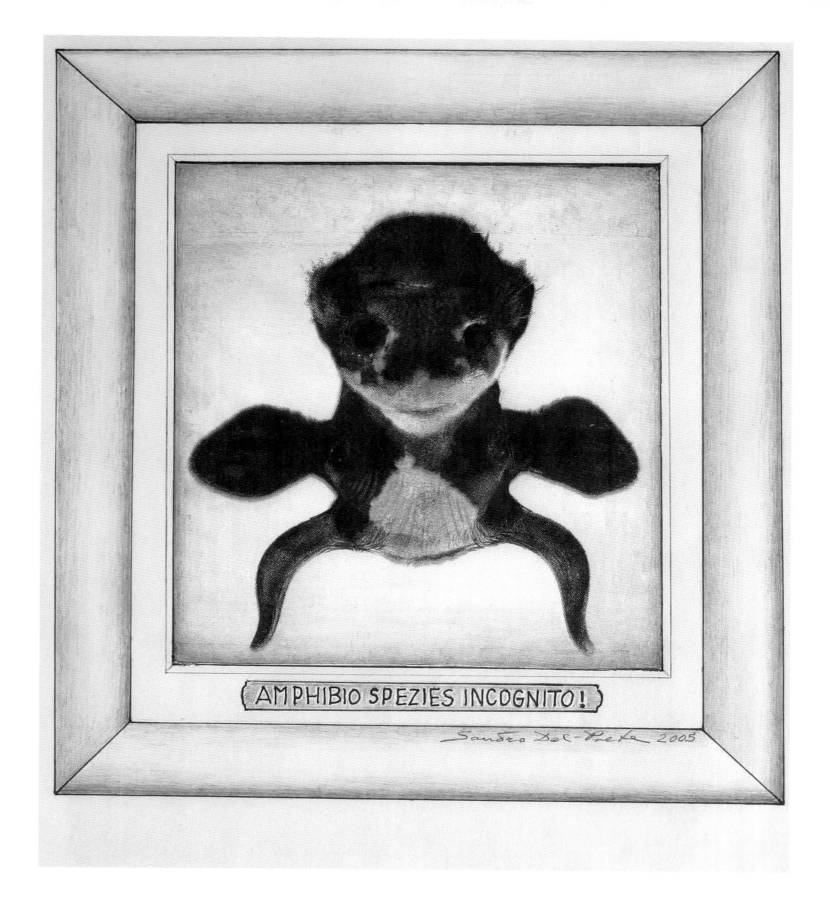

Mutated Tools—A Narrative in Eleven Chapters

The idea of representing animals and shapes with tools was already practiced in the sixteenth century by Giuseppe Arcimboldo in his famous work, *Humani Victis Instrumenta*.

Years ago, when I found some of my deceased grandfather's old farming tools, I had little or no idea of what to do with them. That is when I had the inspired notion of building a dragon to protect our house in the canton of Ticino, Switzerland. In time, other implements joined the ranks of mutated tools, and the following story was born (pages 222 to 242).

The Tool Dragon

From the series *Tools Used in a Nonconformist Way*.
 The estrangement of everyday tools
 Translation of text in the image: Don't worry! It won't bite unless you touch it!
 Before the door, a dragon
 Guards the treasures of the chest.
 Protecting mutant pieces
 Locked inside, he does his best.
 A lot of tools mutated,
 With new parts they've been joined.
 Some tools became like animals
 Converted, and rejoined!

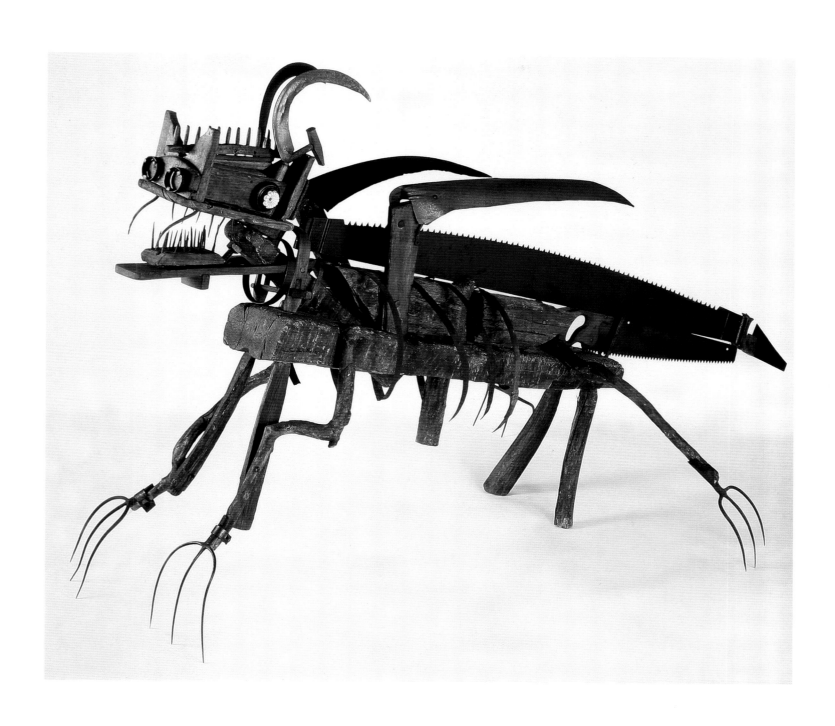

The Woodpecker Hammer

It certainly seemed an original idea to affix the hammer like a woodpecker to the bark, atop a wall of wood. The hammer lies ready to be used and cannot be misplaced. It is decorative and always nearby in case of need. . . . But how can I use the hammer if it is nailed to the wall? No problem! I have a solution.

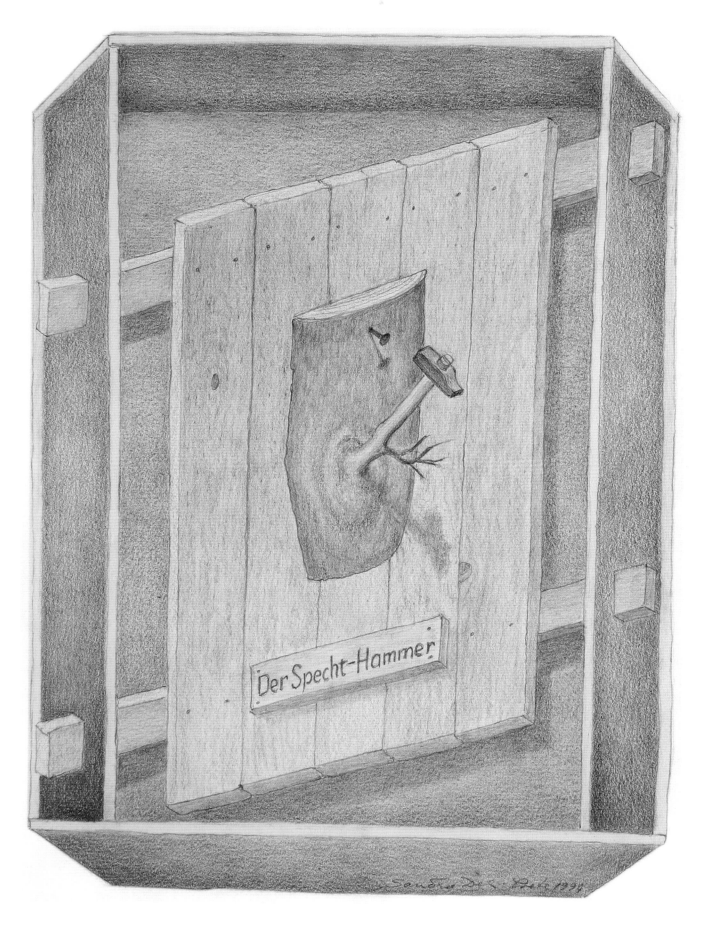

The Self-Biting Pliers

The problem here is self-explanatory, but before I can use the pliers to free the hammer in the previous picture, the jaws need to be loosened up a bit. Perhaps one of the handles could be straightened with the Exhausted, Adjustable Monkey Wrench on the next spread?

The Exhausted, Adjustable Monkey Wrench

Of course, this tool might need a bit of oil—castor oil, perhaps? I will simply have to remove the wrench from the body. I will need a Screwdriver to help me free the Monkey Wrench.

The Screwdriver

Ah, here is my favorite Screwdriver. Good man! Ok, that is all well and fine, but I still need to remove the nail that holds the hammer to the wall! Hmmm, the Woodpecker Hammer might be cute, but it seems a bit impractical. It seems that, to solve this problem, I will need my "Circular" Saw. . . .

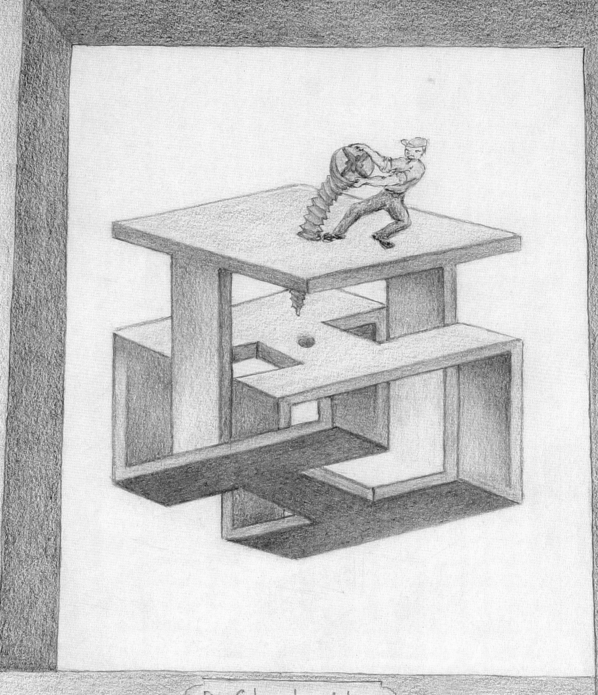

· Der Schraubenzieher ·

Sandro Del-Prete 1995

The "Circular" Saw

This flexible "Circular" Saw is easy to place around the hammer's handle, which happens to have sprouted from a tree trunk. A few good to's and fro's, and the handle will be separated from the tree. There is still another little problem to deal with, however: the small branch has to be removed as well. The easiest way to do so is with my trusty Metal Shears, Ready for Takeoff. . . .

The Metal Shears Ready for Takeoff

Done! The Woodpecker Hammer has been freed and is ready to use! Oh no, the head is a bit loose! Well, fortunately there is a slot in the handle to tighten the head to the neck. Wait a minute, there is nothing with which to hammer in the wedge. Well, no problem! A good craftsman always has a solution. I can always use the other wrench . . . The Adjustable Wrench That Is Ready for a Bullfight, and convert it. . . .

Sandro Del-Prete 1993

THE ADJUSTABLE WRENCH THAT IS READY FOR A BULLFIGHT

The bull's mouth can act like a hammer. The wedge is in, and the real hammer works wonderfully! There is nothing like having everything you need within reach. Now, that is the way to avoid problems! You see, time saved is time gained, and time gained can be spent to treat myself to a glass (not the drunken one) of wine. That means that it is time for . . . The Corkscrew.

The Corkscrew

Here we are . . . to celebrate the day.

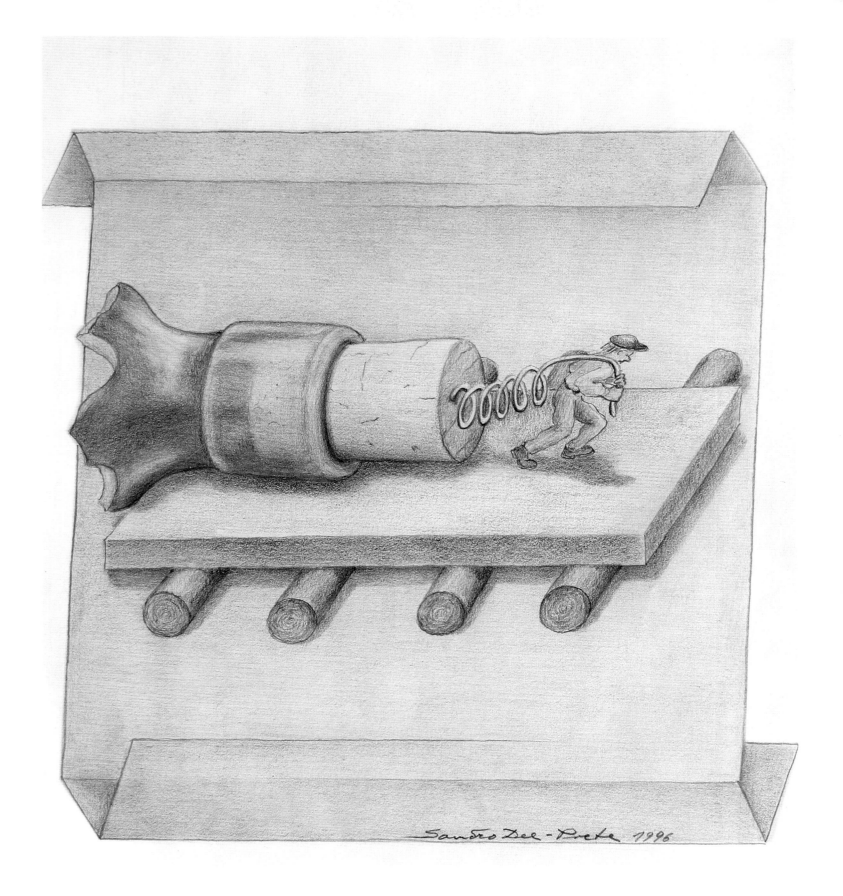

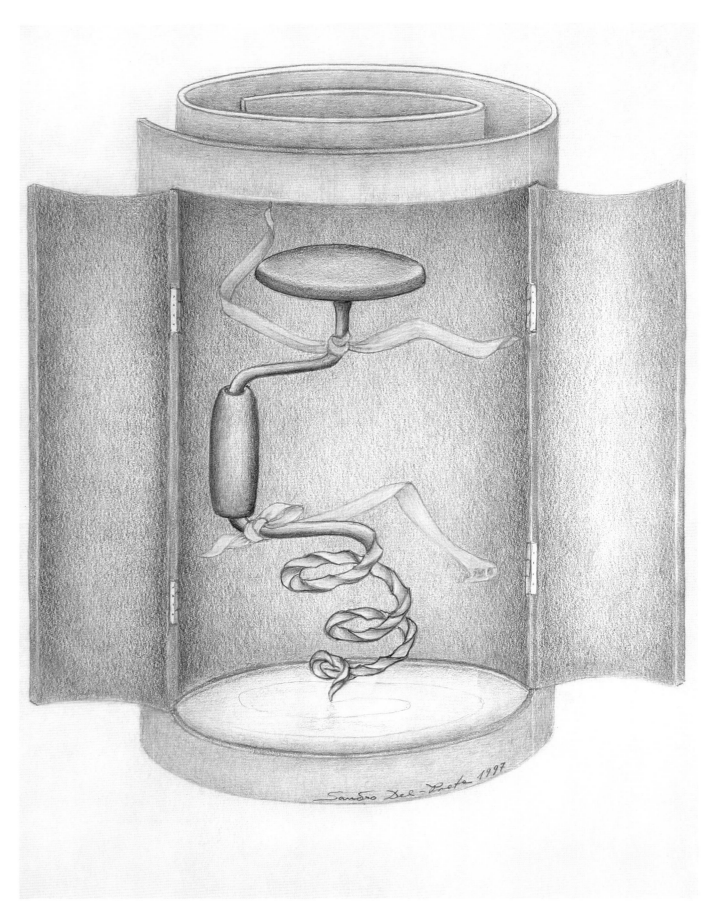

The Pirouette Brace (opposite)

The Pirouette Brace begins to dance! Everybody is happy; everyone, that is, except . . .

The Mute Parrot Rib Joint Pliers (next page)

. . . the Mute Parrot Rib Joint Pliers, which are pouting in the corner, refusing to talk because they were left unused. Oh well, maybe next time!

Now, what did I want to use that hammer for in the first place? Oh, never mind. That Woodpecker Hammer needs to go back where it belongs—everything in its proper place! It just saves everyone a lot of trouble and aggravation!

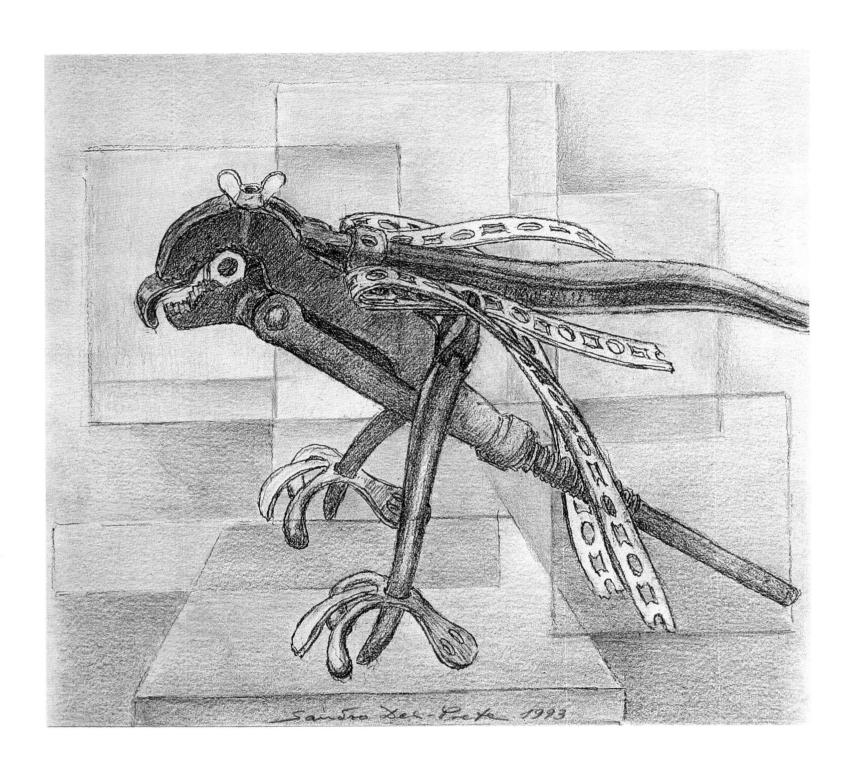

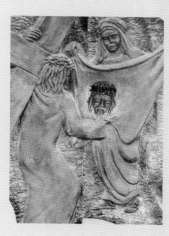

SACRED ART

During my studies in Florence, Italy, I was very inspired by sacred art in churches and museums. It was as much by the mysticism of the Old Masters as by their painting and sculpture techniques that I was fascinated.

Barely arrived in Bern, I plunged into my initial period of production and created *Inocencia*. I painted it in the classical style. The inquisitive face of childhood, typifying innocence, projects from the somber background. The child's face becomes the focal point for the observer.

In addition to drawing and painting, I began to produce wooden sculptures. Here also, the influence of the Old Masters can be felt. The *Madonna With Child*, depicted in seventeenth-century style, seeks to radiate peace, calmness, and humility.

Even during this period, illusorisms played a dominant role in combination with sacred themes. The illustration of Jesus' head, adorned with his crown of thorns, came straight from the description in the *Gospel of Matthew*. I needed only to apply a greater or lesser pressure on my pencil to achieve it.

On *The Way of the Cross* of Astano, the techniques of optical deception were used in three reliefs to lend a deeper meaning to the traditional Stations of the Cross.

Inocencia

This is an oil on canvas, 22 × 26 inches (56 × 67 cm), 1965.

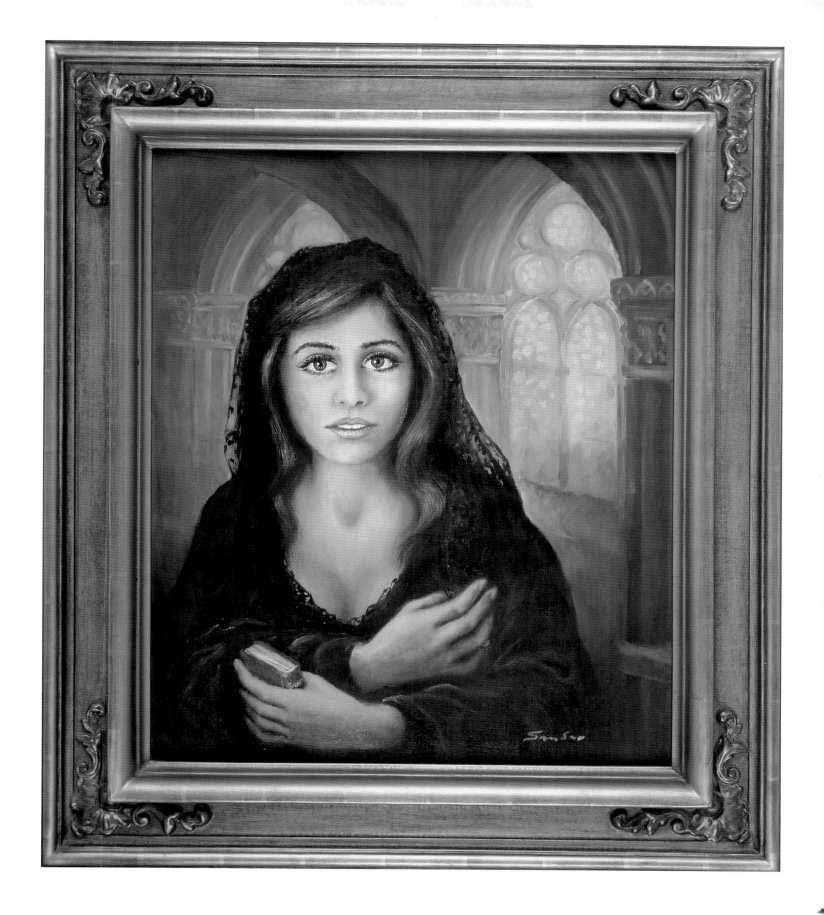

The Forsaken Paradise

This image depicts the Tree of Life and the Tree of Enlightenment or Knowledge. Adam and Eve are immortalized on the monument. Eve is on the front, while Adam is on its opposite face, standing reflected in the silver picture frame: that is why the inscription is inverted. The snake which seduced them is portrayed in the form of the river, its head to the right, with both an open mouth and a split tongue.

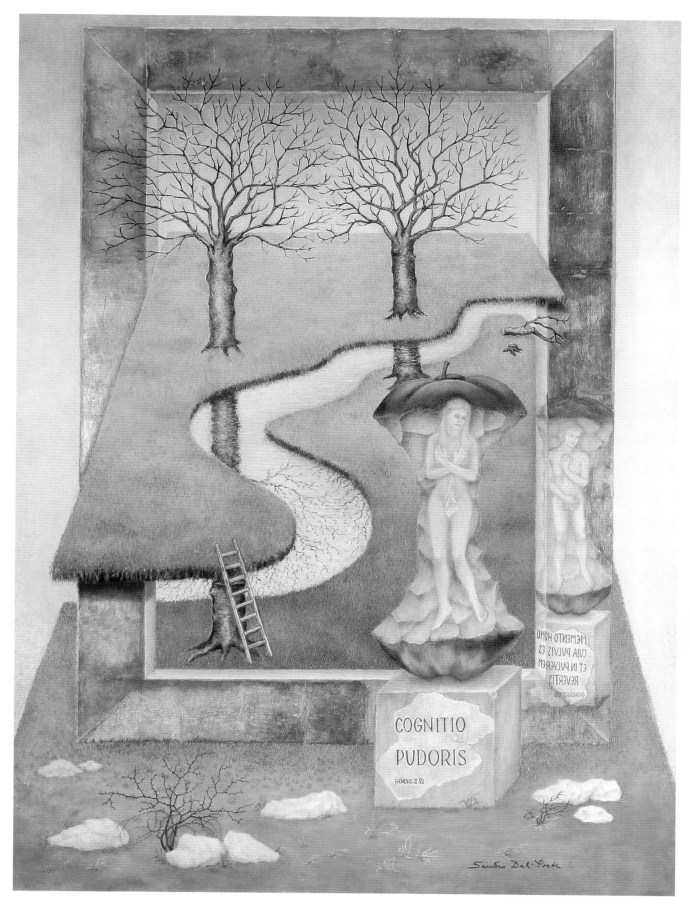

Hands and What They Can Do

(Top Illustration) God created plants and animals . . .

(Upper Middle Illustration) And on the sixth day, He created man; the human being, the crown of creation—in HIS image—*counterpart*.

(Lower Middle Illustration) Man's weariness from countless wars . . . after misusing the power he was given.

(Bottom Illustration) The ultimate preservation of creation through eternal peace.

Man has been given leave to do as he wishes with the power he was given. He can either use or misuse it, but he must bear the consequences of his decisions.

Statues: *Madonna with Child and Angel with Candlestick*

To carve these two statues, sweet chestnut wood was used, taken from an antique rafter in an old stable.

The Passion of Jesus Christ

The text in this image comes from the *Gospel of Matthew*, which recounts the story of the anguish of Christ's Passion. By using different degrees of pressure on the canvas with his pencil, Sandro Del-Prete re-created the suffering face of Jesus as it appears on the Turin Shroud.

Matthäus-Passion

Sandro Del Prete 1997

The Symbolic Hole in the Wall

As designed, the hole in the wall seems to suggest the outline of Jesus on the Cross.

A wall, like barbed wire, is used to restrict personal freedom. A prison is built with these same materials. A hole in the wall offers a way to break free.

This design was a draft for the bronze statue *The Way of the Cross* in Astano, sculpted at a later date (see page 256).

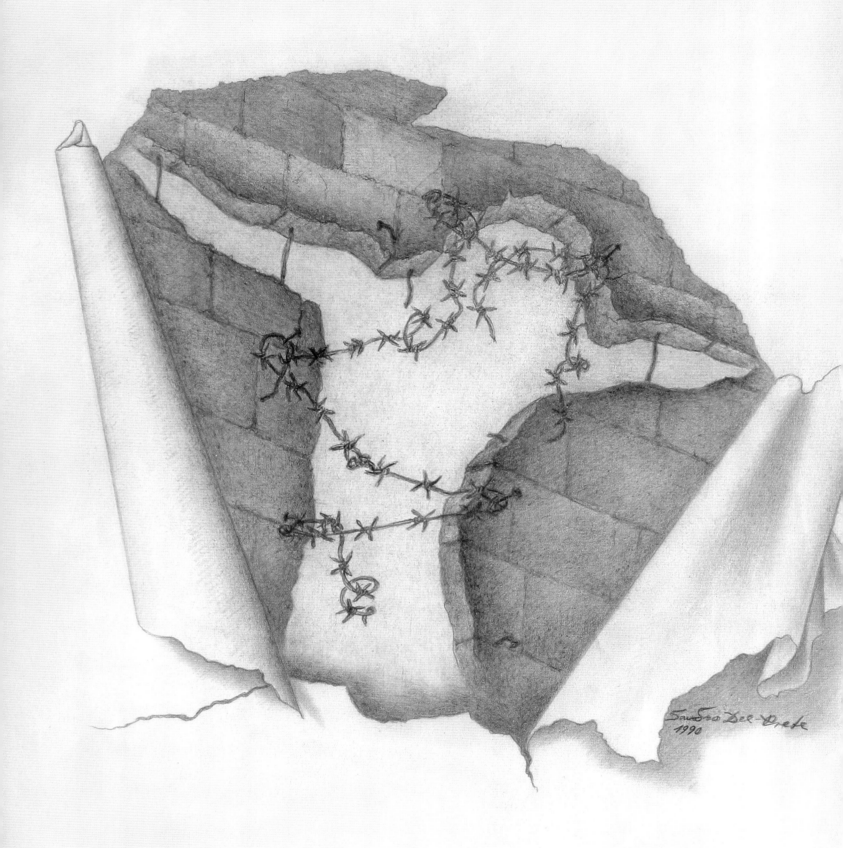

The Way of the Cross, Church of Astano, Switzerland

The images in the following pages show *The Way of the Cross* reliefs (2004) surrounding the Church of Astano in the canton of Ticino, Switzerland. The bronze reliefs, measuring approximately 28 × 20 inches (70 × 50 cm), are placed in the chapel-like buildings surrounding the church. Three of them, presented individually, have unique illusory effects, giving the whole exhibit a special symbolism.

THE FIRST THREE STATIONS OF THE CROSS

Opposite.

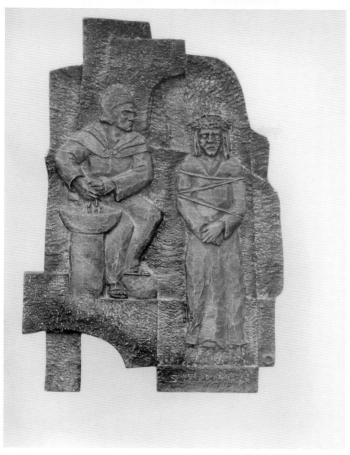

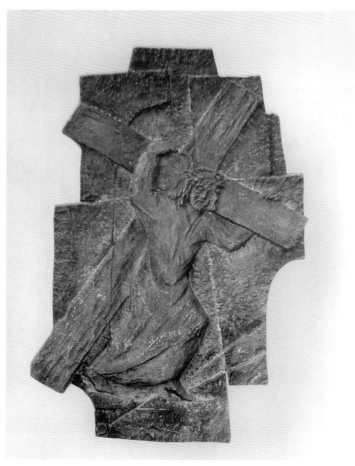

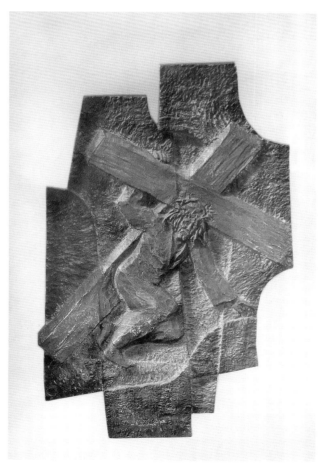

First Illusory Relief of *The Way of the Cross*

This bronze relief was created using the technique of inversion. The face of Jesus is visible on the veil held by Veronica; his face can be seen from all sides, as it were, following you on your way.

Symbolically, this means that Jesus suffered for *everyone*—those standing on his left, before him, and to his right—and that he is always *present* to everyone.

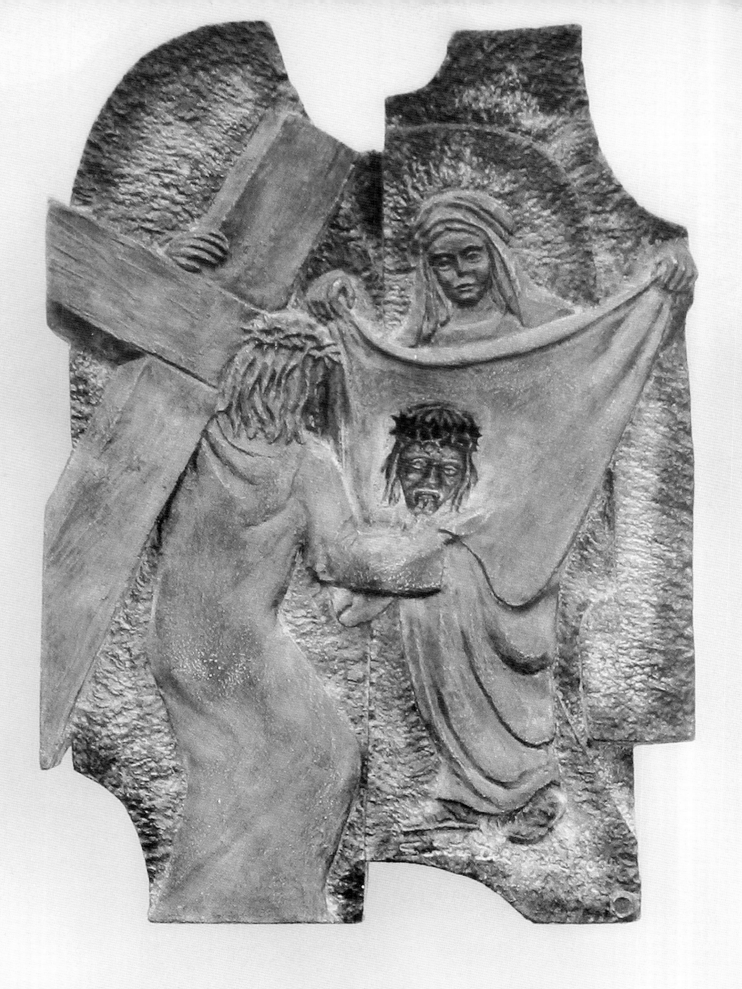

Four More Stations of the Cross

Another four bronze reliefs of *The Way of the Cross* at the Church of Astano, Switzerland.

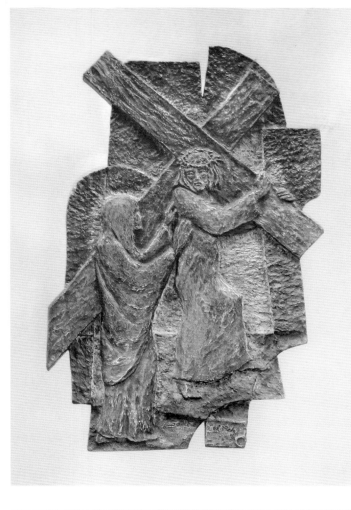 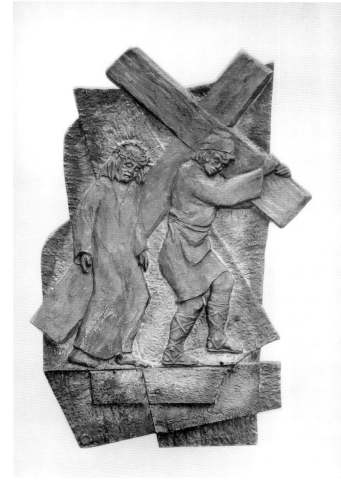

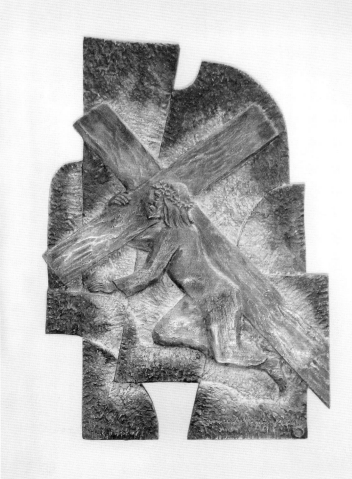 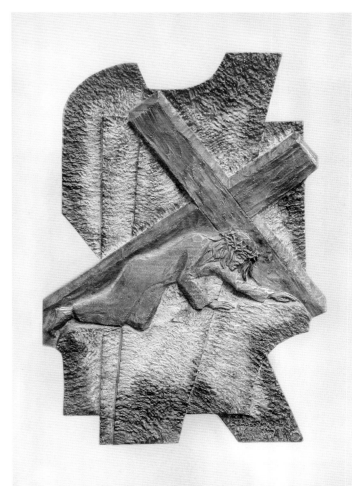

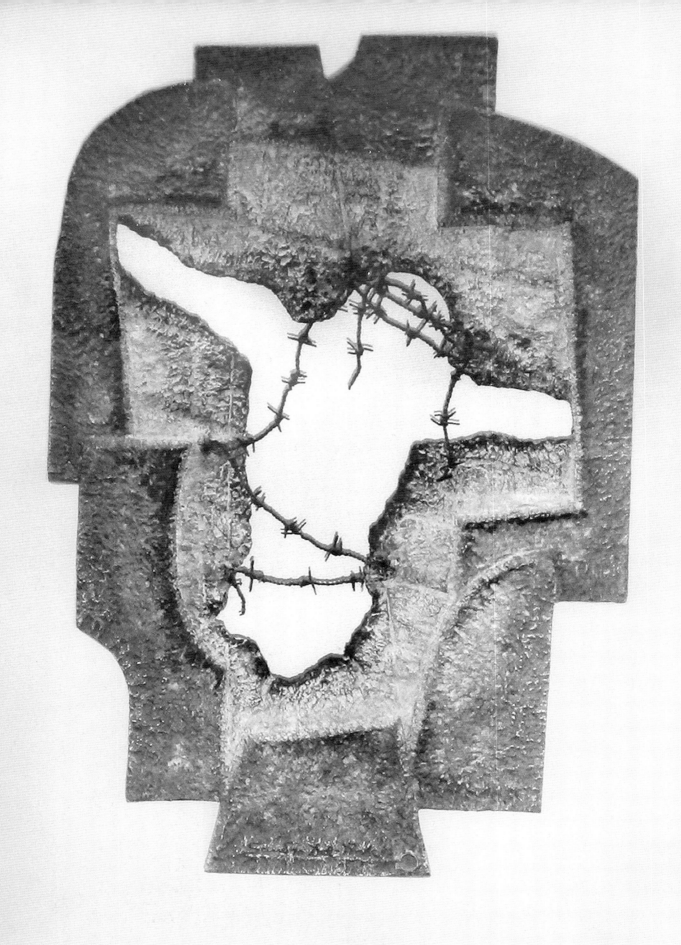

Second Illusory Relief

This bronze relief reveals to us Jesus on the Cross.

Symbolically, this image depicts the "prison of sin" in which we are all trapped. We can find redemption (i.e., break out of this prison) only through the "hole" of redemption. For this, Jesus suffered on the Cross.

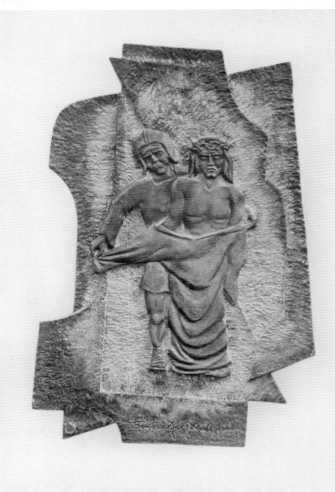

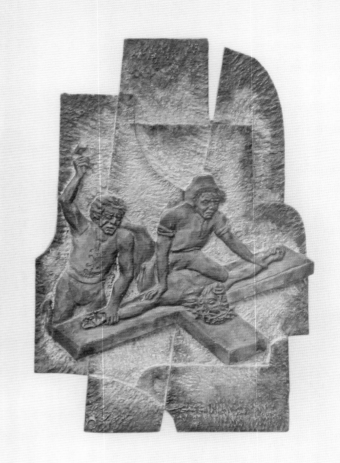

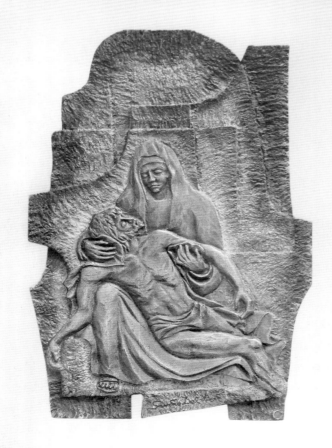

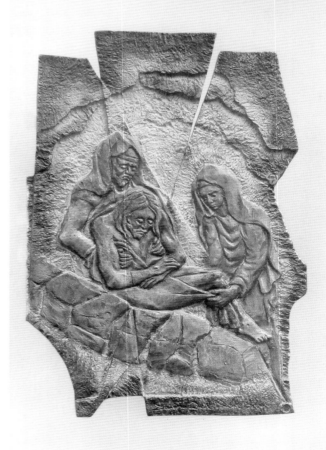

Another Four Stations of the Cross (opposite)

These four bronze reliefs represent classical views of the Stations of the Cross at the Church of Astano, Switzerland.

Third Illusory Relief: Jesus' Resurrection
(next page)

This relief is an unusual feature of *The Way of the Cross* at the Church of Astano: it represents the Resurrection, an episode not normally depicted in classical portrayals of the Stations of the Cross, although this is arguably the most important event in the Life of Christ.

If you focus on the center of the statue, which represents the Resurrection of Jesus, the closer you get, the more you can see figures of angels revolving around Him. Symbolically, this means that as long as a person concentrates on Him instead of losing himself in triviality, the angels are seen to revolve around Jesus; however, if you concentrate on the angels, they stop moving.

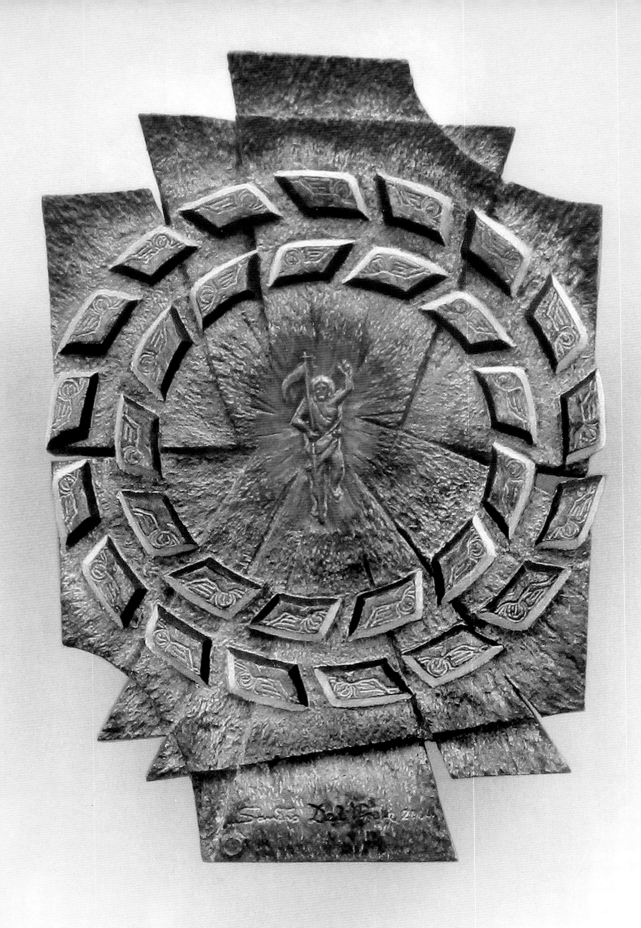

INVERSION AND EVERSION SCULPTURES AND RELIEF IMAGES

During my studies in Florence, Italy, I learned, after reading an old book, that there were statues which seemed to stare at the observer, no matter where the observer stood with respect to the sculpted figure. The technique was a well-guarded secret that only a few sculptors had ever mastered. The inversion technique was passed on from father to son, but had seemingly never been recorded in writing. A few years later, I remembered what I had read, and since I was a specialist in depicting optical illusions, I became obsessed with the idea of unlocking this mystery.

I assumed the technique had a basis in illusion since it was not possible to solve it mechanically. So I experimented and soon realized that a simple negative of a sculpture was insufficient. It was necessary to incorporate a technique of progressive reduction that could outwit our perceptions and thereby simulate movement. Combined with what is called *eversion,* where the exact opposite occurs, what one gets is a confusing chain of movement, which continues for as long as the observer progresses before the sculpture laterally, i.e., from one side to the other.

Unfortunately, this chain of movement is difficult to reproduce with any degree of fluidity on a two-dimensional plane; I have attempted to present the concept in several of the following images with photographs from different perspectives.

Professor Turnhead

Inversion sculpture made from gypsum, 69 × 27.5 inches (175 × 70 cm), 1984.

Museum of Fun, Tokyo, Japan, organized by *Asahi Shimbun*. Director: Itsuo Sakane.

Phänomena

Inversion sculpture, 1984, current location unknown.

Thanks to a complicated mathematical process that progressively calculates the reduction, it is possible to achieve these various natural changes of the face and hair without any distortion detectable by the human eye that would call attention to the optical illusion.

The base of the image in the upper left quadrant shows that the photo was made from the upper left side.

The image of the sculpture in the lower right quadrant was photographed from a central viewpoint, slightly south of center.

Mr. Nosey

Inversion statue made from gypsum, 100 × 80 inches (250 × 200 cm), 1988.

Exhibited at the Food Center in Bangkok, Thailand.

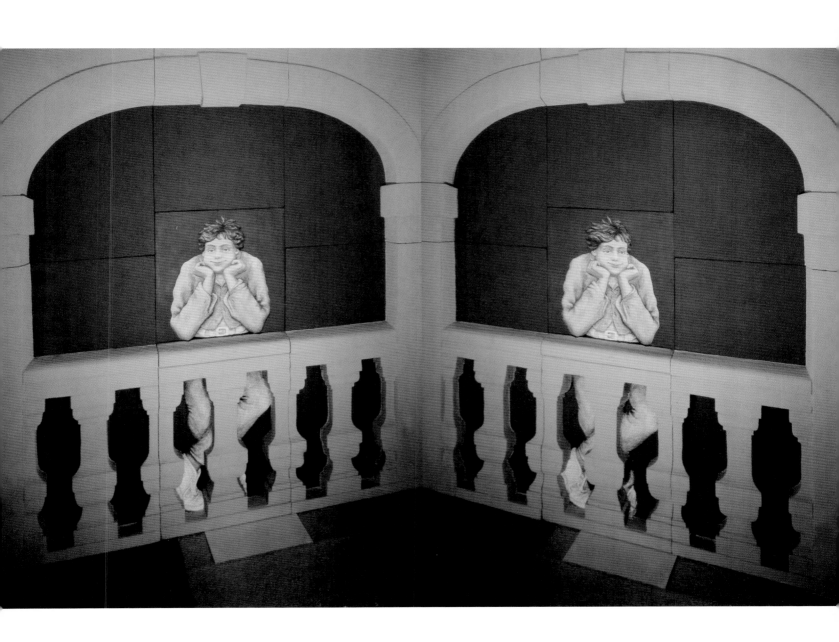

Bernese Bear (Bärner Bär)

Inversion sculpture made from gypsum, 71 × 49 inches (180 × 125 cm), 1988, at the Emch-Elevator Company in Bern, Switzerland.

When one uses the elevator, the bear's head follow the passenger up and down.

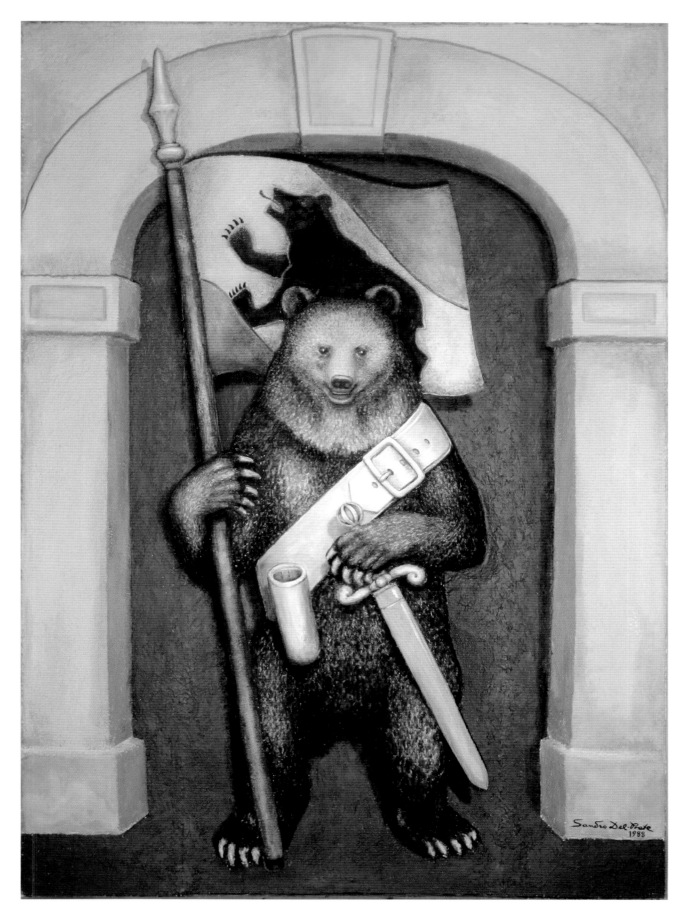

Lazy Dog *(Fulehung)*

Inversion sculpture, 1989, displayed near the Thun city wall, Switzerland.

The origin of this custom dates back to the Middle Ages. During the so-called Burgundy Wars, more specifically the battle of Murten, the Swiss captured the court jester of Charles the Bold. They brought him back to the city of Thun and paraded him like a trophy through the city streets, whose inhabitants laughed at him. Since then, it has become, during the last week in September, an annual custom for a masked jester to chase after the children of Thun, who tease him in the streets. The jester's original mask is preserved in the city of Thun.

Jeremias Gotthelf
Inversion sculpture made from gypsum, 2000.

This sculpture of the Swiss author is on display in the Gotthelf Museum in Lützelflüh, Switzerland.

He points to the visitors with a pen, as he did his pointed character portraits in his written works.

The Little Rascal *(Ds Lusbuebli)*
Inversion sculpture made of bronze, 55 × 28 × 28 inches (140 × 70 × 70 cm), 2004.

Part of a private collection in Switzerland.

 A sculpture of a little boy who amuses himself by playing pranks on passers-by. Since he is but a lad, and his innocent pranks make people laugh, they are tolerated by his victims and encouraged by observers.

The Four Seasons: Spring, Summer, Autumn, and Winter

Inversion sculpture made from gypsum and synthetic material—oil painting, 20 × 7 feet (6 × 2.2 meters), 2000.

On display in the Coop Supercenter, Bümpliz/Bern, Switzerland.

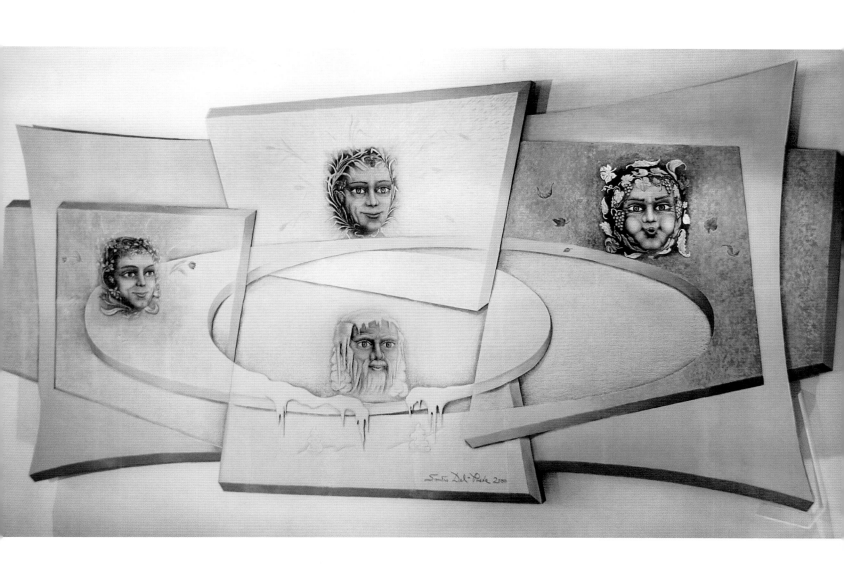

THE FLOATING VASE

Inversion and eversion image / sculpture, oil on board, 80 × 39 inches (200 × 100 cm), 2005.

"The climax of the exhibition is a huge panoramic oil painting that uses a relief technique showing Thun Lake with the Eiger, Mönch, and Jungfrau—the world-famous mountain range in the Swiss Alps. In the forefront, one perceives columns and a floating vase (a vase floating in midair). This image is a novelty, as Sandro Del-Prete is the first artist to use techniques of inversion and eversion in the same image. I was invited to walk before the image but, when I did, the whole exhibit began to move. The vase and columns were really moving, though I had not had a single drop of alcohol."

—Excerpt from the Foreword by Annemarie Koch

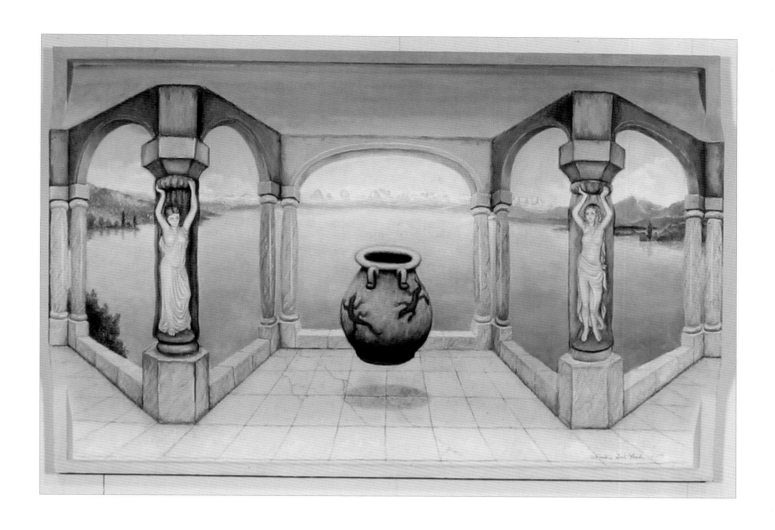

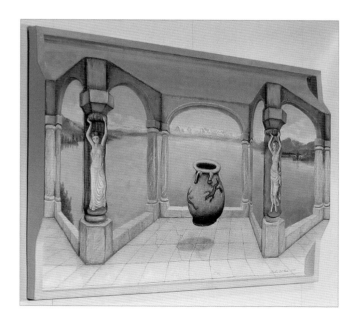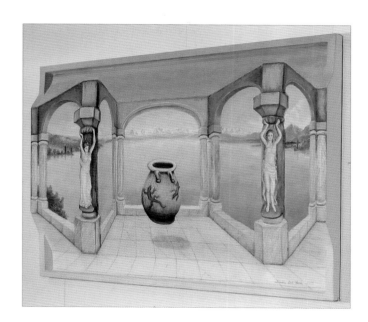

Sculpture and Relief Images in *Illusoria-Land*

Illusoria-Land is a museum (and much more); it is a world of adventure that provides the opportunity to personally experience the art of optical illusion. You can see, *firsthand*, its fascinating images and illustrations, some of which are reproduced for your perusal in this volume. You can also experience for yourself the wondrous moving statues described in the previous chapter. For the more adventurous, *Illusoria-Land* provides a unique opportunity to experience mind-boggling "room visions"* and holographs.

As with holographs, in room visions, one can see objects in the room in three dimensions, but contrary to holographs, room visions move and emit sounds, though they cannot be touched or manipulated in one's hands. Similarly, this world of adventure and experience offers illusions that are generated by the observer's movement—for example, the rotation tunnel.

Illusoria-Land's main purpose is that of observing and discovering the many wonders of the art of illusion. Contrary to *Castel Nero* (*The Castle of Darkness*), where one is guided by blind people, *Illusoria-Land* stimulates all of one's senses to experience, firsthand, the art of illusion.

Here you will find some examples of the images and statues on display at *Illusoria-Land* (pages 286 to 301).

* Room visions are in-house exhibits, created and patented by myself to be enjoyed by friends and visitors to *Illusoria-Land*.

THE DEMON OF GAMBLING IN A DICE
Inversion relief painting in oil, 24 × 33 inches (61 × 83 cm), 2005.

When passing in front of the painting, one's attention is drawn to the one-dot surface; a small door opens, and a little demon peeps out.

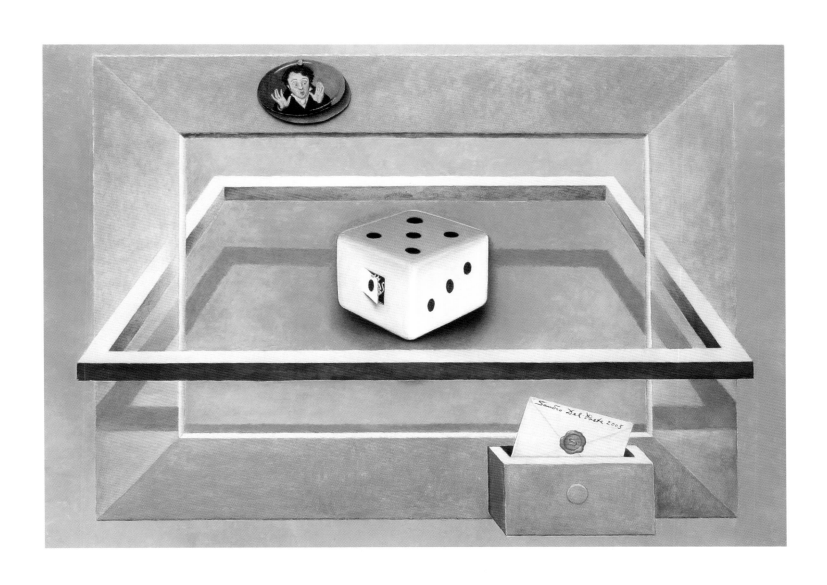

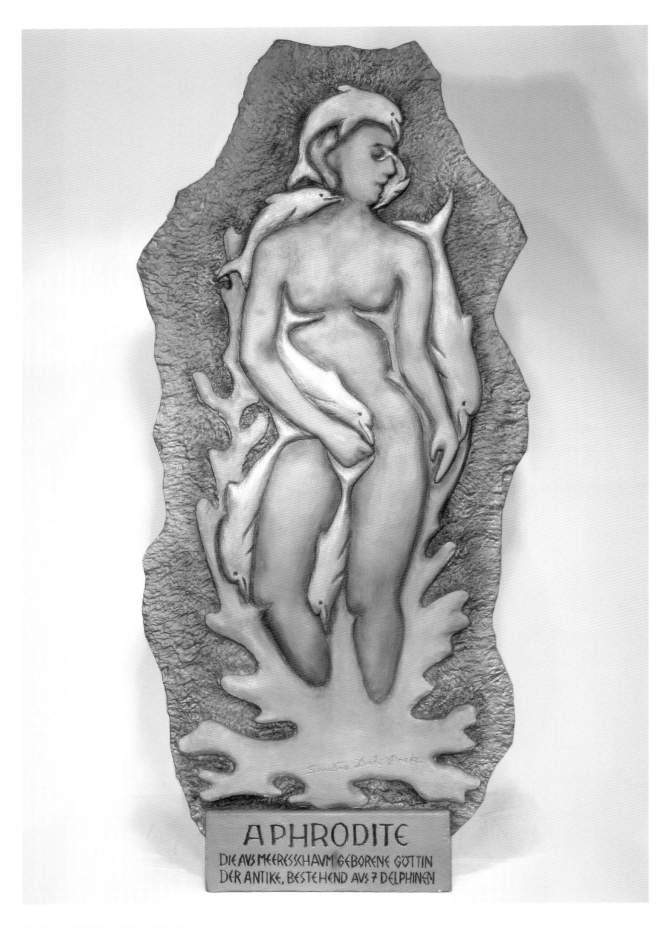

APHRODITE

DIE AVS MEERESSCHAVM GEBORENE GÖTTIN
DER ANTIKE, BESTEHEND AVS 7 DELPHINEN

Aphrodite

Bronze sculpture, 55 × 26 inches (140 × 65 cm), 2004.

Part of a private collection in Astano, Switzerland.

This ancient goddess, according to legend, emerged from the sea foam of waves breaking on the beach and was responsible for the generation of all life on earth.

In this sculpture, she is fashioned from dolphins and sea foam.

Unveiling of Venus

Inversion sculpture made from gypsum, 39 × 55 inches (100 × 140 cm), 1986.

This sculpture is on display at *Illusoria-Land* in Ittigen, Bern, Switzerland.

Illusorius

Inversion sculpture made from gypsum, 81 × 35 inches (205 × 90 cm), 1981.

On display at *Illusoria-Land* in Ittigen, Bern, Switzerland.

Antique Bronze Mask in Amethyst, on a Bronze Pedestal

63 × 28 inches (160 × 70 cm), 1981.

On display at *Illusoria-Land* in Ittigen, Bern, Switzerland.

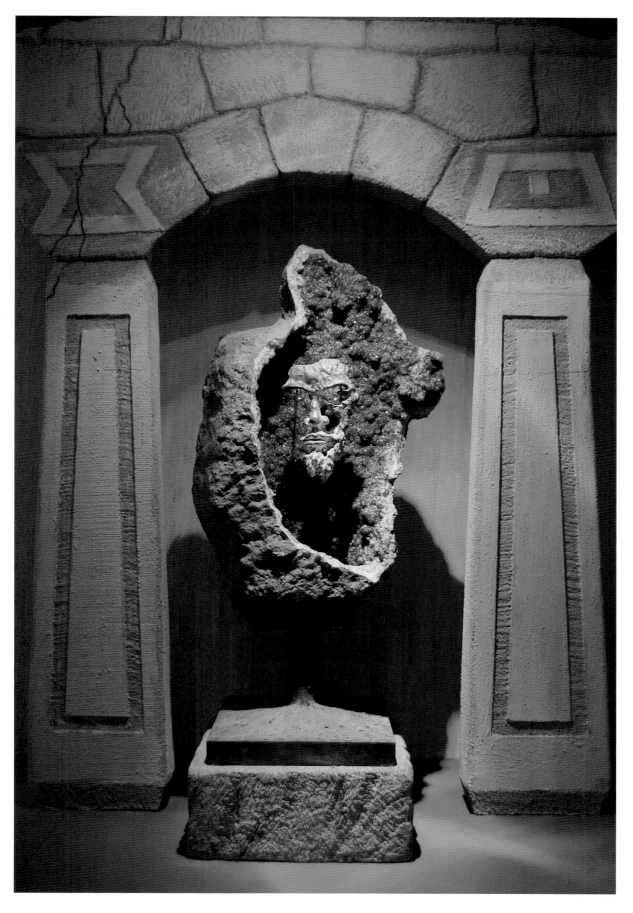

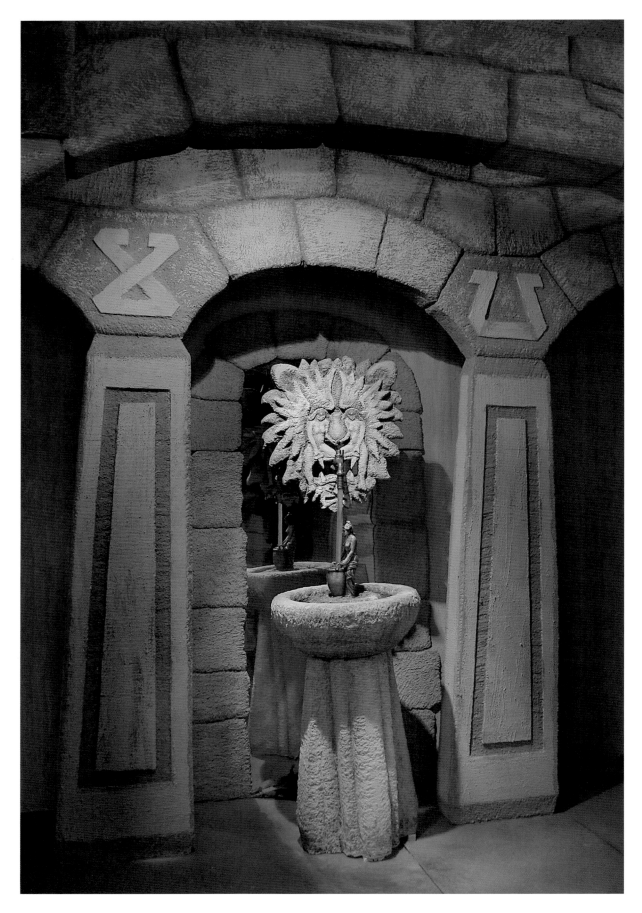

LION'S HEAD, FASHIONED OUT OF TWO ANGELS

Sculpture made of synthetic material; 55 × 20 inches (140 × 50 cm), 2001.

A fountain with a water tap and flowing water, but no water pipe . . .

ALEC IN ILLUSORIA-WONDERLAND

This is an aeruginous (greenish-blue) figure, crafted from synthetic material, 55 inches (140 cm), and a specially prepared mirror, 6.5 × 6.5 feet (2 × 2 meters).

Alec goes through the mirror to attain to the virtual world of Illusoria-Wonderland.

The End of the Story

The book before us is both a beginning and a terminus. Even as the final series of letters escapes from the last page, a sign is already pointing to a new destination: *Illusoria-Land*.

But . . . that is another story!

CLOSING WORDS

I trust that you have enjoyed this collection of works from *Illusoria-Land*, and that your curiosity has been sparked by the inspiration derived from its pages.

With your kind indulgence, I would now like to address the distinguished members of the artistic community as I attempt to underline the important contribution of artists who have followed the path laid down by M. C. Escher. Many colleagues deserve honorable mention, and though I could not possibly name them all, I would like to draw your attention to those I am especially familiar with.

Aside from the masters mentioned herein who have already passed away, I would like to point out the contributions of such colleagues as Jos de Mey, Shigeo Fukuda, Rob Gonsalves, Mathieu Hamaekers, Scott Kim, Akiyoshi Kitaoka, Guido Moretti, Octavio Ocampo, István Orosz, John Pugh, Roger Shepard, and Dick Termes.

On this momentous occasion, I would also like to express my deep gratitude to Al Seckel for his wonderful book, *Masters of Deception*.

I have made the acquaintance of many colleagues through the M. C. Escher convention in Rome: Tamás Farkas, Teja Krasek, Makoto Nakamura, Eva Knoll, Kelly M. Houle, Victor Acevedo, and others whose names I have unfortunately forgotten or misplaced, and to whom I sincerely express my regrets.

I would especially like to say a word of thanks to the organizers of the convention, Doris Schattschneider and Michele Emmer, whose efforts rewarded our community by laying the foundations for the international communion of fellow artists and colleagues, as experienced during this event. We also recognize the important contribution of many mathematics professors, physicists, and authors, such as Bruno Ernst, Douglas Hofstadter, and others.

A growing number of artists throughout the world are following in our footsteps and have joined our list of followers: among them are Mitsumasa Anno, Victor Molev, Monika Buch, Dirk Huizer, Joop van Bossum, and Hermann Paulsen. As time goes on, others will join the ranks of enthusiasts who, like us, have taken it upon themselves to follow the path of the masters. Perhaps we will be awarded the privilege of meeting them at our next convention.

The flame that ignited the birth of this movement burns on through the inspired works of its growing membership, giving us all hope that it will never be extinguished.

Hands are but a tool that can be used to craft beauty or to wage war. . . . Sandro Del-Prete's were created to craft beauty!

PUBLICATIONS AND MAJOR EXHIBITIONS

Publications

1981 *Illusorismen – Illusorismes – Illusorisms.* Bern, Switzerland: Benteli Verlag. (In German, French and English)

1987 *Illusoria.* Bern, Switzerland: Benteli Verlag (in German and French)

1988 "Künstlerportrait von Sandro Del-Prete." *Aarburger Neujahrsblatt.*

Illusoria Gallery

1984–1999 *Illusoria Gallery,* Bern, Switzerland

Museum and Gallery

Since 2000 *Illusoria-Land,* Ittigen (near Bern), Switzerland: permanent exhibition

Major Exhibitions

1984 *Phänomena* in Zurich, Switzerland

1984 *Museum of Fun,* Tokyo, Japan: traveling exhibition

1985 *Phänomena,* Rotterdam, The Netherlands

1990–2000 Twenty-five special exhibitions in major shopping malls in twenty-two cities throughout Switzerland

Since 2001 Special exhibitions at the MOWO ("Modernes Wohnen"/Modern Living) in Bern, Switzerland

Since 1981 Various exhibitions in Switzerland and abroad

Acknowledgments

I would like to extend my heartfelt thanks to everyone who had a hand, however great or small, in the success of my work. This book is the culmination of an important chapter in my life, as well as my work, and the starting point of another. My thanks go to:

My wife Yolanda, for her moral support and lifelong patience;

My son Carlo and his wife Brigitte, for their enthusiastic support;

My son Silvano, for his criticism, sometimes harsh, but always visionary;

My friend Annemarie Koch, whose priceless ideas, texts, and dedication helped make this volume a reality;

Michel A. Di Iorio, translator and proofreader from Québec, Canada, for his generous contribution;

Malu Barben, the photographer who made room in her busy agenda;

Robert Lüthi, who provided his photos of *The Way of the Cross*;

Jens-B. Augustiny, who was there before we even knew that we needed him;

Anne Zimmermann, for her proofreading;

My friends Gerhard Stief and Ines Martini, for their precious assistance in the realization of this project;

Al Seckel, for including my work in his books, thus opening the door to America for me;

Sterling Publishing Co., Inc., New York, for including my work in their collection; and

Many more whose forgiveness I seek for having forgotten to name them.

INDEX

About the Author

The Ticinese family name of Del-Prete originated in Astano, the cradle of numerous internationally acclaimed and recognized artists and architects of the Malcantone region in the Italian-speaking part of Switzerland.

Among the ancestors of Sandro Del-Prete, many emigrated to escape the arid soil of their homeland, which was unable to sustain its inhabitants. Sandro's father established himself in the German-speaking part of Switzerland, where he successfully completed an apprenticeship in mechanics. Though his trade left him somewhat indifferent, he plied it for many years, convinced that a stable government job was an indispensable asset for the security and well-being of his family. His attitude was reflected in his children's strict education and future career orientations.

Sandro was born on September 19, 1937, in Bern, the capital city of Switzerland, where he attended school and pursued post-secondary commercial studies at a college in Fribourg. An average student,[1] his interests revolved around various artistic endeavors, including the art of drawing, for which he rapidly developed an unquestionable talent. After completing his mandatory military training, he had but one objective in mind: to sustain himself well enough to pursue his artistic training and ambitions.

Shortly thereafter, he afforded himself a six-month trip to the Florence Academy of Fine Arts in Italy. Though of relatively short duration, his trip to Florence became a pillar of his artistic development, where he learned to appreciate the works of the Old Masters, adopting the likes of Botticelli, da Vinci, Michelangelo, Rembrandt, and Rubens as inspirational role models. More than by his theoretical studies, Sandro was influenced by many long hours spent studying the masterpieces of these Old Masters. A regular visitor to the Pitti Palace and the Uffizi Gallery in Florence, he trained his eyes to analyze their structure, lighting techniques, and colors in an attempt to lend content and purpose to his visits. Relentlessly, he explored the intimate link that existed between the Masters and their works.

Predictably, money began to run out, and Sandro was faced with an important decision: whether to adopt a safer, middle-class lifestyle or to embrace the precarious existence of an

unknown artist. He opted for the comfort of security but never lost sight of his objective. Scholarships were taboo, and it was out of the question for him to be involved in commercial advertising contests and commissions. He preferred to freely exercise his creativity without running the risk of compromising his integrity. During the next twenty years, he successfully persevered as an individualist. Upon his return to Bern, he was hired as a consultant by an important company and received on-the-job training as a licensed traveling salesman.

In 1966, he married his childhood friend and sweetheart, Yolanda Imhof. She gave him two wonderful sons, Carlo and Silvano, who provided Sandro with the family atmosphere he needed to thrive in the northern quarter of Bern. Yolanda, in addition to being a wife and mother, assumed the trying role of chief administrator of Sandro's enterprise, freeing Sandro to pursue his destiny as a creative artist.

Once again he changed his metier before becoming his own master. During the course of thirteen years, he worked as an inspector for CNA Insurance Company in Europe. During this period, Sandro used most of his free time to pursue his vocation, distancing himself from the more time-consuming creation of oil paintings and wood sculptures. He was never short of ideas and produced hundreds upon hundreds of charcoal and pencil drawings, which led him to develop an interest in the art of illusion.

His job constrained him and prevented him from immediately following up on sudden inspirations, whether experienced en route to a client or while sitting around a conference table; these contraints, in addition to persistent digestive problems, deeply troubled him. A composite of his work was presented in an initial illustrated collection entitled *Illusorisms*, first published in 1981. The rapid success of this volume, and a "second chance at life"[2] encouraged him to inaugurate his gallery, appropriately christened *Illusoria,* situated at 70 Schwarztorstrasse in Bern.

It was during this period that the artist decided to apply himself exclusively to his creations. The original character of his gallery provoked the interest of many art lovers, experts, and students. During a stopover in Bern, the director of the Japanese magazine *Asahi Shimbun* purchased numerous canvases. The inverted sculpture entitled *Professor Turnhead,* permanently facing the observer, so impressed him that he immediately ordered a copy, with the intention of exhibiting it at the Museum of Fun in Tokyo alongside the acquired canvases. Another of Sandro's sculptures, known as *Mr. Nosey,* was exhibited in Bangkok.

Sandro Del-Prete is a painter, an artist, and a sculptor. After many trials, he finally discovered the secrets of suppleness and movement that had elicited people's admiration of statuary during the time of the Renaissance. In 1984, his sculptures attracted the attention of the organizers of Zurich's *Phänomena,* a major national exhibition. For months, the artist's two inverted statues attracted attention like a superpowered magnet. Sandro lost no time in disproving the old adage that one is least appreciated by those who are most familiar with you. In 1985, he was commissioned to decorate the *Schweizerhofpassage* with the statue of a typical Bernese personage. His *Loubegaffer*